virtual interiorities
book three: senses of place and space

edited by Dave Gottwald, Gregory Turner-Rahman, and Vahid Vahdat

CARNEGIE MELLON UNIVERSITY: ETC PRESS
PITTSBURGH, PA

Virtual Interiorities by Carnegie Mellon University: ETC Press is licensed under a Creative Commons Attribution-NonCommercial-NoDerivatives 4.0 International License, except where otherwise noted.

COVER DESIGN Dave Gottwald and Gregory Turner-Rahman

BOOK DESIGN Dave Gottwald

COPY EDITING Rebecca J. Kanaskie

virtualinteriorities.org

Copyright © by ETC Press 2022
press.etc.cmu.edu

ISBN: 978-1-387-50497-8 (Print)
ISBN: 978-1-387-49250-3 (ePUB)

The text of this work is licensed under a Creative Commons Attribution-NonCommercial-NonDerivative 2.5 License (creativecommons.org/licenses/by-nc-nd/2.5/). All images appearing in this work are property of the respective copyright owners, and are not released into the Creative Commons. The respective owners reserve all rights.

This book was produced with Pressbooks (https://pressbooks.com) and rendered with Prince.

contents

Acknowledgements — v

Foreword — vii
Graham Harman

Introduction — xiii
Dave Gottwald

V. VIRTUAL ONTOLOGIES

Representing Imaginary Spaces — 21
Fantasy, Fiction, and Virtuality
Nele Van de Mosselaer and Stefano Gualeni

A Journey from Total Cinema to Total World — 45
Realizing the Film Set as Virtual Performer
Dave Gottwald

Making Sense of Virtual Heritage — 77
How Immersive Fitness Evokes a Past that Suits the Present
Johan Höglund and Cornelius Holtorf

The Theme Park Ride (In and of Itself) as a Cultural Form — 99
An Investigation of Kinetics, Narrative, Immersion, and Concept
Scott A. Lukas

VI. POSTHUMAN VIRTUALITIES

Gods of the Sandbox — 145
Animal Crossing: New Horizons and the Fluidity of Virtual Environments
Daniel Vella

Space at Hand Ever Nearer to HALF-LIFE **Michael Nitsche**	169
Aerial Viscosity The Architecture of Drone Photography **Jon Yoder**	185
About the Editors	211
About the Contributors	213
About the ETC Press	217

acknowledgements

The editors wish to thank, first and foremost, all our contributors. During a global pandemic—during which many of us were living under some kind of lockdown—they replied kindly to our emails and met over Zoom calls across disparate timezones to plan and produce the compelling essays comprising these three books. Thank you to Dr. Scott Lukas for recommending the good people at Carnegie Mellon University's ETC Press, and to Editorial Director Brad King and his associates there for their ongoing support of this project. Dave Gottwald wishes to thank Brad Beacom and Emma Sondock for stimulating conversations about his work and for their ongoing friendship and support. Gregory Turner-Rahman wishes to thank Jim Bizzocchi for taking the time to discuss his work. Vahid Vahdat wishes to thank Graham Harman for accepting his invitation to write a thought-provoking foreword to this collection. Finally, great thanks from the editors to Rebecca J. Kanaskie for her sharp eye in copy editing the final manuscript.

foreword

Graham Harman

In the academic world it is an open secret that a certain percentage of edited anthologies are doomed to sink quickly beneath the waves, never to be heard from again. Often amounting to repositories for well-meaning conference papers, such books are those that fail to gain traction with the reading public, whether through a lack of internal unity of their various chapters or for purely accidental reasons. This three-volume collection now before you is something much better than that, and thus deserves a more glorious fate. Its title, *Virtual Interiorities*, should be read in a surprisingly literal manner, for its chapters discuss nothing less than the possible transformation of our conception of space (and even time) by way of a number of challenging technologies, ranging historically from amusement parks to the latest video game interfaces. In the introductions that follow for each book, the editors give a fine chapter-by-chapter overview of the individual contributions that form this collection. Here I will do something different, providing a general philosophical framework to assist the reader in grasping the possible stakes of *Virtual Interiorities*.

One common way to think of space and time is to view them as stable, empty containers within which things and events are located. At least prior to Albert Einstein and his general theory of relativity, which speaks of the distortion of space and time by mass, the empty container theory was the dominant one in modern physical science. The locus classicus of this concept is the Principia of Isaac Newton, where we find the following emblematic words: "Absolute, true, and mathematical time, of itself, and from its own nature, flows equably without relation to anything external ... Absolute space, in its own nature, without relation to anything external, remains always similar and immovable."[1] It could be said that the chief philosopher of the modern era, Immanuel Kant, retained this theory in his own system of thought.[2] True enough, Kant treats time and space as universal forms of human subjectivity rather than as objective containers found in the outside world. Nonetheless, both continua remain constant for Kant as well as for Newton: no stretching, bending, or twisting of time or space is conceivable for either of them.

Long before Kant this theory was defended on Newton's behalf by his ally Samuel Clarke in a famous debate with the philosopher G.W. Leibniz that ended with Leibniz's death in 1714.[3] Famously, Leibniz challenged the Newtonian conception of time and space by offering a relational alternative: space and time do not exist independently of the entities that occupy them but are defined by those entities in the first place. Among other rhetorical strategies, Leibniz ridicules the possibility that God might have created the universe ten minutes earlier than he did or one mile further to the west, since neither earlier/later nor east/west could have any meaning at all prior to the creation of the universe. Hence, space and time require a purely relational structure in which all temporal and spatial conceptions make sense only when entities are measured against one another. Given that relationality is highly fashionable in today's intellectual atmosphere, few will resist the chance to snap at the bait of Leibniz's argument. For reasons lying beyond the scope of this foreword, I am inclined to push

1. Isaac Newton, *Philosophiae Naturalis Principia Mathematica*, Book One, trans. Andrew Motte (Berkeley, CA: University of California Press, 1934), 6.
2. Immanuel Kant, *Critique of Pure Reason*, trans James Ellington (Indianapolis: Hackett, 1996).
3. *G.W. Leibniz & Samuel Clarke, Correspondence* (Indianapolis: Hackett, 2000).

back against relational ontologies of this sort. Yet that is beside the point, for more relevant to us here is the implication that far from being stable backgrounds for events—as even quantum theory still assumes—the Leibnizian model entails that our spatio-temporal framework is changeable. It was Albert Einstein who developed this possibility, in both the special and general theories of relativity, in which velocity (special) as well as mass and acceleration (general) play a previously unknown role in distorting one or both of the background continua we inhabit.

But, instead of these famous discoveries in physics, the three books of *Virtual Interiorities* discuss the possible role of technology in warping our usual sense of space and time. In a sense, this far predates what we think of modern technology. Ancient empires are known to have used gigantic statues and related techniques to terrify their enemies. Indeed, architecture itself might be viewed as a method of distorting natural space into something more emphatic or even psychedelic, with torch-lit inner chambers or distressing pyramids and ziggurats bringing a disoriented awe to those who visit them. The present work, however, focuses on more recent history, beginning with the pioneering amusement parks of the early twentieth century. Other chapters focus on advances in video game technology, including certain engines that allow players to explore worlds where the customary laws of physics are violated. While there may be limits to how much space and time can be modified without neurosurgical tampering, the still-young field of virtual reality is already capable of producing vertiginous effects in its users.

It was the great merit of Jakob von Uexküll to explore in empirical detail how the environment of each animal is determined by the limits of what it is able to perceive.[4] Although his most famous example is that of the tick, I am even more struck by his observation that different animals are capable of seeing the same flash of light a differing number of times per second. For instance, a snail is able to see just three or four flashes per second; more than that and it sees a steady light instead. A human is capable of seeing more than three times as many flashes per second as

4. Jakob von Uexküll, *A Foray into the Worlds of Animals and Humans: With A Theory of Meaning*, trans. Joseph O'Neil (Minneapolis: University of Minnesota Press, 2010).

snails, but fighting fish turn out to be even more gifted in this respect.[5] Of course, it is well-known that dogs hear in different registers from humans and that many animal species feel storms coming even while humans experience nothing but the blue sky above, however, the coming technologies might eventually put these animal talents within human reach. In his interesting book *Discognition*, Steven Shaviro further explores the cognitive difference between humans and such exotic creatures as slime molds,[6] but theorizing such topics in books is one thing and enabling journeys into these theorized alternate worlds is quite another. What the contributors to *Virtual Interiorities* succeed in doing is making us feel closer than ever to a technological era in which such questions as Thomas Nagel's famous query "What is it like to be a bat?" are not just philosophical thought-experiments but possible advertising slogans for products that enable customers to find out for themselves.[7] If there is anything I envy in the young, it is the fact that the power of space-time manipulation might be technologically within reach during their lifetimes, though probably not in my own. *Virtual Interiorities* improved my imagination by giving an early sketch of how such a thing might happen.

Long Beach, California
September 2022

Bibliography

Harman, Graham. "Magic Uexküll," in *Living Earth: Field Notes from the Dark Ecology Project 2014-2016*: 115-130. Amsterdam: Sonic Acts Press, 2016.

Kant, Immanuel. *Critique of Pure Reason*. Translated by James Ellington. Indianapolis: Hackett, 1996.

Leibniz, G.W. & Samuel Clarke. *Correspondence*. Indianapolis: Hackett, 2000.

Nagel, Thomas. "What is it Like to Be a Bat?" *The Philosophical Review* 83, no. 4 (1974): 435-450.

Newton, Isaac. *Philosophiae Naturalis Principia Mathematica*, Book One. Translated by

5. See Graham Harman, "Magic Uexküll," in *Living Earth: Field Notes from the Dark Ecology Project 2014-2016*: 115-130 (Amsterdam: Sonic Acts Press, 2016).
6. Steven Shaviro, *Discognition* (London: Repeater, 2016).
7. Thomas Nagel, "What is it Like to Be a Bat?," *The Philosophical Review* 83, no. 4 (1974):435-450.

Andrew Motte. Berkeley, CA: University of California Press, 1934.

Shaviro, Steven. *Discognition*. London: Repeater, 2016.

Uexküll, Jakob von. *A Foray into the Worlds of Animals and Humans: With A Theory of Meaning*. Translated by Joseph O'Neil. Minneapolis: University of Minnesota Press, 2010.

introduction

Dave Gottwald

> In experience, the meaning of space often merges with that of place. "Space" is more abstract than "place." What begins as undifferentiated space becomes place as we get to know it better and endow it with value. Architects talk about the spatial qualities of place; they can equally well speak of the locational (place) qualities of space. The ideas "space" and "place" require each other for definition.
>
> —Yi-Fu Tuan[1]

The seven chapters which comprise *Book Three: Senses of Place and Space* are all concerned with ontological matters of spatiality, representation, and inhabitation. As the first two volumes in this collection demonstrate, contemporary virtuality complicates traditional distinctions between what is "physical" and what is "virtual" to reveal new collisions and liminalities. The mediated experience itself has also been redefined; the very concept of illusion is not what it once was. And this is also true of what is meant by "place" and by "space."

1. Yi-Fu Tuan, *Space and Place: The Perspective of Experience* (Minneapolis: University of Minnesota Press, 1977), 6.

In his seminal work *Space and Place* (1977), humanistic geographer Yi-Fu Tuan characterized the relationship between the two as being embedded within a powerful matrix of time and experience. As concepts they cannot be cleaved from one another, but they can certainly be reconfigured, and this reconfiguration plays out across the chapters in this volume. Tuan defines space as being mythical, pragmatic, and abstract or theoretical, with a good deal of overlap between. To these he overlays "place" as a sense of inhabitation which develops over time. What does Tuan's distinction mean on a personal level? Think of checking into a hotel room in an unfamiliar city. Upon arrival, you slide your key into the door and are presented with a new space. Over the time you spend in this space, you unpack your belongings and perhaps rearrange the furniture. You have likely brought spatial practices along with you, such as where you place your toiletry bag by the sink, or what you decide to unpack. You have a favorite place where you charge your phone and perhaps a routine for other items: always a glass of water by the bed, shoes at the door. These are your habits. Literally, through this process of inscribing behavior over time onto a space, you have *inhabited* that space. And this inhabitation means that when you leave at the end of your stay, whether overnight or for a fortnight, you depart from *a place* rather than just *a space*.

All essays across the *Virtual Interiorities* collection complicate Tuan's experiential topology in some way because the virtual allows for nonspaces, placeless spaces, and everything in between: human experience and a sense of inhabitation that is free of any space/place distinction. The chapters in this third and final book are linked by a more direct engagement with these recombinations.

In "Representing Imaginary Space: Fantasy, Fiction, and Virtuality," Nele Van de Mosselaer and Stefano Gualeni present what could be considered the philosophical heart of this volume. For them, Tuan's mythical, pragmatic, and abstract distinctions of space melt completely within the construct of virtuality. Instead, they characterize virtual space "represented by computers and . . . explored interactively" as a unique amalgam of three concepts: lived space, fantasy space, and fictional space. Splitting the difference between lived, fantasy, and fiction, "our imagining of vir-

tual space is not limited nor determined by the represented explorations and perspectives of characters or creators, but rather, much like our experience of actual space, shaped by our own (albeit fictional) spatial practices."

Johan Höglund and Cornelius Holtorf investigate trends in immersive fitness technologies in "Making Sense of Virtual Heritage: How Immersive Fitness Evokes a Past that Suits the Present." They describe in detail Les Mills's *The Trip*, a gym experience which merges a room of individual exercise bike riders with a domed IMAX-like visualization. Various virtual films are shown which combine images of cultural antiquity with fantasy spaces and pop music. The result shuffles space and place, reducing inhabitation to the duration of the workout and providing something like a time travel experience in which those exercising "navigate through ancient landscapes that are ultimately not about the past but about the future." Egypt blends with Classical Greece, African plains, and modern American cityscapes in these films, thus reinforcing the way these locales are consumed as tourist stereotypes rather than leveraging their virtuality to deepen the cultural probe of each place.

Scott A. Lukas considers both place and space as a singular, dynamic, embedded experiential "dream object" in "The Theme Park Ride (In and of Itself) as a Cultural Form: An Investigation of Kinetics, Narrative, Immersion, and Concept." Here he charts the evolution of the amusement park/theme park attraction across four overlapping eras beginning at the dawn of the twentieth century: kinetics, narrative, immersion, and, finally, the transmechanical. At first a rider's sense of place—of inhabitation—was purely visceral; it was one of motion, speed, and heights. Then, as cinema became intertwined via the dark ride model, external places of popular culture formed a "shared spatial aesthetic" which has inevitably led to increasing levels of both immersion and virtuality. With many ride experiences now both virtual and gamified, Lukas posits that as space and place continually reconfigure and transmorph via emerging technologies "devices of the home will not only resemble (if not replace) public theme park rides, attractions, and associated entertainment machines," and they "may also achieve a future state of singularity."

Daniel Vella's "Gods of the Sandbox: *Animal Crossing: New Horizons* and the Fluidity of Virtual Environments" interrogates the unique properties of the virtual sandbox world of *Animal Crossing: New Horizons* (2020) and similar digital games. Such sandboxes are neither interactive, resistant playgrounds of ludic push and pull nor "god games" where the player is disembodied and omniscient. Instead, *AC:NH* and like virtual environments are "a non-place, a possibility space." Yi-Fu Tuan's separate notions of space and place crumble across this playscape in which every contour can be remade at will and both the grid of digital space and time itself are atomized and cut up by an ontology of measure. Vella draws upon contemporary philosophers Byung-Chul Han and Federico Campagna to demonstrate that, through their inexorable fluidity, the virtual sandbox is "central to our contemporary moment and a perfect representation of it." Inhabitation becomes compartmentalized; the landscape itself becomes a mutable social media feed of tasks, messages, and relationships.

"Space at Hand: Ever Nearer to *HλLF-LIFE*" by Michael Nitsche reminds us that the virtual world goes well beyond environments. Evoking performance theory and puppeteering, Nitsche uses the *HλLF-LIFE* game series as a case study to demonstrate the evolution of actionable objects and game engine physics. This culminates with *HλLF-LIFE: Alyx* (2020) in which "players can form their own sub-spaces . . . within which the role of the active object is growing." He argues that the game's Gravity Gloves—which allow the player a typical range of hand motions like grasping, holding, and writing, but also lifting impossibly heavy objects and pulling with invisible force distant ones—creates an entirely new notion of space within VR, a "space-at-hand." This "scaling up of detail in close quarters" shatters Yi-Fu Tuan's static conceptions of space, calls attention to enhanced object agency as a spatial practice, and emphasizes yet another unique property of the virtual—its elasticity.

Lastly, in Jon Yoder's "Aerial Viscosity: The Architecture of Drone Photography" we are reminded that virtuality is also bound up with *perceptions* of space. In arguing that "the architecture of drone photography draws attention to the intricacies of the aerial apparatus itself," Yoder

characterizes his own photography as well as the work of others as a deconstructivist practice which cuts across property lines and development narratives to free structures from the cartesian grid. Especially via oblique views which allow for greater dynamism than a satellite's top-down perspective, drones provide a "non-dimensional yet relational perspective" that allows artists and designers to explore the built environment as a digital game "from walkthrough to flythrough." Here, the idea of place is challenged by shifting the paradigm from which space is interrogated, allowing that which has already been "lived space" (in Van de Mosselaer and Gualeni's terms) to combine with the technological regime of the camera and drone itself, thus becoming its own unique kind of virtual experience.

Throughout these three volumes of *Virtual Interiorities*, the editors have favored approaches that may be concerned with technological matters yet are not overly wedded to them. This particular group of chapters invites us to consider the gym, digital games, the theme park attraction, a pair of virtual gloves, or the aerial drone through the lens of place and space. As Nele Van de Mosselaer and Stefano Gualeni remind us, the contributions to all three volumes are each, in their own way, somewhat philosophical in nature. Through this broader and more inclusive praxis, we hope future researchers will consider this or that technological advancement as a fluid entry point into a vast and ever-expanding metaworld of virtual experiences, identities, and perceptions.

Bibliography

Tuan, Yi-Fu. *Space and Place: The Perspective of Experience*. Minneapolis: University of Minnesota Press, 1977.

V. VIRTUAL ONTOLOGIES

Representing Imaginary Spaces
Fantasy, Fiction, and Virtuality

Nele Van de Mosselaer and Stefano Gualeni

Introduction

> It was . . . like a great barn-door; and they all felt that it was a door because of the ornate lintel, threshold, and jambs around it, though they could not decide whether it lay flat like a trap-door or slantwise like an outside cellar-door. As Wilcox would have said, the geometry of the place was all wrong. One could not be sure that the sea and the ground were horizontal, hence the relative position of everything else seemed phantasmally variable.
>
> —H.P. Lovecraft[1]

What kind of space was presented in the previous paragraph? Its description is clearly not an incentive to think of it as the kind of space that could be intuitively grasped or easily navigated by human beings. The readers of the passage above are not supposed to believe that such a space exists: they are merely prompted to imagine its existence, appearance, and unfamiliar qualities. The space described here is thus an example of what we call an "imaginary space." In this chapter, we want to analyze and discuss how we experience such spaces.

1. H.P. Lovecraft, *Cthulhu Tome Revised* (Ingersoll: Devoted Publishing, 2019), 233.

Imaginary spaces can manifest in many different ways. The space described above, for example, originally only existed in the fantasy of H.P. Lovecraft, who conceptualized it, gave it a certain shape and specific colors, imaginatively decorated it with objects, and rendered it in a textual description. In the original conceptualization of that space, Lovecraft was bound by the limits of his own creativity and was able to freely conceive and transform this space within his imagination. For whoever reads Lovecraft's work, on the other hand, this space is a represented space that is to be imagined based on the text of the above paragraph. The reader, in other words, cannot just freely imagine anything about this particular space but is constrained by the information given within Lovecraft's work of fiction. This space is thus what we will call a "fictional space": it is a space readers imaginatively encounter based on the information contained in the text.

Regardless of this space being freely conceived in fantasy or imagined based on its description, the way we experience this imaginary space differs from how we tend to experience real, physical spaces. After all, the described space cannot be entered, touched, interacted with, or explored any further. As it is an imaginary space, it is not a space that we can inhabit (that is, a space that we can be interior to): at most, we can imagine ourselves navigating it.[2] Imaginary spaces are fully interiorized: they are spaces that only exist within the mind, in the shape of mental images and/or imagined propositions.

Textual descriptions are not the only way to represent imaginary spaces, however. We can also be prompted and guided in our imagining of space by pictures, moving images, soundscapes, and even interactive, digital entities. The latter, which we call virtual representations of space, are of specific interest in this chapter. Computer-generated, interactive representations of spaces, especially those found in video games and virtual reality media, are not only designed to motivate their users to imagine the spaces they represent, but also to make these users imagine being interactively involved with these spaces. Virtual representations of space

2. See Gordon Calleja, *In-Game: From Immersion to Incorporation* (Cambridge, MA: The MIT Press, 2011), 74.

evoke spatial experiences that are imaginative yet also characterized by an illusion or feeling of being present within the represented space. Virtually represented spaces are interiorized, in the sense that they only exist as spaces within our imagination, but we also can be interior to them, in the sense that they mandate us to imagine our own existence within them (i.e., they prescribe self-involved imaginings).

The title of this collection, *Virtual Interiorities,* is interpreted in this chapter through the dual perspective of users who not only interiorize virtual spaces through their imagination but are also imaginatively interior to them. To make this clear, we will situate the experience of virtual spaces within the larger context of our experiences of imaginary spaces, defining the latter as spaces that are imagined—but not believed—to exist.

Imagination and Space

It is hard to pin down the concept of space. Generally speaking, the notion can refer to abstract, mathematical space, understood as boundless, three-dimensional geometry. Yet, such an interpretation of space is a mere abstraction from "the intuitive three-dimensional totality of everyday experience," which Christian Norberg-Schulz calls "concrete space."[3] Rather than focusing on abstract, mathematical space or space as independent of any perceiving subject, this chapter deals with "experiences of space," and thus with the concrete, so-called "lived space" that we inhabit.[4]

3. Christian Norberg-Schulz, *Genius Loci: Towards a Phenomenology of Architecture* (New York: Rizzoli, 1980), 11.
4. It would perhaps be clearer to specify that here we are not talking about space as such, but of specific spaces and places. A space or place, then, is understood as "a specific, limited location," which can be analyzed based on "the objects it contains and the actions it allows." Daniel Vella, "There's No Place Like Home: Dwelling and Being at Home in Digital Games," in *Ludotopia: Spaces, Places and Territories in Computer Games*, ed. Espen Aarseth and Stephan Günzel (Bielefeld: Transcript-Verlag, 2019), 2.

This chapter more specifically focuses on imaginary spaces, or spaces that are not believed, but merely imagined to exist. We here define imagining as thinking about something without affirming its truth or existence.[5] When we imagine something, we do not have a direct, perceptual experience of it, but rather entertain it in thought as something that is non-existent, or at least absent from our direct environment.[6] In light of such a definition of imagination, we propose to understand an imaginary space as a space that is posited as not actually existent, not physically present, and not immediately interactable with. As Kendall Walton writes, imagined spaces are separated from the world that actually surrounds us.[7] They have no physicality and offer no possibility for actually interacting with them. Based on these characteristics, it should not be surprising that the experiences of imaginary spaces that are discussed in this chapter significantly differ from experiences of real-life spaces and places.

Most noticeably, imaginary spaces do not allow for the same spatial practices that shape real-life, lived space. Many philosophers have pointed out that actual space only appears to us in a meaningful way because of how we interact with it, traverse it, perceive it, and in general, exist within it. In *The Production of Space*, Henri Lefebvre talks about space as being produced through a society's spatial practice.[8] Society's space is revealed in this practice, which "propounds and presupposes it, in a dialectical interaction." Similarly, Michel de Certeau writes how specific spatial orders only exist and emerge as they are enacted: "If it is true that a spatial order organizes an ensemble of possibilities (e.g., by a place in which one can move) and interdictions (e.g., by a wall that prevents one from going further), then the walker actualizes some of these possibilities. In that way, he makes them exist as well as emerge."[9] Edward Casey

5. See Nele Van de Mosselaer, "The Paradox of Interactive Fiction" (PhD diss., University of Antwerp, 2020), 25–26; and Elizabeth Picciuto and Peter Carruthers, "Imagination and Pretense," in *The Routledge Handbook of Philosophy of Imagination*, ed. Amy Kind (London: Routledge, 2016), 314.
6. Jean-Paul Sartre, *The Imaginary: A Phenomenological Psychology of the Imagination*, trans. Jonathan Webber (London and New York: Routledge, 2004), 12.
7. Kendall Walton, "How Remote are Fictional Worlds from the Real World?," *The Journal of Aesthetics and Art Criticism* 37, no. 1 (1978): 12.
8. Henri Lefebvre, *The Production of Space* (Hoboken, NY: Wiley-Blackwell, 1991), 38.
9. Michel De Certeau, *The Practice of Everyday Life* (Los Angeles: University of California Press, 1984), 98.

talks about the inherent "experimentalism" of place: abstract space only becomes meaningful when it is experienced by an active body as a "place of concerted action."[10] Shaun Gallagher and Dan Zahavi emphasize that it is our bodily possibilities that define experienced environments as "situations of meaning and circumstances for action."[11] From the perspective of existentialism, spaces gain meaning for one particular subject through the way they function within this subject's "existential project."[12] This existential project can be defined as "the aspiration to be in a particular way—to be a certain kind of subject."[13] It is through the lens of an individual's existential project that "things and events encountered in a world become meaningful for the individual: they can be recognized as obstacles to the fulfillment of the project, as tools and opportunities that can be leveraged towards the achievement of the project itself or parts of it, and so on."[14] In sum, the experience of (perceptual, actual, lived) space can be described and defined in terms of a rapport between space and an active body, with the meaning of specific places being produced through interactions, in practices such as traversal, exploration, and projectuality.

But what could such spatial practices entail when the space in question does not actually exist, but is only imagined or represented to exist? To analyze our experiences of imaginary spaces in more detail, this chapter will distinguish between different modes in which such spaces can be experienced. We will compare spaces that are freely evoked in personal fantasy with two kinds of fictional spaces: spaces that are represented in non-interactive works of fiction and spaces that are presented through interactive, digital media.

10. Edward Casey, *The Fate of Place* (Los Angeles: University of California Press, 2013), 29–30.
11. Shaun Gallagher and Dan Zahavi, *The Phenomenological Mind* (New York: Routledge, 2020), 156.
12. Jean-Paul Sartre, *Being and Nothingness*, trans. Hazel E. Barnes (New York: Washington Square Press, 1966), 717-722.
13. Stefano Gualeni and Daniel Vella. *Virtual Existentialism: Meaning and Subjectivity in Virtual Worlds* (Cham: Springer, 2020), 2.
14. Ibid.

Fantasy Space

Close your eyes and try to conjure up a space in your fantasy. Add whatever objects and details you want to it, let your imagination run free. Now keep this space in mind and ask yourself: What makes your imaginative experience of this space specifically "spatial"? Recall that Gallagher and Zahavi describe spaces as "situations of meaning and circumstances for action"[15] and that Lefebvre emphasizes that space is produced in a dialectical interaction or spatial practice.[16] Conversely, the space that you just conjured up in your personal fantasy does not allow for such a dialectical encounter. After all, your consciousness of this space already completely determines the space itself; you cannot explore this space, but merely build it. There can be no confrontation or interaction between you and your imagined space because the space is, per definition, not independent from you. For this reason, it can never surprise you. As Jean-Paul Sartre writes, you will never find anything there but what you put there yourself.[17] The space conceived in personal fantasy is not a lived space, but rather what Sartre calls a world of images where nothing ever happens.[18] This is because every movement in this space, every change of perspective or attempt to explore it further simply boils down to one thing: you conjure up an increasingly detailed and progressively more complete mental construct. Your experience of this space coincides, in other words, with your creation of it.

While real spaces emerge in our lived interactions with them, fantasy spaces are thus the product of private, creative imagination. This has two interesting consequences. First of all, your imagination of this so-called space is only restricted by the limits of your imagination. Fantasy space does not have to abide by physical laws, be persistent or stable (rather, it can morph incessantly and take on new and different shapes at the whims of the fantasizer), or be consistent with any knowledge we have about actual space. Secondly, the experience of a space entertained in fantasy

15. Gallagher and Zahavi, *The Phenomenological Mind*, 156.
16. Lefebvre, *The Production of Space*, 38.
17. Sartre, *The Imaginary*, 9.
18. Ibid., 11.

is not cognitively accessible to anyone but the fantasizer. Whenever this person tries to share what they conjured up in any way with other people, the mode in which these spaces are experienced changes. In this case, the fantasy space is crystallized into a represented, fictional space, the experience of which we describe in the next section.

To conclude this part, fantasy space is, in a way, a space without any of its usual characteristics: it has no physicality except for imagined physicality, it is never encountered, but merely conjured up mentally, it is not perceptually stable or behaviorally consistent, and it cannot be objectively experienced, nor can it be intersubjectively shared. Fantasy space is the semblance of space. It is a mental construct of space that can never give rise to, nor be discovered through, an experience that we would call spatial.

Fictional Space

The imaginary spaces discussed in the previous paragraph were those entertained in fantasy. It should now be clarified that, in this chapter, we identify a sharp distinction between the creative imaginings that happen when fantasizing and the imaginings that one engages in when appreciating a work of fiction.[19] Imagination is often thought of as "a free, unregulated activity, subject to no constraints save whim, happenstance, and the obscure demands of the unconscious."[20] Yet, such freedom only characterizes the whimsical imaginings of personal fantasies. As Walton clarifies, our imaginings can also be, and very often are, structured and constrained in ways that sets them apart from fantasy.[21] This is especially the case when appreciating works of fiction. For example, the book *Harry Potter and the Philosopher's Stone*[22] asks us to imagine that there is a castle named Hogwarts, which serves as a school for young wizards. In other

19. A more in-depth discussion of this distinction can be found in *Recreative Minds: Imagination in Philosophy and Psychology* (Oxford: Oxford University Press, 2002), in which Gregory Currie and Ian Ravenscroft mark both kinds of imagining as respectively creative and recreative imagination.
20. Kendall Walton, *Mimesis as Make-Believe: On the Foundations of the Representational Arts* (Cambridge, MA: Harvard University Press, 1990), 39.
21. Ibid. See also Roger Scruton, *Art and Imagination: A Study in the Philosophy of Mind* (Indiana: St. Augustine's Press, 1998), 99.
22. J. K. Rowling, *Harry Potter and the Philosopher's Stone* (London: Bloomsbury Publishing, 1997).

words, the Harry Potter book represents this castle. The imaginings we engage in when reading a Harry Potter book are structured by the text on the page we are reading. Actual features of the work—not our own whimsical fantasies—determine the content of our imaginings. This is why Walton calls works of fiction "props": they are artifacts that are designed to prompt and guide the imagining of a fictional world in a specific way.[23]

Having sketched the difference between fantasy and the imaginings that one engages in when appreciating representational works (such as a novel), we can now describe the difference between spaces that are entertained in fantasy and spaces that are represented within works of fiction. As mentioned before, a space someone conjures up in fantasy fully coincides with whatever this person imagines. It is never encountered, but merely created, and can thus never surprise the fantasizer. When imagining a space represented in a work of fiction, however, the fiction appreciator encounters this space and gets to know it in increasing detail through its various representations within the work in question. Even though, like fantasy spaces, fictional spaces can only be said to exist imaginatively, these imaginings are dictated by something outside of the imaginer's own consciousness: the objective prescriptions and limitations imposed by the work of fiction in which the space is represented. This work serves as a prop and mandates the spatial characteristics that need to be imagined. Any failure to comply with this mandate entails a failure to get to know the fictional space represented in the work. If a reader of the Harry Potter series, for example, imagines Hogwarts to be a spacecraft instead of a castle, their imagining is inappropriate, as it fails to correctly interpret the represented, fictional space.[24]

Contrary to how we freely imagine spaces in fantasy, the way in which we imagine fictional spaces entails a confrontation with a space in which the features are determined independently from our subjective, private imaginings. Fictional spaces can surprise us because we did not create them;

23. Walton, *Mimesis as Make-Believe*, 51.
24. It is, of course, possible for a reader of *Harry Potter* to imagine Hogwarts being a spacecraft. But in that case, the reader is no longer interacting with the story of Harry Potter, nor with what is fictional in the book. Rather, they are fantasizing—making up their own version of Hogwarts in their creative imagination, instead of letting their imagination be guided by the contents of the book.

Nele Van de Mosselaer and Stefano Gualeni

rather, we encounter them when engaging with a work of fiction. As a consequence, various appreciators engaging with the same work of fiction will be able to intersubjectively experience the spaces represented within this work.

The specific shape that such an encounter with fictional space takes is, however, dependent on the mode or medium through which this space is represented. To describe the experience of fictional space in more detail, we make a distinction between the non-interactive mode in which novels, paintings, plays, and movies typically represent fictional spaces[25] and the interactive ways in which those spaces are represented within interactive, digital media such as video games or training simulations.

Non-interactive Representations of Imaginary Spaces

Many works of fiction represent spaces through images, text, and/or sound in ways that are non-interactive. These works of fiction are props that have the function to mandate us to imagine certain fictional worlds, and these worlds—as we explained in the introduction section—only exist imaginarily. They are separated from the actual world, so that cross-world interaction is impossible.[26] We cannot interact with fictional spaces, but only with the medium through which they are represented: we can turn pages of a book and read them, get closer to the TV screen when a movie is playing, or point at objects depicted in a painting. And yet, none of these actions have any effect on the mediated contents or on the spaces represented within these books, movies, and paintings.

Moreover, although novels, movies, paintings, and plays all represent certain spaces, they do not usually invite their audiences to even imagine that they are present or involved in these spaces as active bodies. That is, these works of fiction do not typically invite so-called "de se" or self-

25. We acknowledge that there are books, such as the *Choose-Your-Own-Adventure* book series, and various forms of improvisational theater performances that represent their stories in interactive ways. Yet, the spaces represented in these books cannot be interactively experienced like the spaces represented in video games can (see the section on "Virtually Represented Space" in this chapter).
26. See Walton, "How Remote are Fictional Worlds"; and Peter Lamarque, "How Can We Fear and Pity Fictions?," *The British Journal of Aesthetics* 21, no. 4 (1981): 292.

involving imaginative engagement.[27] The Lovecraft quote at the beginning of this chapter, for example, does not ask us, the readers, to imagine that we are physically present in the described space. When imagining that unfamiliar, mind-boggling space, it would be inappropriate for a reader of Lovecraft's work to imagine that this space does not only contain an incomprehensible door that defies our understanding of space but also contains the reader, as it simply does not. Instead, this text invites the reader to engage in an "impersonal imagining" of the described space without necessarily imagining any (perceptual or physical) relations between them and the space.[28]

Indeed, even though appreciators of non-interactive works of fiction can encounter fictional spaces in their engagements with these works, those fictional spaces are not experienced from within, nor through a spatial practice these appreciators undertake. Rather, these spaces are always encountered through "second-hand" spatial experiences, described in the voice of a character or narrator, or rendered through the eye of the visual artist. There is no way for the reader or viewer of the Harry Potter series to peek behind a corner in one of Hogwarts' hallways, just like there is no way to walk around the buildings in Escher's surrealistic works to find out how these impossible structures are held up. Fiction appreciators can in no way interact or explore these spaces but are rather dependent on descriptions or depictions of Harry Potter walking through the hallways or the specific perspective from which Escher chose to represent his buildings.

27. See Peter Alward, "Leave Me Out of It: De Re, But Not De Se, Imaginative Engagement with Fiction." *Journal of Aesthetics and Art Criticism* 64, no. 4 (2006): 451; and Jon Robson and Aaron Meskin, "Video Games as Self-Involving Interactive Fictions," *Journal of Aesthetics and Art Criticism* 74, no. 2 (2016): 165.

28. See Gregory Currie, *Image and Mind: Film, Philosophy, and Cognitive Science* (Cambridge: Cambridge University Press, 1995), 179. Of course, the imagining of such fictional spaces might involve visualizing these spaces from a perspective that is internal to it. We are merely arguing that non-interactive works in no way offer their audience props to imagine inhabiting these spaces, unlike video games (see Calleja, "In-Game," 167). Only exceptionally, when they break the fourth wall, do non-interactive fictional works invite their audiences to imagine existing in the same space as the fictional characters. See Derek Matravers, *Fiction and Narrative* (Oxford: Oxford University Press, 2014), 116.

This also means that there are many aspects and parts of fictional spaces that appreciators simply have no access to. Incompleteness is a foundational and defining aspect of our relationship with fiction, and it is inevitable that many spatial elements and details are left unresolved or open in a work of fiction, raising questions to which the work does not offer any definite answers.[29] Such incompleteness is inevitable when representing spaces, regardless of whether the representation is a fictional or a non-fictional one. Actual spatial experiences are, after all, infinitely rich: "there is, at every moment, always infinitely more than we can see; to exhaust the richness of my current perception would take an infinite time."[30] Novelist George Perec illustrated this boundlessness of actual spatial experiences in his *Attempt at Exhausting a Place in Paris*,[31] in which he tried to give a complete description of everything that he perceived to happen on Saint-Sulpice Square in Paris. Bertrand Westphal writes that, although Perec was "confined to one location at a specific time, the project was actually boundless" and would have remained incomplete even if Perec had "camped out in the heart of the Sahara."[32] Indeed, an experience of represented space, be it fictional or non-fictional, can never approach the perceptual richness of an actual spatial experience, even if it is described or depicted in the most meticulously detailed manner.

The inability to completely determine the characteristics of represented spaces and to exhaust the spatial experience also has evident benefits. Visual artist and architect Philipp Schaerrer stresses how the pictorial representation of spaces, although less perceptually rich, "creates many more possibilities than actually being present in space, because you can project more into an image."[33] The obvious limits and ellipses of represented spaces leave much more freedom to the imagination of its

29. See Nathan Wildman and Richard Woodward, "Interactivity, Fictionality, and Incompleteness," in *The Aesthetics of video games*, ed. Grant Tavinor and Jon Robson (New York: Routledge, 2018).
30. Sartre, *The Imaginary*, 9.
31. Georges Perec, *An Attempt at Exhausting a Place in Paris*, trans. Marc Lowenthal (Cambridge, MA: Wakefield Press, 2010).
32. Bertrand Westphal, *Geocriticism: Real and Fictional Spaces*, trans. Robert Tally (New York: Palgrave Macmillan, 2011), 250.
33. Philipp Schaerer, "Free your Imagination!," in *Architectonics of Game Spaces*, ed. Andri Gerber and Ulrich Götz (Bielefeld: Transcript-Verlag, 2019), 102.

observer. The inexhaustibility of actual space thus finds its counterpart in the incompleteness of represented space: whereas the former can never be fully known or described due to its infinite richness, the latter creates innumerable possibilities for curiosity and imagination due to the inevitable and deliberate poverty of its representation.

This incompleteness is hence not a shortcoming of spatial representations, but rather affords the creators of these spaces a degree of freedom and flexibility when designing them. An example of an architecture that creatively leverages the inherent incompleteness and the instability of fictional spaces can be recognized in the house of the protagonist of the Italian comic series *Dylan Dog: L'Indagatore dell'Incubo* ("Dylan Dog: Nightmare Detective"). Dylan Dog's house on Craven Road 7 of a fictional London is an unstable fictional space: Tiziano Sclavi, the author of the comic series, never conclusively defined an internal plan for the house, which shifted and got reimagined in its internal arrangement from one episode to the next. In an interview with Caterina Grimaldi, the author explicitly stated that by allowing his collaborators that creative freedom, the house became a flexible space that "can dilate and always accommodate new situations."[34] Scrooge McDuck's money bin and Dr. Who's TARDIS could also be mentioned as famous examples of flexible and unstable fictional architectures.

Designers of fictional spaces can "disregard gravity and objects can be morphed, blended, or scaled without any problem."[35] This creates the possibility of representing spaces that can only exist in imagination, as is famously illustrated by the above-mentioned pictures of impossible buildings by Escher and Dylan Dog's house. Any incoherence or contradiction that exists within such spaces need not be addressed or solved: it is not the purpose of the representation to justify the existence of the space that is represented, but merely to mandate the imagining of it.

34. Caterina Grimaldi, "La casa che non c'e' - Intervista a Tiziano Sclavi," *Abitare*, no. 501 (2010): 65.
35. Ibid., 99.

Lastly, the incompleteness of the spatial information described or depicted in works of fiction can even be said to be crucial for the represented fictional space to become meaningful. The goal of the fiction creator should not be to present the most accurate picture of a space, but rather to make sure the fiction appreciator is not rendered "lost in the space" due to an overabundance of indiscriminate details.[36]

Just like actual spaces, fictional spaces become meaningful, so-called "lived spaces" only when they are specific locations that are experienced through a guided, spatial practice. Such lived spaces are conceived as including "a subject who is affected by (and in turn affects) space, a subject who experiences and reacts to space in a bodily way, a subject who 'feels' space through existential living conditions, mood, and atmosphere."[37] In the case of non-interactive fictional spaces, it is not the reader or viewer who can take on this subject-role. The meaningfulness of the represented space is rather accomplished through engagements with this space that are themselves represented in the work: the predetermined spatial explorations of fictional characters, the incomplete descriptions by narrators, and the specific perspectives chosen by visual artists.

Virtually Represented Space

When imaginary or fictional spaces are represented through interactive, digital media, they afford very different kinds of experiences. Virtual spaces—defined here as spaces that are represented by computers and can be explored interactively—share characteristics with all of the above-mentioned kinds of spaces. They share with actual spaces the fact that they afford action possibilities: their users can take an internal perspective in these spaces and explore them from within. Virtual spaces are also

36. Robert Tally Jr., *Spatiality* (New York: Routledge, 2012), 54.
37. Sabine Buchholz and Jahn Manfred, "Space in Narrative," in *Routledge Encyclopedia of Narrative Theory*, ed. David Herman, Manfred Jahn, and Marie- Laure Ryan (London: Routledge, 2005), 553.

similar to fantasy spaces as they are the expression of the free, "externalized" fantasy of whomever designed them. Lastly, virtual spaces are a kind of fictional space as users are mandated to imagine these spaces to exist based on certain representations generated by computers.

Within academic research, various scholars have commented on virtual spaces as involving a combination of actual and imaginary elements. Daniel O'Shiel mentions how spaces represented in video games are "superreal" as they combine characteristics of imaginary and actual experiences, thereby being "neither just real nor just imaginary, but a forceful combination of the two."[38] Lambert Wiesing writes that, in virtual reality, the images on the screen no longer merely serve as representations of absent space, but become "a medium by means of which a particular kind of object is produced and presented—an object, that is, that is exclusively visible and yet, like a ghost, acts as if it had a substance and the properties of a substance."[39] Wiesing seems to hint that imaginary spaces are not represented by interactive, digital media but rather presented: they are given to the user to be interacted with and explored in ways that are very similar to how we experience actual spaces. Indeed, the very possibility of interacting with and exploring virtual spaces seems to give them a semblance of reality that contradicts their fictional or representational nature. This raises a paradox: If virtual spaces are merely represented, which means they do not really exist but are merely prescribed to be imagined to exist, then how can users interact with these spaces?[40]

38. Daniel O'Shiel, "Computer Games, Image-Consciousness and Magic," *Proceedings of the 13th International Philosophy of Computer Games Conference,* 2019, 13.
39. Lambert Wiesing, *Artificial Presence: Philosophical Studies in Image Theory*, trans. Nils F. Schott (Stanford: Stanford University Press, 2010), 100.
40. This problem is related to a broader paradox of interactive fiction that does not only concern our interactions with virtual space. Rather, any player interaction with a fictional object or character raises this problem, as none of these fictional entities can be said to actually exist. See Nele Van de Mosselaer, "How Can We be Moved to Shoot Zombies? A Paradox of Fictional Emotions and Actions in Interactive Fiction," *Journal of Literary Theory* 12, no. 2 (2018): 279–299.

David Chalmers seems to think that the solution to this paradox lies in the fact that virtual spaces are not represented spaces at all, but spaces that are "part of the real world, in virtue of existing on real computers."[41] Interacting with them is unproblematic, because "virtual reality is a sort of genuine reality, virtual objects are real objects, and what goes on in virtual reality is truly real."[42] Chalmers' argument, however, seems to ignore the inevitable fictionality of virtual spaces: what we see on our computer screen is never an actually inhabitable space. In essence, the only thing we have in front of us when navigating virtual spaces are pixels and polygons that are flatly rendered on a screen (be it the screen of a TV connected to a console, a computer monitor, or a VR-headset). These pixels and polygons serve as props: they mandate us to imagine a space. As Aarseth writes, digital games offer us "a representation of space that is not in itself spatial, but symbolic and rule-based."[43] Thus, instead of treating virtual spaces as actual digital spaces that exist on computers, we believe it is crucial to acknowledge their representational character, consider the specific digital constitution of the props that represent these spaces, and investigate the rules by which users are invited to interact with these props.

The most salient difference between the representations of fictional spaces discussed in the previous section and virtual representations of space is that the latter make use of props that involve the user in the way the space is imagined. Whereas it is inappropriate—or at least unwarranted—for appreciators to imagine themselves inhabiting the space described by Lovecraft in this chapter's introductory paragraph, such self-involvement is clearly mandated to be imagined by virtual representations of space. Such imaginings are supported by the fact that even users themselves become part of the representation when engaging with virtual spaces: their actual actions of manipulating input devices (such as "pressing X"), become props that mandate them to imagine they are interact-

41. David Chalmers, "The Virtual and the Real," *Disputatio* 9, no. 46 (2017): 320.
42. Ibid., 309.
43. Espen Aarseth, "Allegories of Space: The Question of Spatiality in Computer Games," in *Cybertext Yearbook 2000*, ed. Markku Eskelinen and Raine Koskimaa (Jyväskylä: Research Centre for Contemporary Culture, 2001), 163.

ing with the represented space (and are, for example, "opening a door").[44] This is possible because there is an actual causal link between users' motor input and the sensory output or visual information on the screen.[45] The props involved in virtual space representations thus introduce experiences of fictional spaces that are characterized once again by a spatial practice, even though this practice is largely imaginary itself. Actual people cannot interact with merely represented spaces; the ontological gap between the two cannot be crossed.[46] But they can interact with real props—such as images on a screen which they can control through input devices—and use these interactions as a basis to imagine interacting with the space represented by those images.

As spaces that are to be imagined, virtual spaces are interior to the mind of their users: they only exist as spaces within imaginative consciousness. Yet, due to their interactivity, virtual space representations also mandate their users to imagine being interior to these spaces. Users are to imagine their own existence within these spaces based on the props they are presented with. Calleja describes this twofold process of interiorization as "incorporation": "the player incorporates (in the sense of internalizing or assimilating) the game environment into consciousness while *simultaneously* being incorporated through the avatar into that environment."[47] He adds that this description of incorporation "precludes its application to any non-ergodic media, such as movies or books."[48] The latter are not props that mandate their appreciators to imagine being involved within spaces they represent, as they do not acknowledge their appreciators' presence and agency within these spaces.

44. Nele Van de Mosselaer, "Fictionally Flipping Tetrominoes? Defining the Fictionality of a Videogame Player's Actions." *Journal of the Philosophy of Games* 1, no. 1 (2018). See also Stefano Gualeni and Nele Van de Mosselaer, *Doors (the game)*, digital game developed with Diego Zamprogno, Rebecca Portelli, Costantino Oliva, et al., available to play online at https://doors.gua-le-ni.com.
45. Geert Gooskens, "Varieties of Pictorial Experience," (PhD diss., University of Antwerp, 2012), 87.
46. Walton, *Mimesis as Make-Believe*, 195.
47. Calleja, *In-Game: From Immersion to Incorporation*, 169.
48. Ibid., 173.

Unlike non-interactive works of fiction, video games thus allow players to fictionally interact with the spaces they represent. These virtual spaces emerge and gain meaning throughout the player's exploration of the action possibilities these places afford by means of the body of the avatar or the perspective of an in-game proxy. Contrary to how we experience non-interactive fictional spaces, our imagining of virtual spaces is not limited nor determined by the represented explorations and perspectives of characters or creators, but rather, much like our experience of actual space, shaped by our own (albeit fictional) spatial practices. This makes for an experientially richer and more fictionally complete experience of fictional spaces. Take, for example, the post-apocalyptic environments represented in *The Last of Us Part II* (2020), a third-person survival-horror game in which the player traverses a fictional version of the United States where a fungus has turned most of humanity into cannibalistic zombies.[49] Although players are still limited by the boundaries of the designed game space and of the character they control, they have the freedom to explore these spaces within those limits. They are not bound to a predetermined fictional perspective on these environments. Rather, they can choose to look at the ruins of skyscrapers at their own pace, from a variety of angles, as well as visit the outer, hidden corners of the map just to see what is there, how it can be valuable to them, and how they can proceed. As players are situated within the game's environments as subjects, these environments can be experienced as an existential, meaningful situation: "as a world in which one can plan, act, and pursue a project."[50]

The spatial practice we can engage in when playing *The Last of Us Part II* is relatively realistic, as it adheres to very similar physical laws just as real-life spaces do. Digital media can, however, also present us with spaces that would be impossible to encounter in real life. While the non-interactive works of fiction described in the previous part could invite us to imagine the existence of such spaces, interactive, digital media such as video games can also invite us to imagine these spaces to be existentially meaningful to us. Recall Escher's prints, which depict paradox-

49. Naughty Dog, *The Last of Us Part II*, Sony Interactive Entertainment, PlayStation 4, 2020.
50. Gualeni and Vella, *Virtual Existentialism*, 4.

ical buildings to be imagined from the specific perspective that Escher chose. It is hard, if not impossible, to imagine how these buildings can actually stand or what they would look like from the back based on the representations offered to us by Escher. Yet, virtual representations of similar perspective-defying buildings have succeeded in making players imagine what it could be like to move through and interact with such impossible spaces. *Monument Valley* (2014)[51] not only allows players to explore Escher-like landscapes but also quickly gets them to accept these paradoxical landscapes as spaces they can easily manipulate and explore. *Echochrome* (2008)[52] lets players navigate spaces based on five alternative laws of perspective that are directly inspired by Escher's works. *Manifold Garden* (2019)[53] equally allows players to traverse spaces that subvert known physical laws. Similarly, *Fez* (2012)[54] lets players experience what it is like to move through spaces that dynamically shift between being two and three-dimensional. Rather than just representing impossible, fictional spaces, as was already possible before, the virtual medium also allows its users to imaginatively experience these spaces as spatial by mandating them to imagine engaging in impossible spatial practices. If anything, these virtual spaces can introduce a new kind of spatiality to players by making them imagine interacting with space in a way that might have been unthinkable before.

With this interactivity, however, also comes a new kind of incompleteness.[55] Whereas actual spaces are, as mentioned before, inexhaustible, virtual spaces are limited by computational constraints of the media they are represented on.[56] They do not afford an infinity of actions to be performed, but our explorations of them are constricted by the specific affordances designed into the game. We cannot leave the predetermined paths in *Monument Valley,* and we are not able to swim to the locations that are

51. Ustwo Games, *Monument Valley*, Ustwo Games, Android, 2014.
52. SCE Studios Japan, *Echochrome*, Sony Interactive Entertainment, PlayStation 3, 2008.
53. William Chyr, *Manifold Garden,* William Chyr Studio, PC, 2019.
54. Polytron, *Fez*, Trapdoor, PlayStation 4, 2012.
55. For a more detailed explanation of digital game incompleteness, see Nele Van de Mosselaer and Stefano Gualeni, "The Fictional Incompleteness of Digital Gameworlds," *Transactions of the Digital Games Research Association*, forthcoming.
56. See also O'Shiel, "Computer Games," 13.

off-screen in *Fez*. In fact, players of any game will very likely encounter the finitude of the virtual spaces that they are fictionally exploring, as well as their limited freedom in this act of exploration. Due to their being interactive but also having clear spatial and operational boundaries, virtual environments are more likely to elicit dissatisfaction and boredom in users than both non-interactive fictional spaces and actual spaces. Virtual spaces thus evoke what could be understood as a kind of "virtual world weariness."[57]

This inherently finite and exhaustible experience of virtual spaces is, for now at least, still far removed from the infinitely rich experience offered by actual spaces. In this regard, Aarseth argues that even the most "open"—in the sense of the most explorable and rich—computer-generated landscapes are characterized by a strict and limited topology that ultimately makes them quite different from real space.[58] With the concept of "virtual space representations," Aarseth refers to incomplete copies or mere images of the real world: "games can never depict space as it is perceived, completely, as it exists 'in real life.'"[59] Aarseth concludes his paper by calling the computer-generated spaces we encounter in games mere "allegories" of space as they afford imperfect approximations of actual space experiences, ultimately showing that it is impossible to represent real space.[60]

Two remarks require mention here. First of all, as said before, the value of virtual space representations should not necessarily be sought in the way they succeed in simulating actual space. It is true that within game development there is a growing tendency towards complete and realistic

57. Stefano Gualeni, "Virtual World-Weariness: On Delaying the Experiential Erosion of Digital Environments," in *Architectonics of Game Spaces*, ed. Andri Gerber and Ulrich Götz (Bielefeld: Transcript-Verlag, 2019), 157. In analogy with actual-world weariness, the dissatisfaction and the boredom with digital game environments emerges, according to Gualeni, from aspects of their finitude and banality. The most common among these "world-pains" are the players' direct encounters with the spatial boundaries of a virtual world (tall walls, invisible barriers, puffy clouds, cliffs, fences, etc.). Other frequent triggers of virtual Weltschmerz consist in the recognition of aesthetic repetitions of textures and assets (such as buildings, trees, statues, textures, characters).
58. Aarseth, "Allegories of Space," 169.
59. Stephan Günzel, "The Lived Space of Computer Games," in *Architectonics of Game Spaces*, ed. Andri Gerber and Ulrich Götz (Bielefeld: Transcript-Verlag, 2019), 170.
60. Aarseth, "Allegories of Space," 169.

representations of spaces.⁶¹ Digital games, especially virtual reality ones, excel evermore in mimicking real-life spatial experiences to the point that users sometimes mistake their explorations of virtual space for experiences of actual space. Think, for example, of VR players who fall to the ground because they are trying to lean against virtual walls. Yet, as props that mandate spatial imaginings, the value of virtual representations might lie in how they deviate from actual spaces. As virtual space representations are not bound to being realistic depictions of space, they can be used for disclosing unfamiliar and extraordinary ways of experiencing space,⁶² as was illustrated by the earlier discussed examples of *Echochrome, Fez, Manifold Garden,* and *Monument Valley*. As O'Shiel writes, most digital games are not ultimately interested in replacing reality, but rather are engaged in developing super realities that infuse the familiar spatial experience with fantastical and imaginary elements and capacities.⁶³ When judging the value of virtual space representations, one should not only ask to what degree they approximate actual space, but also focus on how they succeed in externalizing the imaginary space that originated in the fantasy of their creator and the kinds of imaginings they aspire and manage to inspire in their users.

Secondly, although the apparent artificiality and limits of virtual spaces can invoke boredom, they also give these spaces an appeal that real spaces do not have. Virtual spaces, by grace of being artificial spaces that afford predesigned action possibilities, possess not only simplicity, but also inherent meaningfulness. With regard to their simplicity, Aarseth himself remarks that computer game spaces "rely on their deviation from reality in order to make the illusion playable."⁶⁴ He posits that the fact that videogame spaces are always a reduction of whatever would be pos-

61. See Van de Mosselaer and Gualeni, "The Fictional Incompleteness."
62. Gualeni, "Virtual World-Weariness," 154.
63. O'Shiel, "Computer Games," 13–14.
64. Aarseth, "Allegories of Space," 169. In another paper, Aarseth mentions the process of "ludoforming" in this regard, which denotes the action of turning a contemporary, historical, or fictional landscape into a game world. This often involves "a restriction, reduction or distillation of the source landscape, or simply a reshaping that meets the ludic demands." Espen Aarseth, "Ludoforming: Changing Actual, Historical or Fictional Topographies into Ludic Topologies," in *Ludotopia*, ed. Espen Aarseth and Stephan Günzel (Bielefeld: Transcript-Verlag, 2019), 139.

sible in real space is precisely what makes gameplay possible.[65] Nguyen argues that this simplicity of game environments is also what makes them so appealing: they are "realms of agency in which the functions of objects and the meaning of actions are entirely obvious" as they are "cleared of various ambiguities and complexities" that characterize real-life spaces.[66] This clarity or "crispness," as Nguyen calls it, of virtual spaces allows us to experience a spatial practice that is elegant in its simplicity, easily graspable, and often specifically designed to foster the feelings of meaningful interaction and progress.[67]

Regarding their inherent meaningfulness, we have suggested elsewhere that the overt artificiality of virtual game environments, and the player's accompanying realization that these environments have been designed with certain intentions, are crucial in the player's exploration of these spaces.[68] On the basis of their knowledge that even the most insignificant visual detail within these spaces, as well as every affordance they offer, was created deliberately by their designers, players can assume that these are spaces are interesting and valuable to explore. Just like real space, the meaning of virtual space emerges in the spatial practices their inhabitants engage in. Contrary to real space, however, the fact that virtual spaces have embedded functions and meanings is already guaranteed before any interaction even takes place. This is because the potential interactions users can have with a virtual space are already programmed into the representation of this space itself. Thus, although the artificiality, incompleteness, and limited possibilities offered by virtual spaces might make them easily exhaustible, they also tend to guarantee that there is meaning and purpose to them.

Bibliography

Aarseth, Espen. "Allegories of Space: The Question of Spatiality in Computer Games." In

65. Ibid., 163.
66. C. Thi Nguyen, *Games: Agency as Art* (New York: Oxford University Press, 2020), 68.
67. Stefano Gualeni, *Virtual Worlds as Philosophical Tools: How to Philosophize with a Digital Hammer* (Basingstoke, UK: Palgrave Macmillan, 2015), 128.
68. Nele Van de Mosselaer and Stefano Gualeni, "The Implied Designer and the Experience of Gameworlds," *Proceedings of the 2020 DiGRA international Conference.*

Cybertext Yearbook 2000, edited by Markku Eskelinen and Raine Koskimaa, 152–171. Jyväskylä: Research Centre for Contemporary Culture, 2001.

———. "Ludoforming: Changing Actual, Historical or Fictional Topographies into Ludic Topologies." In *Ludotopia: Spaces, Places and Territories in Computer Games,* edited by Espen Aarseth and Stephan Günzel, 127–140. Bielefeld: Transcript-Verlag, 2019.

Alward, Peter. "Leave Me Out of It: De Re, But Not De Se, Imaginative Engagement with Fiction." *Journal of Aesthetics and Art Criticism* 64, no. 4 (2006): 451–459.

Buchholz, Sabine, and Manfred Jahn. "Space in Narrative." In *Routledge Encyclopedia of Narrative Theory*, edited by David Herman, Manfred Jahn, and Marie- Laure Ryan, 551–55. London: Routledge, 2005.

Calleja, Gordon. *In-Game: From Immersion to Incorporation*. Cambridge, MA: The MIT Press, 2011.

Casey, Edward. *The Fate of Place*. Berkeley: University of California Press, 2013.

Chalmers, David J. "The Virtual and the Real." *Disputatio* 9, no. 46 (2017): 309–352.

Chyr, William. *Manifold Garden*. William Chyr Studio. PC. 2019.

Currie, Gregory, and Ian Ravenscroft. *Recreative Minds: Imagination in Philosophy and Psychology*. Oxford: Oxford University Press, 2002.

Currie, Gregory. *Image and Mind: Film, Philosophy, and Cognitive Science*. Cambridge: Cambridge University Press, 1995.

De Certeau, Michel. *The Practice of Everyday Life*. Berkeley: University of California Press, 1984.

Gallagher, Shaun, and Dan Zahavi. *The Phenomenological Mind*. New York: Routledge, 2020.

Gooskens, Geert. "Varieties of Pictorial Experience." PhD diss., University of Antwerp, 2012.

Grimaldi, Caterina. "La casa che non c'e' – Intervista a Tiziano Sclavi." *Abitare*, no. 501 (2010): 62–67.

Gualeni, Stefano, and Nele Van de Mosselaer. *Doors (the game)*, digital game developed with Diego Zamprogno, Rebecca Portelli, Costantino Oliva, et al. 2021. https://doors.gua-le-ni.com.

Gualeni, Stefano, and Daniel Vella. *Virtual Existentialism: Meaning and Subjectivity in Virtual Worlds*. Cham: Springer, 2020.

Gualeni, Stefano. "Virtual World-Weariness: On Delaying the Experiential Erosion of Digital Environments." In *Architectonics of Game Spaces*, edited by Andri Gerber and Ulrich Götz, 153–165. Bielefeld: Transcript-Verlag, 2019.

———. *Virtual Worlds as Philosophical Tools: How to Philosophize with a Digital Hammer.* Basingstoke, UK: Palgrave Macmillan, 2015.

Günzel, Stephan. "The Lived Space of Computer Games." In *Architectonics of Game Spaces*, edited by Andri Gerber and Ulrich Götz, 167–181. Bielefeld: Transcript-Verlag, 2019.

Lamarque, Peter. "How Can We Fear and Pity Fictions?" *The British Journal of Aesthetics* 21, no. 4 (1981): 291–304.

Lefebvre, Henri. *The Production of Space*. Hoboken, NY: Wiley-Blackwell, 1991 (1974).

Lovecraft, H.P. *Cthulhu Tome Revised*. Ingersoll: Devoted Publishing, 2019.

Matravers, Derek. *Fiction and Narrative*. Oxford: Oxford University Press, 2014.

Naughty Dog. *The Last of Us Part II*. Sony Interactive Entertainment. PlayStation 4. 2020.

Nguyen, C. Thi. *Games: Agency as Art*. New York: Oxford University Press, 2020.

Norberg-Schulz, Christian. *Genius Loci: Towards a Phenomenology of Architecture*. New York: Rizzoli, 1980.

O'Shiel, Daniel. "Computer Games, Image-Consciousness and Magic." *Proceedings of the 13th International Philosophy of Computer Games Conference,* 2019.

Perec, Georges. *An Attempt at Exhausting a Place in Paris*. Translated by Marc Lowenthal. Cambridge, MA: Wakefield Press, 2010.

Picciuto, Elizabeth, and Peter Carruthers. "Imagination and Pretense." In *The Routledge Handbook of Philosophy of Imagination*, edited by Amy Kind, 314–325. London: Routledge, 2016.

Polytron. *Fez*. Trapdoor. PlayStation 4. 2012.

Robson, Jon, and Aaron Meskin. "Video Games as Self-Involving Interactive Fictions." *Journal of Aesthetics and Art Criticism* 74, no. 2 (2016): 165–177.

Rowling, J.K. *Harry Potter and the Philosopher's Stone*. London: Bloomsbury Publishing, 1997.

Sartre, Jean-Paul. *Being and Nothingness*. Translated by Hazel E. Barnes. New York: Washington Square Press, 1966 (1943).

———. *The Imaginary: A Phenomenological Psychology of the Imagination*. Translated by Jonathan Webber. London and New York: Routledge, 2004 (1940).

SCE Studios Japan. *Echochrome*. Sony Interactive Entertainment. PlayStation 3. 2008.

Schaerer, Philipp. "Free your Imagination!" In *Architectonics of Game Spaces*, edited by Andri Gerber and Ulrich Götz, 95–110. Bielefeld: Transcript-Verlag, 2019.

Scruton, Roger. *Art and Imagination: A Study in the Philosophy of Mind*. Indiana: St. Augustine's Press, 1998 (1974).

Tally Jr, Robert. *Spatiality*. New York: Routledge, 2012.

Ustwo Games. *Monument Valley*. Ustwo Games. Android. 2014.

Van de Mosselaer, Nele, and Stefano Gualeni. "The Fictional Incompleteness of Digital Gameworlds." *Transactions of the Digital Games Research Association*. Forthcoming.

———. "The Implied Designer and the Experience of Gameworlds." *Proceedings of the 2020 DiGRA international Conference*.

Van de Mosselaer, Nele. "Fictionally Flipping Tetrominoes? Defining the Fictionality of a Videogame Player's Actions." *Journal of the Philosophy of Games* 1, no. 1 (2018). https://doi.org/10.5617/jpg.6035.

———. "How Can We be Moved to Shoot Zombies? A Paradox of Fictional Emotions and Actions in Interactive Fiction." *Journal of Literary Theory* 12, no. 2 (2018): 279–299.

———. "The Paradox of Interactive Fiction." PhD diss., University of Antwerp, 2020.

Vella, Daniel. "There's No Place Like Home: Dwelling and Being at Home in Digital Games." In *Ludotopia: Spaces, Places and Territories in Computer Games*, edited by Espen Aarseth and Stephan Günzel, 141–166. Bielefeld: Transcript-Verlag, 2019.

Walton, Kendall L. "How Remote are Fictional Worlds from the Real World?" *The Journal of Aesthetics and Art Criticism* 37, no. 1 (1978): 11–23.

———. *Mimesis as Make-Believe. On the Foundations of the Representational Arts*. Cambridge, MA: Harvard University Press, 1990.

Westphal, Bertrand. *Geocriticism: Real and Fictional Spaces*. Translated by Robert Tally. New York: Palgrave Macmillan, 2011.

Wiesing, Lambert. *Artificial Presence: Philosophical Studies in Image Theory*. Translated by Nils F. Schott. Stanford: Stanford University Press, 2010.

Wildman, Nathan, and Richard Woodward. "Interactivity, Fictionality, and Incompleteness." In *The Aesthetics of Video Games*, edited by Grant Tavinor and Jon Robson, 112–127. New York: Routledge, 2018

A Journey from Total Cinema to Total World

Realizing the Film Set as Virtual Performer

Dave Gottwald

"Realism in art can only be achieved in one way—through artifice."

—André Bazin[1]

Introduction

Whatever else fascinated French film theorist and critic André Bazin about motion pictures, he did not mention their sets often. In his discussion of *Une fée pas comme les autres* (*The Secret of Magic Island*) (1956), Bazin does not mention its production design at all.[2] This is puzzling because the miniature sets of the film not only complete the unreality of the story but are in fact its central conceit. Without presenting the small animals at human scale, all the tricks and sleight of hand Bazin considers—pouring cocktails, playing billiards—are for naught. Absolutely

1. André Bazin, *What is Cinema? Volume II*, trans. Hugh Gray, reprint edition (Berkeley: University of California Press: 2005 [1971]), 26.
2. This film by French director Jean Tourane, whose "naive ambition . . . [was] to make Disney pictures with live animals," consists of the creatures appearing to behave like people using tricks "either with a hand offscreen guiding them, or an artificial paw like a marionette on a string." André Bazin, *What is Cinema? Volume I*, trans. Hugh Gray, reprint edition (Berkeley: University of California Press: 2005 [1967]), 43; 44.

nothing in the film works. To show the animals in the actual built environment would shatter the entire exercise in anthropomorphism. Rather than a rabbit driving a car, the rabbit is now in danger of being run over by one.

This chapter charts a novel history of the spatial philosophy of film sets—one in which the experiential modes of themed spaces, video games, and virtuality each become a different synthesis of the rigid theater/cinema dichotomy formulated by André Bazin.[3] Here, I apply Bazin's writings[4] to a spatial regime model as published by myself and Gregory Turner-Rahman in which we link "key historical moments when the cinematic imaginary and its entire contemporary offspring collide and collude"[5] across the twentieth century. In this model we have traced how film sets begat the contemporary theme park, then the interactive worlds of the video game, and finally, were reconstituted virtually within the holistic construct of game engine software. In this way, sets have spread well beyond the boundaries of cinema. Once you are familiar with their contours and contrivances, you will see sets everywhere; they are part of the virtuality of everyday life. Much like Bazin insisted that "cinema is also a language,"[6] sets have a visual grammar. The properties of set design were first dissected in the 1980s,[7] but our spatial regime model takes that grammar and forms a classification system beyond the soundstage—through the **filmic**, the **thematic**, the **electronic**, and the **holistic**.[8] Our concept is adapted from the work of Arsenault and Côté who use the term "graphical regime" to describe the relationship between play

3. This chapter is based on an earlier essay: Dave Gottwald, "Total Cinema, Total Theatre, Total World: From Set as Architecture to Set as Virtual Performer," *Disegno—Journal of Design Culture* 6, no. 1 (December 2022), 12–32. https://doi.org/10.21096/disegno_2022_1dg.
4. I have limited my discussion here to the essays which comprise the two volumes of *What is Cinema?* (Bazin 1967; 1971).
5. Dave Gottwald and Gregory Turner-Rahman, "Toward a Taxonomy of Contemporary Spatial Regimes: From the Architectonic to the Holistic," *The International Journal of Architectonic, Spatial, and Environmental Design* 15, no. 1 (May 2021), https://doi.org/10.18848/2325-1662/cgp/v15i01/109-127.
6. Bazin, *What is Cinema? Volume I*, 16.
7. Charles Affron and Mirella Jona Affron, *Sets in Motion: Art Direction and Film Narrative* (New Brunswick, NJ: Rutgers University Press, 1995); Juan Antonio Ramírez, *Architecture for the Screen: A Critical Study of Set Design in Hollywood's Golden Age*, trans. John F. Moffitt (Jefferson, NC: McFarland Press, 2004 [1986]), 81.
8. Gottwald and Turner-Rahman, "Toward a Taxonomy."

and imaging within a given gamespace.[9] After them, our "spatial regime" denotes the relationship between experience and spatialization. By reorienting Bazin's theater/cinema dichotomy, here I add roles as spectators, participants, and even designers within each experience. Through this lens, our spatial regimes can be seen as an evolving, reconfigurable model of theater and cinema as a single, coalesced experiential medium. Just as Vahid Vahdat evoked him in the introduction to Book Two of this collection, I ask us to reconsider Bazin in the context of virtual reality. With regards to his weighing the constructs of theater and cinema against one another, he can also be read as a kind of spatialist. Bazin might have found common ground with media theorist Marshall McLuhan, who once cautioned that "patterns of environments elude easy perception."[10]

Beginning in the 1990s, critics used computer generated imagery (CGI) to dismantle Bazin's notion of cinematic truth.[11] *The Matrix* series (1999–2003) and the *Star Wars* prequels (1999–2005) appeared to unravel Bazin's image object,[12] a critique which I feel misses his philosophical mainspring.[13] He was fine with illusion if it served the greater truth of the fiction. All his image plastics and even montage (editing and all assembly, including the soundtrack) "can work either to the advantage or to the

9. Dominic Arsenault and Pierre-Marc Côté. "Reverse-Engineering Graphical Innovation: An Introduction to Graphical Regimes." Game: The Italian Journal of Game Studies 2, no.1 (2013): 57–67. https://www.gamejournal.it/reverse-engineering-graphical-innovation-an-introductionto-graphical-regimes.
10. Marshall McLuhan and Quentin Fiore, *The Medium Is the Massage: An Inventory of Effects* (Berkeley, CA: Gingko Press, 2001 [1967]), 68.
11. Debray's *Life and Death of the Image* (1992) is a key text which gives birth to this polemic. For a more recent discussion of Bazin in the context of CGI, digital animation, and digital imaging, see J. Hoberman, *Film After Film: Or, What Became of 21st-Century Cinema?* (Brooklyn, NY: Verso, 2013). For a broader view of digital film provocations, see André Gaudreault and Philippe Marion, *The End of Cinema? A Medium in Crisis in the Digital Age*, trans. Timothy Barnard (New York: Columbia University Press, 2015).
12. "Now the digitization of the image threatens to cut the umbilical cord between photograph and referent on which Bazin founded his entire theory." Peter Matthews, "The Innovators 1950–1960: Divining the Real," *Sight & Sound* 9, no. 8 (August 1999), https://www2.bfi.org.uk/news-opinion/sight-sound-magazine/features/andre-bazin-divining-real-film-criticism-overview.
13. "Because Bazin thought of the cinema camera as an unmediated instrument for capturing a 'pro-filmic reality,' and because he did not have a critique of its mediated illusionism, Bazinian 'realism' has been a debate in film studies for more than two decades" Anne Friedberg, *Window Shopping: Cinema and the Postmodern* (Berkeley, CA: University of California Press, 1994), 130.

detriment of realism"[14] as long as the illusions are immersive and the lie is credible. "We would define as 'realist' then, all narrative means tending *to bring an added measure of reality* to the screen."[15] Accepting this, I apply Bazin's parsing of stage and soundstage to the experiential journey below which suggests that cinema, combined with performative theatricality, has come to subsume our spaces, and thus, our very lives.[16]

Stage Becomes Set, Set Becomes Architecture

Cinema began wedded to still photography.[17] Similarly, early film sets were bound up with the art of scenic design, a tradition as old as antiquity.[18] Technology moved both away from their antecedents. Early films resembled theater, so that "if the scene were played on a stage and seen from a seat in the orchestra, it would have the same meaning."[19] Painted backdrops and simple flats sufficed for this.[20] The first to employ more sophisticated sets was Frenchman Georges Méliès.[21] Méliès enjoyed creating illusion through editing and employed special effects, as in *Le voyage dans la lune* (*A Trip to the Moon*) (1902). So, it seems natural that he would realize the power of sets.[22] Soon, appetite for spectacle led to larger productions. Italian director Enrico Guazzoni was the first to

14. Bazin, *What is Cinema? Volume II*, 27.
15. Ibid., emphasis added.
16. Neal Gabler, *Life—The Movie: How Entertainment Conquered Reality* (New York: Vintage Books, 2000); Norman Klein, *The Vatican to Vegas: A History of Special Effects* (New York: New Press, 2004); Dave Gottwald and Gregory Turner-Rahman, "The End of Architecture: Theme Parks, Video Games, and the Built Environment in Cinematic Mode," *The International Journal of the Constructed Environment* 10, no. 2 (2019), https://doi.org/10.18848/2154-8587/CGP/v10i02/41-60.
17. Bazin, *What is Cinema? Volume I*.
18. Leon Barsacq, *Caligari's Cabinet and Other Grand Illusions: A History of Film Design*, ed. Elliott Stein, trans. Michael Bullock (Boston: New York Graphic Society, 1976).
19. Ibid., 32.
20. Ramírez, *Architecture for the Screen*.
21. Barsacq, *Caligari's Cabinet*; Ramírez, *Architecture for the Screen*; Cathy Whitlock and The Art Directors Guild, *Designs on Film: A Century of Hollywood Art Direction* (New York: It Books, 2010).
22. Barsacq, *Caligari's Cabinet*.

film using large-scale, three-dimensional sets.[23] American director D. W. Griffith followed with massive Babylonian sets for *Intolerance* (1916).[24] Then beginning in Hollywood in the early 1920s, designers began working architecturally.[25]

Three factors explain how more elaborate sets developed. The first was panchromatic film stock, which allowed for greater clarity.[26] Costumes and props now required more detail; painted backgrounds would only fool the eye at a great distance.[27] Another was better lensing: capturing with "equal sharpness the whole field of vision contained simultaneously within the dramatic field."[28] Deep focus meant structures would read dimensionally. Most revolutionary was camera motion. During the silent era, the camera was fixed, so the audience experience was static.[29] With rigs which allowed for movement towards and around actors, the audience's connection to the camera's point of view (POV) became dynamic.[30] Cranes now also took cameras and audiences into sets. By the late 1920s, what were once crude flats became environments which could be inhabited by actors.[31] This was the shift from stage to set; from staging a drama to acting in a setting. It was a dynamic camera which cleaved sets away from the stage, delivering shots now empowered with "a god-like character that the Hollywood crane has bestowed."[32]

23. Ramírez, *Architecture for the Screen*.
24. Affron and Affron, *Sets in Motion*.
25. Donald Albrecht, *Designing Dreams: Modern Architecture in the Movies* (New York: Harper & Row, 1986); Gabrielle Esperdy, "From Instruction to Consumption: Architecture and Design in Hollywood Movies of the 1930s," *The Journal of American Culture* 30, no. 2 (2007), https://doi.org/10.1111/j.1542-734X.2007.00509.x.
26. Bazin, *What is Cinema? Volume I*.
27. Esperdy, "From Instruction."
28. Bazin, *What is Cinema? Volume II*.
29. Anne Friedberg, *The Virtual Window: From Alberti to Microsoft* (Cambridge, MA: The MIT Press, 2009 [2006]).
30. Affron and Affron, *Sets in Motion*.
31. Gottwald and Turner-Rahman, "The End of Architecture."
32. Bazin, *What is Cinema? Volume II*, 33.

Attributing Jean-Paul Sartre, Bazin observed that "in the theater the drama proceeds from the actor, in the cinema it goes from the decor to man. This reversal of the dramatic flow is of decisive importance. It is bound up with the very essence of the mise-en-scène."[33] In theater the performer sets the stage, and in cinema the set stages the performer. The architecture of the theater functions as a container for drama; stage and backstage, wings and amphitheater. It is a sealed box where performance takes place "in contrast to the rest of the world" because "play and reality are opposed" and "theater of its very essence must not be confused with nature under penalty of being absorbed."[34] Bazin does not use the terms "set" or "scenic design" but instead refers to all manner of stage dressing as "décor."[35] And he does not distinguish between the soundstage and locations. To Bazin, a farmhouse and a hillside are both décor. Ontologically—as image objects—they are identical. Important to Bazin are two notions: that the set has been torn out of the stage and placed at will (thus ceasing to be architecture), and that mise-en-scène does not require performers at all. "On the screen man is no longer the focus of the drama . . . The decor that surrounds him is part of the solidity of the world. For this reason the actor as such can be absent from it."[36] Décor is what distinguishes theater from cinema.

There are six "distinctive qualities"[37] or properties which separate sets from true architecture, whether constructed within a soundstage or on location.[38] First, film sets are typically **fragmentary**. Only what is photographed is constructed. Second, **sets have altered size and proportion** to account for lens distortion and to accommodate where they are built. To create illusions, perspectives are altered. Third, further con-

33. Quite literally in English "setting the stage," mise-en-scène is a theater arts term which became more widely used in film criticism during the 1950s by the writers of French film magazine *Cahiers du Cinéma*, including its co-founder Bazin. For him, mise-en-scène comprises all that you see on the screen, from set design to costumes and lighting, composition to camera motion. Bazin called these individual properties "image plastics." See Bazin, *What is Cinema? Volume I,* 102.
34. Ibid., 104.
35. Ibid., 103.
36. Ibid., 106.
37. Ramírez, *Architecture for the Screen,* 81.
38. For this original discussion in English translation, see Ramírez, *Architecture for the Screen*. For the later expansion, see Affron and Affron, *Sets in Motion,* 31–50.

torting, the interiors are **rarely orthogonal**, producing "strange deformities."³⁹ Rooms are trapezoidal, to control echoes and to "force" perspective for an illusion of depth. Fourth, sets are **hyperbolic** "as much to simplify as to create greater complexities."⁴⁰ Such exaggerations can communicate instantly, establishing locale, period, and class.⁴¹ Sets thus function as characters, conveying both atmosphere and exposition.⁴² Fifth, sets must be **mobile and flexible**. They are frequently disassembled, so the camera can enter, making them "wild." Finally, film sets are the very definition of ephemera, **built rapidly and abruptly demolished**.

Referencing Italian Marxist critics Baldo Bandini and Glauco Viazzi, the Affrons posit that "as soon as the camera began to move, stage design was no longer suited to the film medium. Cinematic sets can, indeed must, conform to spatial and temporal rhythms; theatrical sets remain tied to the constraints of the stage."⁴³ The properties thus fracture the film set, breaking the fixed relationship between performer and spectator established by the theater stage which "mark[s] out a privileged spot."⁴⁴ "Because it is only part of the architecture of the stage, the decor of the theater is thus an area materially enclosed, limited, circumscribed,"⁴⁵ and now it is free. For before the camera began to move, "the framing in [a] 1910 film [was] a substitute for the missing fourth wall of the theatrical stage."⁴⁶

Sets were now truly spaces, and skilled labor was needed to design them. During the 1920s, industry press was lively with articles calling for men to work in motion pictures. *The American Architect* declared that "for the purposes of the modern picture play the ordinary stage setting will no

39. Ramírez, *Architecture for the Screen,* 84.
40. Ibid., 85.
41. J. H. Macfarland, "Architectural Problems in Motion Picture Production," *American Architect* 118 (1920), https://archive.org/details/americanarchite118newyuoft.
42. Esperdy, "From Instruction."
43. Affron and Affron, *Sets in Motion,* 33.
44. Bazin, *What is Cinema? Volume I,* 104.
45. Ibid.
46. Ibid., 34.

longer suffice . . . [sets now] are in three dimensions."[47] During the Great Depression, many architecture graduates could only find steady employment at film studios. Nearly all the industry's art directors during the 1930s had been trained in architecture school.[48] The pay was good, the work interesting, and film sets would arguably be seen by a wider audience than real buildings. Only the wealthy traveled abroad at this time, yet millions went to the movies every week. If the American public had a chance to admire an Italian villa, a Greek temple, or a French cathedral, it would be via cinema.[49] Thus, some argued that the sociocultural impact of cinema exceeded that of architecture, and that images of environments would educate and make lasting impressions.[50]

At the same time architects began designing sets, studio people designed architecture. This **filmic regime** brought three properties of set design to the built environment: buildings were wildly hyperbolic and stylized, sometimes nonorthogonal in nature, and often employed forced perspective.[51] Southern California was ready for this shift. The glamor of Hollywood sets felt right to Hollywood people, and the look of the region was already trafficking in similar illusions.[52] As greater Los Angeles was colonized by this "movie architecture"—the built environment as a kind of a grand production—we are reminded of Bazin's praise for the Italian urban landscape, so "prodigiously photogenic" and "theatrical and decorative."[53] He considered films shot on location there superior: "City life is a spectacle . . . that the Italians stage for their own pleasure . . . The courtyard is an Elizabethan set . . . the theatrical façades of the palazzi

47. Carl A. Ziegler, "Architecture and the Motion Picture," *The American Architect* 119, no. 2367 (1921): 547, https://archive.org/details/tamericanarchitec119newyuoft.
48. George P. Erengis, "Cedric Gibbons," *Films in Review* 16 (April 1965).
49. Macfarland, "Architectural Problems."
50. Macfarland, "Architectural Problems"; Ramírez, *Architecture for the Screen*; G. Harrison Wiley, "The House That Jack Builds," *Motion Picture Director* 2, no. 6 (1926), https://archive.org/details/motionpicturedir4240moti; Ziegler, "Architecture."
51. Gottwald and Turner-Rahman, "Toward a Taxonomy."
52. This began with the Spanish Colonial Revival in the early 1900s. Similar architectural revival styles also took root in the Los Angeles area during this time, from English Tudor to Moorish. See David Gebhard, "A Lasting Architecture" in *California Crazy: American Pop Architecture*, ed. Jim Heimann (Köln: Taschen, 2018 [1980]), 285–313; Jim Heimann, *California Crazy: American Pop Architecture* (Köln: Taschen, 2018 [1980]).
53. Bazin, *What is Cinema? Volume II*, 28-29.

combine their operatic effects with the stage-like architecture of the houses."[54] The stages which Bazin describes evolved naturally of course, which prompts architects and critics to label all cities, as Bazin does Rome, authentic; the ultimate soundstage for total cinema. Conversely, Los Angeles in the early twentieth century was a blank slate, designed with intention and immediacy. L.A. is not "fake," yet it is the kind of real untruth that Bazin was fascinated by, a nouveau Garden of Eden fed by all manner of illusion: an imagined water supply, romanticized Spanish glory, and a fantasy architecture born on the Hollywood studio lot.[55]

The Inhabitable Set: Themed Environments

Disneyland opened in Anaheim, California, on July 17, 1955, and heralded the birth of the **thematic regime**. Considered the sui generis contemporary theme park,[56] it arrived directly in the middle of the "cinematic century."[57] Until this moment, the application of set design to the built environment was intermittent and varied. True to how critics describe these works today, the filmic regime was regarded as a novelty.[58] Sets of course are designed and constructed to service the story of a film. There is no such narrative framework for a Los Feliz mansion built in the Storybook Style, or a Las Vegas casino approximating the Wild West. Just aesthetics, impressions; mere motifs without context. What was truly needed for sets to exist outside the soundstage was a script.

54. Ibid., 29.
55. For a discussion of Los Angeles and all its fantasies in those early decades, see Gary Krist, *The Mirage Factory: Illusion, Imagination, and the Invention of Los Angeles* (New York: Broadway Books, 2018).
56. Judith A. Adams, *The American Amusement Park Industry: A History of Technology and Thrills* (Boston: Twayne, 1991); Karal Ann Marling, *As Seen On TV: The Visual Culture of Everyday Life in the 1950s* (Cambridge, MA: Harvard University Press, 1994); Miodrag Mitrašinović, *Total Landscape, Theme Parks, Public Space* (London: Routledge, 2006); Scott Lukas, *Theme Park* (London: Reaktion Books, 2009).
57. Friedberg, *The Virtual Window,* 242.
58. Heimann, *California Crazy.*

It was at Disneyland where the properties of the film set were codified into an experiential language. This is the interdisciplinary development of themed spaces, the "praxis of thematic design."[59] During the filmic regime, the language of sets was applied in architecture, with art directors taking on the real as architects took on the illusory. At Disneyland, the intermix would produce a fantasy Potemkin village like no other; the film set as a replacement for architecture. After consulting with architect Welton Becket, Walt Disney decided to form his own company staffed with Hollywood people.[60] Though many had architectural training, there was not one licensed practitioner among them except Ruth Shellhorn, who was belatedly hired to save the landscape design.[61] The rest planned out the park as an interrelated sequence of images, which they storyboarded just like one of Disney's animated films.[62] At Disneyland, the original 1955 narrative is one of the television viewing experiences mapped onto the built environment, fusing Disney's televisuals with an improved version of the amusement park model.[63] Thus, the theme park resembles a soundstage;[64] it is like walking into a movie.[65] In the thematic regime, the language of set design had now been contained, contextualized, and given a screenplay in the form of its storyboards.[66] The themed environment is therefore a kind of scripted space.[67]

59. *Thematic* is used to connote this design process, as opposed to *themed* which refers to the end product. See Gottwald and Turner-Rahman, "The End of Architecture," 41; Scott Lukas, ed. *The Themed Space: Locating Culture, Nation, and Self* (Lanham, MD: Lexington Books, 2007).
60. Karal Ann Marling, ed., *Designing Disney's Theme Parks: The Architecture of Reassurance* (Paris: Flammarion, 1997).
61. Kelly Comras, *Ruth Shellhorn* (Athens: University of Georgia Press, 2016); Todd James Pierce, *Three Years in Wonderland: The Disney Brothers, C.V. Wood, and the Making of the Great American Theme Park* (Jackson, MS: University Press of Mississippi, 2016).
62. Randy Bright, *Disneyland: Inside Story* (New York: Harry N. Abrams, 1987); John Hench and Peggy Van Pelt, *Designing Disney: Imagineering and the Art of the Show* (New York: Disney Editions, 2003).
63. Marling, *As Seen On TV*.
64. Adams, *The American Amusement Park Industry*.
65. Florian Freitag, "'Like Walking into a Movie': Intermedial Relations between Theme Parks and Movies," *The Journal of Popular Culture* 50, no. 4 (2017), https://doi.org/10.1111/jpcu.12569.
66. Dave Gottwald, "From Image as Place to Image as Space: Pinocchio, Pirates, and the Spatial Philosophy of the Multiplane Camera," *The International Journal of the Image* 12, no. 1, https://doi.org/10.18848/2154-8560/CGP/v12i01/71-93.
67. Klein, *The Vatican to Vegas*.

Image 2.1: *Teatro Olimpico di Vicenza. Credit: Dave Gottwald.*

Theme parks are permanent, vary in scale and rigor, and are exaggerated and fanciful. Yet, they are also fragmentary like film sets, for only what is seen by the public is built. The rest is an extensive back of house. Turner-Rahman and I have previously noted its transmediated aspects, and with Bazin we see that the thematic regime is as theatrical as it is cinematic. Consider the novel service vernacular Walt Disney and his staff devised: park employees are known as "cast members," and when in public areas of the park, are "onstage." Areas not visible to the public are "backstage."[68] Operators are called "hosts" and there are no rides but rather "attractions," "adventures," and "shows."[69] Remarkably, within the themed envi-

68. Bright, *Disneyland*; Sabrina Mittermeier, *A Cultural History of the Disneyland Theme Parks: Middle Class Kingdoms* (Bristol: Intellect Books, 2021).
69. By the 1990s, Disney's terminology had transformed the entire hospitality industry. "Host" and "guest" are now used in most experiential contexts and even taught in business schools. See Salvador Anton Clavé, *The Global Theme Park Industry* (Cambridge: CABI, 2007). For an extended insider discussion on this language and how Disney cast members are trained to use it see Van Arsdale France, *Window on Main Street: 35 Years of Creating Happiness at Disneyland Park* (Nashua, NH: Laughter Publications, 1991).

ronment Bazin's spatial construct of the theater folds in on itself. Tourists are called "guests" by Disney because we have been invited by the cast onto a collapsed, common stage. Postmodern architect and critic Charles W. Moore once described the Disneyland experience as one of "inhabitation . . . where we are protected, even engaged, in a space ennobled by our own presence . . . merely celebrants at a real affair but also the objects of celebration."[70] This complicates Bazin's insistence that live performance remain sundered from reality, sequestered within the "locus dramaticus"[71] of the stage as embedded within the architecture of the theater. Reality has not "absorbed"[72] theater as he feared; instead, precisely the opposite. The entry wings of the Teatro Olimpico di Vicenza (see image 2.1)[73] have become the city streets themselves, and backstage has surrounded all common areas. As Jennifer A. Kokai and Tom Robson remind us in Book Two of this collection, within the theme park, the spectators are also performers, inhabiting the same space (see image 2.2).[74]

70. Charles Moore, Peter Becker, and Regula Campbell, *The City Observed: Los Angeles - A Guide to Its Architecture and Landscapes* (New York: Vintage Books, 1984), 38.
71. Bazin, *What is Cinema? Volume I*, 104.
72. Bazin, *What is Cinema? Volume I*.
73. Bazin used the Olympic Theater of Vincenza as his example of how the architecture of the stage functions as an internal world to keep it isolated from reality outside. See Bazin, *What is Cinema? Volume I*, 105.
74. Architectural critique has also come around to approach the theme park experientially. See Anna Klingmann, *Brandscapes: Architecture in the Experience Economy* (Cambridge, MA: The MIT Press, 2007); Brian Lonsway, *Making Leisure Work: Architecture and the Experience Economy* (London: Routledge, 2009).

Image 2.2: Disneyland's collapsed, common stage. Credit: Dave Gottwald.

This collapsed, common stage did not remain inside the gates of Disneyland for long. Over the past 60 years, thematic design has spread throughout the global experience economy[75] encompassing not just hospitality and entertainment, but shaping where we dine, shop, live, and even receive medical treatment.[76] The grammar of sets is the vector by which the cinematic experience had escaped the screen, and not just

75. B. Joseph Pine and James H. Gilmore, *The Experience Economy: Competing for Customer Time, Attention, and Money* (Boston: Harvard Business Review Press, 2019 [1999]).
76. Mark Gottdiener, *The Theming of America: Dreams, Media Fantasies, and Themed Environments, Second Edition* (Boulder, CO: Westview Press, 2001 [1997]); Lonsway, *Making Leisure Work*.

within the private sphere. Beginning in the 1970s in the United States, smaller towns revitalized their own main streets in the guise of Disney's example.[77] They were redesigned and collapsed into their own common stages.

> When we stroll down Disney's Main Street, we become participants in a much larger drama that is redefining how we perceive place . . . *because the streetscape itself was designed as a set of sorts* . . . Disney's Main Street (and, by definition, historic restorations of Main Streets in real towns) puts the observer in a unique position. *In the process of consumption and commodification on the one hand,* [we are] *a consumer of the landscape and, on the other, actually* [become] *one of the elements or objects consumed by others; the process, like filmmaking itself, forever confuses consumption with object, and commerce with art.*[78]

When Umberto Eco visited in the early 1970s, he found Disneyland to be "a fantasy world more real than reality, breaking down the wall of the second dimension, creating not a movie, which is illusion, but *total theater.*"[79] This harmonizes well with Bazin's total cinema, yet tellingly Eco also called film "illusion." If cinema's "fundamental contradiction . . . at once unacceptable and necessary"[80] is that it can never reach the state that it was designed for, that it so desires to be (reality itself), then themed spaces overcome the dilemma by declaring themselves "real" without any fidelity to reality.[81] This assaults Bazin's myth with a different one entirely, for "Disneyland is presented as imaginary in order to make us believe that the rest is real, whereas all of Los Angeles and the America that surrounds it are no longer real."[82] Disneyland functions as a counterpoint to a built environment which claims authenticity but has already

77. Richard V. Francaviglia, *Main Street Revisited: Time, Space, and Image Building in Small-Town America* (Iowa City, IA: University of Iowa Press, 1996).
78. Ibid., 183, emphasis added.
79. Umberto Eco, *Travels in Hyperreality: Essays*, trans. William Weaver (San Diego, CA: Harcourt, 1986), 45, emphasis added.
80. Bazin, *What is Cinema? Volume II*, 26.
81. "Disney is not attempting to recreate actual structures or to simulate authentic experiences . . . It is not a poor copy of reality, because there is no attempt to recreate reality." Jennifer A. Kokai and Tom Robson, eds. *Performance and The Disney Theme Park Experience: The Tourist as Actor* (Cham, Switzerland: Palgrave Macmillan, 2019), 7.
82. Jean Baudrillard, *Simulacra and Simulation,* trans Sheila Glaser (Ann Arbor, MI: The University of Michigan Press, 1994 [1981]), 13.

Dave Gottwald

been Disneyized.[83] And yet Eco's assessment that Disney "tells us that technology can give us more reality than nature can"[84] lets us substitute the theme park for cinema and still retain an essence of Bazin, that verisimilitude is tied up with technological representation. The audience of a film observes; the audience of a themed space observes and simultaneously acts.[85] Yet, both are consuming an art form whose purpose is "the creation of an ideal world in the likeness of the real."[86] The themed space is a manifestation of Bazin's quest for ideal realism in cinema, a kind of credible illusion, constructed on a stage: total theater.

The Playable Set: Video Games

By the 1990s, video games had evolved from primitive, third person constructs to richer, more immersive environments.[87] *Wolfenstein 3D* (1992) and *Doom* (1993) brought the advent of the first-person shooter (FPS) genre. The FPS made gameplay more cinematic. In *Doom,* one plays through the virtual camera's POV and interacts from the perspective of an avatar, the character being played.[88] Once again, the camera drove the spatial evolution of sets forward. As Bazin notes of cinema, "the screen is not a frame like that of a picture but *a mask which allows only a part of the action to be seen.* When a character moves off screen, we accept the fact that he is out of sight, but he continues to exist in his own capacity *at some other place in the decor which is hidden from us.*"[89] The world of the video game is also one of hidden décor, revealed to the player over time. And the spatial construct of gameplay is Bazin's "mask" of the camera which only permits a part of the gameworld to be experienced.

83. Alan Bryman, *The Disneyization of Society* (London: Sage Publications, [2004] 2006).
84. Eco, *Travels in Hyperreality,* 44.
85. Lukas, *The Themed Space*; Kokai and Robson, *Performance.*
86. Bazin, *What is Cinema? Volume I,* 10,
87. Michael Nitsche, *Video Game Spaces: Image, Play, and Structure in 3D Worlds* (Cambridge, MA: The MIT Press, 2008).
88. Ibid.
89. Bazin, *What is Cinema? Volume I,* 105, emphasis added.

Like sets, video games are hyperbolic and vary in proportions; like themed spaces, they often contain transmediated narratives, and are fragmentary, as spaces are graphically rendered by the software only when needed.[90] This **electronic regime** also exhibits two additional properties due to its virtuality.[91] Game environments are flexible and mobile in "that they span a multidimensional array of levels to facilitate whatever play requires."[92] And, of course, being electronic, they are also singularly ephemeral: close the software and the world vanishes.

As with all architecture, a video game consists of structure and presentation. The code provides parameters, and the world is presented to us via graphics. Yet, there is also functionality, which makes gamespaces distinct from other spaces.[93] The rules embedded in the game are enmeshed within its environments.[94] Thus, within a gameworld, we are spectators, performers, and players all at once. This combination of structure, presentation, and functionality within a virtual construct is mise-en-image, which defines how interaction is embedded within the graphical environment.[95] The result is a common, collapsed, actionable world; a myth of simulated lived experience.[96] Spectator, performer, player, character, environment, and camera are amalgamated into a single experiential mode. Here we see Bazin's theater/cinema has been reconfigured once again, for the stage has merged with its mask. With cinema, "drama is

90. Both practitioners and scholars have noted the environmental language and experiential objectives which theme parks and video games share. See Don Carson, "Environmental Storytelling: Creating Immersive 3D Worlds Using Lessons Learned from the Theme Park Industry," *Gamasutra*, March 1, 2000, https://www.gamedeveloper.com/design/environmental-storytelling-creating-immersive-3d-worlds-using-lessons-learned-from-the-theme-park-industry; Celia Pearce, "Narrative Environments: From Disneyland to World of Warcraft," in *Space Time Play: Computer Games, Architecture and Urbanism: The Next Level*, ed. Friedrich von Borries, Steffen P. Walz, and Matthias Böttger (Basel: Birkhäuser, 2007).
91. Gottwald and Turner-Rahman, "Toward a Taxonomy."
92. Ibid., 117.
93. Jesper Juul, *Half-Real: Video Games between Real Rules and Fictional Worlds* (Cambridge, MA: The MIT Press, 2005).
94. Nitsche, *Video Game Spaces*.
95. Arsenault and Côté, "Reverse-Engineering."
96. Mark J. P. Wolf, "Video Games, Cinema, Bazin, and the Myth of Simulated Lived Experience," *Game: The Italian Journal of Game Studies* 4, no. 1 (2015), https://www.gamejournal.it/wolf_lived_experience/.

freed by the camera from all contingencies of time and space," yet "the theater in contrast uses a complex machinery to give a feeling of ubiquity."[97] The gameworld is a virtual stage without the backstage which, for Bazin, defines it.[98]

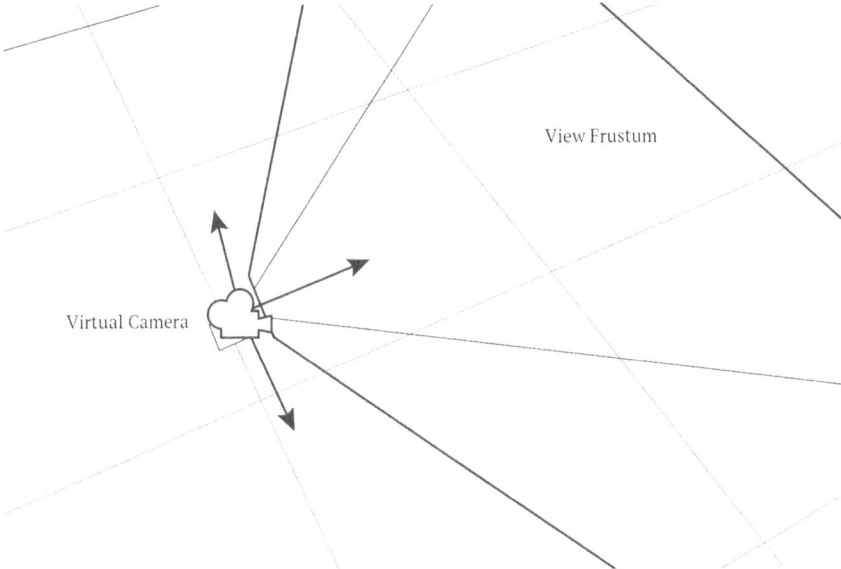

Image 2.3: Typical game engine design space. Credit: Dave Gottwald.

All this shifted paradigmatically with the introduction of game engine software.[99] Imagine a house being built. Now picture a team of architects who live inside it while it is being designed and constructed. They can make any change they want—iterate and test endlessly—while they still live in the house. This interior holism is the game engine, which is also *explicitly* cinematic: the operational metaphor is a virtual "camera" (see image 2.3). Bazin's mask is here called the *view frustum*, which represents the camera's field of vision—the region of the virtual world which will appear on screen.[100] Thus—for a third time—the camera's ability to move and penetrate space advances the overall environment. Turner-Rahman

97. Bazin, *What is Cinema? Volume I*, 103.
98. "[The stage] exists by virtue of its reverse side and its absence from anything beyond, as the painting exists by virtue of its frame." Bazin, *What is Cinema? Volume I*, 105.
99. James Gregory, *Game Engine Architecture, Third Edition* (London: Taylor & Francis, 2018).
100. Kelvin Sung, Peter Shirley, and Steven Baer, *Essentials of Interactive Computer Graphics: Concepts and Implementation* (Wellesley, MA: A K Peters, 2008).

and I call this final phase the **holistic regime**, for virtual space is the tool "and the resultant environment itself . . . in essence both the dreamer and the dream."[101] Today, there are two leading game engine software platforms which are open to all: Unreal (1998) and Unity (2005). Within these, developers inhabit and iterate simultaneously. Environmental changes affect gameplay, so designers must play as they refine.[102] The game engine is a culmination of all our prior spatial regimes.[103] Here, the filmic and thematic are embedded within the electronic, virtualized, and framed by Bazin's mask. In the holistic regime we are now also writers, directors, and editors. Not only have the boundaries between theater and cinema collapsed, but so have production and consumption, design and designer.

The Virtual Set: StageCraft

While shooting *Rogue One: A Star Wars Story* (2016), director of photography Greig Fraser experimented with a large format LED screen depicting a starfield.[104] The spaceship set was mounted on a gimbal, and the digital backgrounds were displayed in real-time synchronization with its motion.[105] Despite the relatively low quality of the effect, director Gareth Edwards saw potential: "You really feel like you're in the place . . . it's really convincing, and I think there will be studios . . . one day that are just wall-to-wall LEDs."[106] Director Jon Favreau similarly experimented with virtual technology on *The Jungle Book* (2016) and *The Lion King* (2019), but those two Disney films still relied heavily on traditional CGI.[107]

101. Gottwald and Turner-Rahman, "Toward a Taxonomy," 120.
102. Gregory, *Game Engine Architecture*.
103. Gottwald and Turner-Rahman, "Toward a Taxonomy."
104. Bryan Bishop, "Rogue One's Best Visual Effects Happened While the Camera Was Rolling," *The Verge*, April 5, 2017, https://www.theverge.com/2017/4/5/15191298/
rogue-one-a-star-wars-story-gareth-edwards-john-knoll-interview-visual-effects. N.B. I rely on practitioner quotes from industry press as these technologies are nascent.
105. Ibid.
106. Ibid.
107. Jay Holben, "*The Mandalorian*: This Is the Way," *American Cinematographer Magazine*, February 6, 2020, https://ascmag.com/articles/the-mandalorian; Anne Thompson, "Jon Favreau's VFX Master: Why 'The Jungle Book' Will Win the Only Oscar It Can Get," *IndieWire*, February 20, 2017, https://www.indiewire.com/2017/02/the-jungle-book-vfx-rob-legato-oscars-2017-1201785243/.

For Favreau's new project, he wanted to solve problems he had with green screens, a technology in use since the 1990s.[108] His Disney streaming series *The Mandalorian* debuted in the fall of 2019 with the answer: StageCraft.[109]

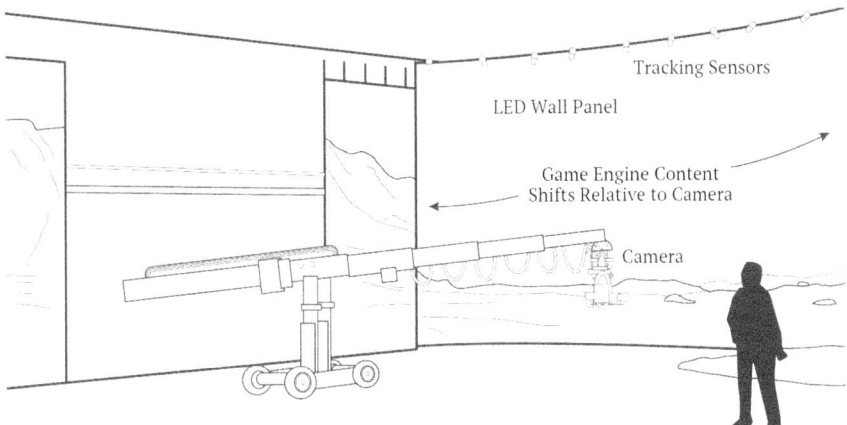

Image 2.4: *StageCraft Volume set. Credit: Dave Gottwald.*

StageCraft is a partnership between Epic Games and Industrial Light & Magic (ILM), the effects house founded by George Lucas to make *Star Wars* (1977).[110] Partnered with other companies, ILM built a small prototype soundstage in June of 2018 which they call "the Volume."[111] StageCraft is the combination of a Volume set covered in LED panels with live Unreal game engine content. The stage is circular, and the backgrounds fill peripheral vision.[112] The larger Volume set built for *The Mandalorian* is approximately 23 meters in diameter, and approximately 6.5 meters high, providing digital imagery on every surface except the floor (see image 2.4).[113] Because partial physical sets, furniture, and props are also on the

108. Matting performers onto backgrounds in post-production is also called "blue screen" because the color was used for the earlier optical process. A bright green is typically used for digital matting.
109. Holben, "*The Mandalorian.*"
110. Industrial Light & Magic, "ILM StageCraft," April 10, 2019, https://www.ilm.com/ilm-stagecraft/.
111. Kevin H. Martin, "A New Hope," *International Cinematographers Guild Magazine*, February 3, 2020, https://www.icgmagazine.com/web/a-new-hope/.
112. Ian Failes, "*The Mandalorian* and the Future of Filmmaking," *VFX Voice: The Magazine of the Visual Effects Society*, April 1, 2020, https://www.vfxvoice.com/the-mandalorian-and-the-future-of-filmmaking/.
113. Industrial Light & Magic, "The Virtual Production of The Mandalorian Season One," uploaded February 20, 2020, YouTube video, 4:42, https://youtu.be/gUnxzVOs3rk.

stage, StageCraft is a mixed reality (MR) environment, and it represents a new kind of immersion. Films which used green screen sets almost exclusively, like the *Star Wars* prequels, were criticized for listless performances.[114] Thus Richard Bluff, visual effects supervisor on *The Mandalorian,* laments that "Jon Favreau found the breakthrough that George [Lucas] was always looking for."[115] *The Mandalorian* was the first major production to use LED walls at a time when blockbuster Marvel films like *Avengers: Endgame* (2019) were still shot within green screen environments.[116]

StageCraft advances filmmaking in several key ways. The LED surfaces not only display content, they also provide realistic lighting with adjustable color. As Kim Libreri at Epic Games notes, "the problem with the green screen is it basically puts a lot of green light on you. We call that 'spill.'" StageCraft completely eliminates this: "If you wrap an actor with a big 360 LED wall, you can light in a way . . . so you can really make it feel like the characters are embedded in the environments."[117] This was important on *The Mandalorian* because the eponymous character wears shiny armor. Every single bit of LED light reflected off that metal is true to life. For this reason alone, traditional CGI is becoming extinct. "Eventually, of course, we hope to never use green screens," says Bluff, though they are still useful within StageCraft itself for matting in close-up. Because it's virtual, digital green can be inserted anywhere within the Volume, limited to say, behind a single character.[118]

114. Film reviews noted this at the time. "There is a certain lifelessness in some of the acting, perhaps because the actors were often filmed in front of blue screens so their environments could be added later by computer." Roger Ebert, "Star Wars—Episode II: Attack of The Clones," *Chicago Sun-Times*, May 10, 2002, https://www.rogerebert.com/reviews/star-wars-episode-ii-attack-of-the-clones-2002.
115. Kristin Baver, "This Is the Way: How Innovative Technology Immersed Us in the World of the Mandalorian," *Star Wars*, May 15, 2020, https://www.starwars.com/news/the-mandalorian-stagecraft-feature.
116. Insider, "Why 'The Mandalorian' Uses Virtual Sets Over Green Screen," uploaded June 11, 2020, YouTube video, 6:38, https://youtu.be/Ufp8weYYDE8.
117. Ibid.
118. Ibid.

StageCraft is dynamic, responsive, and configurable. Because Unreal is serving real-time content, it can be linked to camera positions. As the camera moves around the set, the background moves in response, preserving parallax and depth.[119] A green screen is simply a matte painting, delayed. StageCraft is instead truly virtual mise-en-scène. When describing the relationship, Kris Murray at Lux Machina chose to characterize it as *deception*, because "we can track a camera's position in space in real time and render its perspective so that *we can compellingly convince a camera* that something else is happening in front of it that isn't really there."[120] This is what makes StageCraft fundamentally different from rear screen projection and green screens: the camera views the virtual via the same physics as reality. Also, not unlike a set of Matryoshka dolls, there are nested layers of imagery. Cinema is now being produced in a factory that is itself composed of cinema, shot on a set which is constructed of other movies. Image production and consumption have folded back on themselves and collapsed, just how spectatorship and performance collapsed within the thematic regime. In a stunning perversion of Bazin's ontology, the image object is also an image product, and what is captured exists to be photographed (yet does not really exist either). The image object/product is saved and stored, and all footage can be recalled at any time for later use or manipulation.[121]

Lastly, the Volume set is also a virtual performer. When "you want to turn around on [sic] an actor, you're not physically moving the cameras, you're actually just moving the background, and all the lights change."[122] Director of photography Barry Baz Idoine observes that it's remarkably easy to "shoot any sequence where you say, 'oh, this world's not quite right. Let's just move it a little bit.'"[123] However, StageCraft's most stunning aspect is its reconfigurability. "We now have the capability to grab hold of any tree

119. Martin, "A New Hope."
120. Unreal Engine, "Real-Time In-Camera VFX for Next-Gen Filmmaking | Project Spotlight | Unreal Engine," uploaded August 1, 2019, YouTube video, 2:14, https://youtu.be/bErPsq5kPzE, emphasis added.
121. Industrial Light & Magic, "The Virtual Production of The Mandalorian Season Two," uploaded April 1, 2021, YouTube video, 7:09, https://youtu.be/-gX4N5rDYeQ.
122. Ibid.
123. Industrial Light & Magic, "Virtual Production," 2020.

in a forest," says Bluff, "and move them around independently. To re-set dress on the day, based upon what we were seeing through the camera."[124] Dedicated technicians can adjust the environment, lighting, vantage, and focus. Known as the "Brain Bar,"[125] this team literally moves mountains and turns night into day right in front of the actors. A director can now perpetually remake the entire world of a film while it is being shot.

For the second season of *The Mandalorian* (2021), ILM continued to use Unreal for previsualization, yet also developed their own proprietary engine called Helios. Because it was designed from scratch, StageCraft 2.0 has improved complexity and color fidelity.[126] The new Volume sets are larger and are being used in conjunction with traditionally lit tracking shots that begin outside a Volume and conclude within it seamlessly.[127] Like stage sets before them, virtual sets are becoming contiguous and more architectonic, a mixed reality world with the potential to evolve into an extensible system.[128]

If the theme park was for Eco total theater, then StageCraft is a *total world*. The Volume set provides design, lighting, and even a sense of performance—all of Bazin's plastics at once. To the camera, it looks no different than a location shoot. If you ask StageCraft to move around the performers, it moves (as with blocking). Ask it to change its appearance and it changes (as with costume and makeup). And most importantly, because it was preassembled in the game engine and even edited in situ, StageCraft is montage in the round. The technology is aptly named: it reconciles Bazin's distinction between the "stage" of the theater and the "craft" of filmmaking. Like Teatro Olimpico di Vicenza, a Volume set is "outwardly . . . a purely utilitarian piece of architecture . . . secretly ori-

124. Industrial Light & Magic, "Virtual Production," 2021.
125. Failes, "*The Mandalorian*."
126. Ibid.
127. Mike Seymour, "Mandalorian Season 2 Virtual Production Innovation," *fxguide*, February 10, 2021, https://www.fxguide.com/fxfeatured/mandalorian-season-2-virtual-production-innovations/.
128. "ILM is . . . opening the door to multiple connected volumes, multiple vertical volumes. One can [imagine] new and vast shots that travel from different rooms or spaces, with dynamic LED volumes via connected practical corridors, trenches or openings." Seymour, "Mandalorian Season 2."

ented inward... conceived according to the laws of an aesthetic and artificial space."[129] Yet, StageCraft also honors Bazin's holism and aligns with his declaration that "essential cinema ... is to be found in straightforward photographic respect for the unity of space."[130]

Conclusion

> "Not only does some marvel or some fantastic thing on the screen not undermine the reality of the image, on the contrary it is its most valid justification."
>
> —André Bazin[131]

StageCraft seems like something Bazin certainly anticipated and probably would have embraced.[132] Its dynamic imagery is illusory yet still ontologically "photorealistic." Let us again be clear about what Bazin means by truth. When he complained that "the German school did every kind of violence to the plastics of the image by way of sets and lighting,"[133] he was not saying the production design of *The Cabinet of Dr. Caligari* (1920) was poor. Bazin was decrying the abstractions of the film and was indeed pleased when "the expressionist heresy came to an end."[134] Bazin was not so much a realist as he was an anti-abstractionist. He asked for verisimilitude, not literal truth.

Bazin was a great admirer of American director Orson Welles and his infamous *Citizen Kane* (1941), which is expressed completely by set design, mattes, and practical effects. Apart from stock footage, there are practically no locations in the entire film. Much like the shattered snow globe from its opening moments, *Kane* exists only within an artificial interior world. Bazin praised Welles for his dedication to continuity and skill with

129. Bazin, *What is Cinema? Volume I*, 105.
130. Ibid., 46.
131. Ibid., 108.
132. "The quality of the interior shots will in fact increasingly depend on a complex, delicate and cumbersome apparatus. Some measure of reality must always be sacrificed in the effort of achieving it" Bazin, *What is Cinema? Volume II*, 30.
133. Bazin, *What is Cinema? Volume I*, 26.
134. Bazin, *What is Cinema? Volume II*, 26.

deep focus.[135] For most key scenes the camera does not move at all. Bazin concluded that it was reasonable to forgo locations in order to exert artistic control: "In ruling out . . . all recourse to nature in the raw, natural settings, exteriors, sunlight . . . Welles rejects those qualities of the authentic document for which there is no substitute and which, being likewise a part of reality, *in themselves establish a form of realism.*"[136] Thus, a film can be an entirely virtual event and that makes it no less credible: "There can be no cinema without the setting up of an open space *in place of the universe* rather than as part of it . . . it is less a question of set construction or of architecture or of immensity than of *isolating the aesthetic catalyst.*"[137] Bazin asks the filmmaker, what are your motives? If you are interested in "truth" (by which he means *credibility*),[138] then yes, I consider Bazin a proponent of virtuality. Like themed and gamified spaces, StageCraft is "the creation of an ideal world in the likeness of the real."[139] In fact, Bazin described it perfectly as one of the "future technical improvements . . . [which] will permit *the conquest of the properties of the real.*"[140]

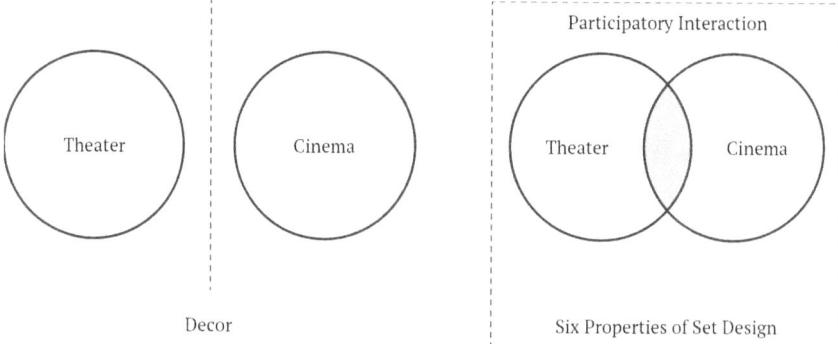

Image 2.5: From Bazin's segregation to unified experiential medium. Credit: Dave Gottwald.

135. "Dramatic effects for which we had formally relied on montage were created out of the movements of the actors within a fixed framework." Bazin, *What is Cinema? Volume I*, 33.
136. Bazin, *What is Cinema? Volume I*, 28-29, emphasis added.
137. Ibid., 110-111.
138. "Cinema is dedicated entirely to the representation if not of natural reality at least of a *plausible reality.*" Bazin, *What is Cinema? Volume I*, 108, emphasis added.
139. Ibid., 10.
140. Bazin, *What is Cinema? Volume II*, 30.

Bazin's inexorable segregation of film and stage was two-fold with his fixation on the spatial characteristics of each and then on how those aspects formulate and facilitate the relationship between audience and performer. While drama is performed within the theater—framed abstractly in self-aware presentation—cinema is captured as life re-enacted. What Bazin could not foresee was how media would shift from passive to active, and how theater and cinema would become a new, single medium of participatory interaction. The catalyst for all this, as well as the binding concept, are the properties of set design (see image 2.5). All of our contemporary spatial regimes have their genesis in the filmic grammar of sets. As such, when we inhabit these spaces, we are acting by default. Bazin's distinction no longer matters. We watch the performance as we ourselves give it.

In his 1967 introduction, editor and translator Hugh Gray praised Bazin for helping advance film studies in the United States, writing that "the more we see the screen as a mirror rather than an escape hatch, the more we will be prepared for what is to come."[141] As we have seen, the screen is not just a mirror. It is also *a projector*. Bazin's ontology of the photograph has been reversed. Rather than the image object as a document of the world which exists (having been captured *from* it), the human-created image brings the world into existence itself (having been released *upon* it). Here we see yet another expression of virtual interiority—a world of virtual screens, virtual mirrors, and virtual projectors. As Gregory Turner-Rahman explores in his chapter in Book One of this collection, the virtual filmmaker's total world of unreality will become wholly merged with daily life in the not-too-distant future. He calls this an "always-on storyspace"—a world in which we desire the cinematic, perpetuate the cinematic, consume the cinematic, and produce the cinematic, all while performing and spectating on a physical stage of its enactment. The unanticipated fusion of Bazin's theater and cinema becomes the totality of our built environment; a single *camera obscura massa*. Once considered

141. Bazin, *What is Cinema? Volume I*, 7.

more holistically, his relevance transcends the photochemical artifact Bazin so revered to reveal the environments in which we live—a world which is increasingly realized as a grand "hallucination that is also a fact."[142]

142. Ibid., 16.

Bibliography

Adams, Judith A. *The American Amusement Park Industry: A History of Technology and Thrills*. Boston: Twayne, 1991.

Affron, Charles, and Mirella Jona Affron. *Sets in Motion: Art Direction and Film Narrative*. New Brunswick, NJ: Rutgers University Press, 1995.

Albrecht, Donald. *Designing Dreams: Modern Architecture in the Movies*. New York: Harper & Row, 1986.

Arsenault, Dominic, and Pierre-Marc Côté. "Reverse-Engineering Graphical Innovation: An Introduction to Graphical Regimes." *Game: The Italian Journal of Game Studies* 2, no.1 (2013): 57–67. https://www.gamejournal.it/reverse-engineering-graphical-innovation-an-introductionto-graphical-regimes.

Barsacq, Leon. *Caligari's Cabinet and Other Grand Illusions: A History of Film Design*, edited and revised by Elliott Stein. Translated by Michael Bullock. Boston: New York Graphic Society, 1976.

Baudrillard, Jean. *Simulacra and Simulation*. Translated by Sheila Glaser. Ann Arbor, MI: The University of Michigan Press, 1994.

Baver, Kristin. "This Is the Way: How Innovative Technology Immersed Us in the World of the Mandalorian." *Star Wars,* May 15, 2020. https://www.starwars.com/news/the-mandalorian-stagecraft-feature.

Bazin, André. *What is Cinema? Volume I*. Translated by Hugh Gray. Reprint, Berkeley: University of California Press, 2005 (1967).

———. *What is Cinema? Volume II*. Translated by Hugh Gray. Reprint, Berkeley: University of California Press, 2005 (1971).

Bishop, Bryan. "Rogue One's Best Visual Effects Happened While the Camera Was Rolling." *The Verge*, April 5, 2017. https://www.theverge.com/2017/4/5/15191298/rogue-one-a-star-wars-story-gareth-edwards-john-knoll-interview-visual-effects.

Bright, Randy. *Disneyland: Inside Story*. New York: Harry N. Abrams, 1987.

Bryman, Alan. *The Disneyization of Society*. London: Sage Publications, 2006.

Carson, Don. "Environmental Storytelling: Creating Immersive 3D Worlds Using Lessons Learned from the Theme Park Industry." *Gamasutra*, March 1, 2000. https://www.gamedeveloper.com/design/environmental-storytelling-creating-immersive-3d-worlds-using-lessons-learned-from-the-theme-park-industry.

Clavé, Salvador Anton. *The Global Theme Park Industry*. Translated by Andrew Clarke. Cambridge: CABI, 2007.

Comras, Kelly. *Ruth Shellhorn*. Athens: University of Georgia Press, 2016.

Debray, Régis. *Vie et mort de l'image*. Paris: Gallimard, 1992.

Ebert, Roger. "Star Wars—Episode II: Attack of The Clones." *Chicago Sun-Times*, May 10, 2002. https://www.rogerebert.com/reviews/star-wars-episode-ii-attack-of-the-clones-2002.

Eco, Umberto. *Travels in Hyperreality: Essays*. Translated by William Weaver. San Diego, CA: Harcourt, 1986.

Erengis, George P. "Cedric Gibbons." *Films in Review* 16 (April 1965): 217–32.

Esperdy, Gabrielle. "From Instruction to Consumption: Architecture and Design in Hollywood Movies of the 1930s." *The Journal of American Culture* 30, no. 2 (2007): 198–211. https://doi.org/10.1111/j.1542-734X.2007.00509.x.

Failes, Ian. "*The Mandalorian* and the Future of Filmmaking." *VFX Voice: The Magazine of the Visual Effects Society*, April 1, 2020. https://www.vfxvoice.com/the-mandalorian-and-the-future-of-filmmaking/.

France, Van Arsdale. *Window on Main Street: 35 Years of Creating Happiness at Disneyland Park*. Nashua, NH: Laughter Publications, 1991.

Francaviglia, Richard V. *Main Street Revisited: Time, Space, and Image Building in Small-Town America*. Iowa City: University of Iowa Press, 1996.

Freitag, Florian. "'Like Walking into a Movie': Intermedial Relations between Theme Parks and Movies." *The Journal of Popular Culture* 50, no. 4 (2017): 704–722. https://doi.org/10.1111/jpcu.12569.

Friedberg, Anne. *The Virtual Window: From Alberti to Microsoft*. Cambridge, MA: The MIT Press, 2009.

———. *Window Shopping: Cinema and the Postmodern*. Berkeley: University of California Press, 1994.

Gabler, Neal. *Life—The Movie: How Entertainment Conquered Reality*. New York: Vintage Books, 2000.

Gaudreault, André, and Philippe Marion. *The End of Cinema? A Medium in Crisis in the Digital Age*. Translated by Timothy Barnard. New York: Columbia University Press, 2015.

Gebhard, David. "A Lasting Architecture," In *California Crazy: American Pop Architecture*, edited by Jim Heimann, 285–313. Köln: Taschen, 2018.

Gottdiener, Mark. *The Theming of America: Dreams, Media Fantasies, and Themed Environments, Second Edition*. Boulder, CO: Westview Press, 2001.

Gottwald, Dave. "Total Cinema, Total Theatre, Total World: From Set as Architecture to Set

as Virtual Performer." *Disegno—Journal of Design Culture* 6, no. 1 (December 2022): 12–32. https://doi.org//10.21096/disegno_2022_1dg.

———. "From Image as Place to Image as Space: Pinocchio, Pirates, and the Spatial Philosophy of the Multiplane Camera." *The International Journal of the Image* 12, no. 1 (2021): 71–93. https://doi.org/10.18848/2154-8560/CGP/v12i01/71-93.

Gottwald, Dave, and Gregory Turner-Rahman. "The End of Architecture: Theme Parks, Video Games, and the Built Environment in Cinematic Mode." *The International Journal of the Constructed Environment* 10, no. 2 (2019): 41–60. https://doi.org/10.18848/2154-8587/CGP/v10i02/41-60.

———. "Toward a Taxonomy of Contemporary Spatial Regimes: From the Architectonic to the Holistic." *The International Journal of Architectonic, Spatial, and Environmental Design* 15, no. 1 (2021): 109–127. https://doi.org/10.18848/2325-1662/CGP/v15i01/109-127.

Gregory, James. *Game Engine Architecture, Third Edition*. London: Taylor & Francis, 2018.

Heimann, Jim, ed. *California Crazy: American Pop Architecture*. Köln: Taschen, 2018.

Hench, John, and Peggy Van Pelt. *Designing Disney: Imagineering and the Art of the Show*. New York: Disney Editions, 2003.

Hoberman, J. *Film After Film: Or, What Became of 21st-Century Cinema?* Brooklyn, NY: Verso, 2013.

Holben, Jay. "*The Mandalorian*: This Is the Way." *American Cinematographer Magazine*, February 6, 2020. https://ascmag.com/articles/the-mandalorian.

Industrial Light & Magic. "The Virtual Production of The Mandalorian Season Two." Uploaded on April 1, 2021. YouTube video, 7:09. https://youtu.be/-gX4N5rDYeQ.

———. "The Virtual Production of The Mandalorian Season One." Uploaded on February 20, 2020. YouTube video, 4:42. https://youtu.be/gUnxzVOs3rk.

———. "ILM StageCraft." April 10, 2019. https://www.ilm.com/ilm-stagecraft/.

Insider. "Why 'The Mandalorian' Uses Virtual Sets Over Green Screen." Uploaded on June 11, 2020. YouTube video, 6:38. https://youtu.be/Ufp8weYYDE8.

Juul, Jesper. *Half-Real: Video Games between Real Rules and Fictional Worlds*. Cambridge, MA: The MIT Press, 2005.

Klein, Norman M. *The Vatican to Vegas: A History of Special Effects*. New York: New Press, 2004.

Klingmann, Anna. *Brandscapes: Architecture in the Experience Economy*. Cambridge, MA: The MIT Press, 2007.

Kokai, Jennifer A., and Tom Robson, eds. *Performance and The Disney Theme Park*

Experience: The Tourist as Actor. Cham, Switzerland: Palgrave Macmillan, 2019.

Krist, Gary. *The Mirage Factory: Illusion, Imagination, and the Invention of Los Angeles*. New York: Broadway Books, 2018.

Lonsway, Brian. *Making Leisure Work: Architecture and the Experience Economy*. London: Routledge, 2009.

Lukas, Scott A. *Theme Park*. London: Reaktion Books, 2008.

———, ed. *The Themed Space: Locating Culture, Nation, and Self*. Lanham, MD: Lexington Books, 2007.

Macfarland, J. H. "Architectural Problems in Motion Picture Production." *American Architect* 118 (1920): 65–70. https://archive.org/details/americanarchite118newyuoft.

Marling, Karal Ann, ed. *Designing Disney's Theme Parks: The Architecture of Reassurance*. Paris: Flammarion, 1997.

———. *As Seen On TV: The Visual Culture of Everyday Life in the 1950s*. Cambridge, MA: Harvard University Press, 1994.

Martin, Kevin H. "A New Hope." *International Cinematographers Guild Magazine,* February 3, 2020. https://www.icgmagazine.com/web/a-new-hope/.

Matthews, Peter. "The Innovators 1950–1960: Divining the Real." *Sight & Sound* 9, no. 8 (August 1999). https://www2.bfi.org.uk/news-opinion/sight-sound-magazine/features/andre-bazin-divining-real-film-criticism-overview.

McLuhan, Marshall, and Quentin Fiore. *The Medium Is the Massage: An Inventory of Effects*. Berkeley, CA: Gingko Press, 2001.

Mitrašinović, Miodrag. *Total Landscape, Theme Parks, Public Space*. London: Routledge, 2006.

Mittermeier, Sabrina. *A Cultural History of the Disneyland Theme Parks: Middle Class Kingdoms*. Bristol: Intellect Books, 2021.

Moore, Charles, Peter Becker, and Regula Campbell. *The City Observed: Los Angeles – A Guide to Its Architecture and Landscapes*. New York: Vintage Books, 1984.

Nitsche, Michael. *Video Game Spaces: Image, Play, and Structure in 3D Worlds*. Cambridge, MA: The MIT Press, 2008.

Pearce, Celia. "Narrative Environments: From Disneyland to World of Warcraft." In *Space Time Play: Computer Games, Architecture and Urbanism: The Next Level*, edited by Friedrich von Borries, Steffen P. Walz, and Matthias Böttger, 200–205. Basel: Birkhäuser, 2007.

Pierce, Todd James. *Three Years in Wonderland: The Disney Brothers, C.V. Wood, and the Making of the Great American Theme Park*. Jackson: University Press of Mississippi, 2016.

Pine, B. Joseph, and James H. Gilmore. *The Experience Economy: Competing for Customer Time, Attention, and Money*. Boston: Harvard Business Review Press, 2019.

Ramírez, Juan Antonio. *Architecture for the Screen: A Critical Study of Set Design in Hollywood's Golden Age*. Translated by John F. Moffitt. Jefferson, NC: McFarland Press, 2004 (1986).

Seymour, Mike. "Mandalorian Season 2 Virtual Production Innovation." *fxguide*. February 10, 2021. https://www.fxguide.com/fxfeatured/mandalorian-season-2-virtual-production-innovations/.

Sung, Kelvin, Peter Shirley, and Steven Baer. *Essentials of Interactive Computer Graphics: Concepts and Implementation*. Wellesley, MA: A K Peters, 2008.

Thompson, Anne. "Jon Favreau's VFX Master: Why 'The Jungle Book' Will Win the Only Oscar It Can Get." *IndieWire*, February 20, 2017. https://www.indiewire.com/2017/02/the-jungle-book-vfx-rob-legato-oscars-2017-1201785243/.

Unreal Engine. "Real-Time In-Camera VFX for Next-Gen Filmmaking | Project Spotlight | Unreal Engine." Uploaded on August 1, 2019. YouTube video, 2:14. https://youtu.be/bErPsq5kPzE.

Whitlock, Cathy, and The Art Directors Guild. *Designs on Film: A Century of Hollywood Art Direction*. New York: It Books, 2010.

Wiley, G. Harrison. "The House That Jack Builds." *Motion Picture Director* 2, no. 6 (1926): 37–39. https://archive.org/details/motionpicturedir4240moti.

Wolf, Mark J.P. "Video Games, Cinema, Bazin, and the Myth of Simulated Lived Experience," *Game: The Italian Journal of Game Studies* 4, no. 1 (2015): 15–24. https://www.gamejournal.it/wolf_lived_experience/.

Ziegler, Carl A. "Architecture and the Motion Picture." *The American Architect* 119, no. 2367 (May 11, 1921): 543–49. https://archive.org/details/tamericanarchitec119newyuoft.

Making Sense of Virtual Heritage

How Immersive Fitness Evokes a Past that Suits the Present

Johan Höglund and Cornelius Holtorf

Immersive Fitness and The Trip

Immersive fitness is an emerging technology that transforms physical exercise through virtual experiences provided for gym users. Some of these experiences draw on representations of cultural heritage. An illustrative example of this merger between cultural heritage and immersive fitness is the international exercise company Les Mills' *The Trip*,[1] which provides an immersive and multimodal fitness regime where participants ride stationary bicycles in front of a large, domed screen where a road winds through a computer-generated landscape that is projected as a motivational aid. Exercisers ride through alleys of Greek sculptures, around futuristic Egyptian pyramids, or through a pirate ship at the bottom of the ocean, in many cases referencing popular clichés of cultural heritage from around the world.

1. The global company Les Mills was named after its 1968 founder in Auckland, New Zealand. *The Trip* was co-created by Les Mills Jr. and Adam Lazarus, originating from an idea they had in 2012. The films came to be produced by the design studio Darkroom and the ride experience was originally designed by the production company Crossworks Project employing multiple, purpose-built projectors and large screens. For the underlying gym and fitness culture in the company Les Mills, see Jesper Andreasson and Thomas Johansson, "'Doing for Group Exercise What McDonald's Did for Hamburgers': Les Mills, and the Fitness Professional as Global Traveller," *Sport, Education and Society* 21, no. 2 (2016): 148–165.

Whereas sports and health studies have looked at the relationship between immersive environments and effects on the body,[2] we investigate this new field via two other and related perspectives: one where we focus on how the heritage on display activates different gender and racial politics lodged in a long European history and another where we consider this heritage encounter in relation to a broader sense of time travel experienced by the embodied individual. Our analysis exemplifies how, through the "gamification of exercise"[3] in fitness centers across Sweden and elsewhere, heritage and the past acquire unexpected meaning and significance in the social context of physical exercise.

Immersive fitness is a concept that uses a range of regimes in which different visual and auditory technologies are employed to create the sense that an exercising individual is performing within a virtual environment. Some of the first Nintendo Wii game titles that debuted in 2006 featured virtual environments (winding roads, a tennis court, a boxing gym) used for exercise and physicality. Unique to the Wii console was its spatio-reactive, hand-held controllers which allowed players to virtually exist within and interact with the game environment. Most gaming consoles now offer similar immersive environments where physical movement in the real world translates into virtual movement in computer generated worlds. In commercial gyms, stair step machines and bikes often come equipped with monitors on which an external environment is projected, some allowing the user to compete with actual or computer-generated opponents. This technology, sometimes referred to as "exergames,"[4] thus

2. Jessica Francombe, "'I Cheer, You Cheer, We Cheer': Physical Technologies and the Normalized Body," *Television & New Media* 11, no. 5 (2010): 350–366; Marie Louise Adams, "Objectified Bodies and Instrumental Movement: What Might Merleau-Ponty Say about Fitness Tracking," in *Sport, Physical Culture, and the Moving Body: Materialism, Technologies, Ecologies*, eds. Joshua L. Newman, Holly Thorpe, and David L Andrews (New Brunswick, NJ: Rutgers University Press, 2020), 69–86.
3. As one observer put it, according to https://www.cnbc.com/2015/04/19/how-virtual-reality-will-get-you-in-shape.html.
4. Anna Lisa Martin-Niedecken and Elisa D Mekler, "The ExerCube: Participatory Design of an Immersive Fitness Game Environment," *Joint International Conference on Serious Games*, 2018.

creates an immersive and "gamified" fitness experience where users compete against virtual opponents within a virtual landscape. Current trends are toward virtual screens in the home or toward personalized VR headsets solutions.

The Trip is one of the most elaborate examples of gym-based immersive fitness that provides a shared cinematic experience. The films, each about forty minutes long, take the participants across a number of computer-generated, virtual, and themed environments inspired by historical narratives, movies, live concerts, and interactive games.[5] These can be jungle landscapes; undersea vistas with sharks, jellyfish, and pirate ships; science fiction worlds where you race spaceships or flying motorcycles; or impossibly long, steep, and vertigo-inducing bridges reaching up into a starry sky. The journey through these spaces is accompanied by directions from an instructor and by a continuous motivational soundscape—some of it produced specifically for Les Mills and some of it covering existing songs. Through intense intervals shifting between fast pedaling with little resistance and virtual steep climbs with very high resistance, the participants work up their heart rates. By controlling the resistance of the bikes, participants can control how strenuous the session becomes, thus adapting it to their own physical status.

Research suggests that this format is motivational and that participants exert themselves to a higher degree than they realize. According to a limited study performed by Les Mills on twelve fitness participants, the audio-visual experience and its immersive qualities enhanced the fitness experience of novice exercisers.[6] As the website boasts, "where the mind goes, the body will follow."[7]

5. https://www.lesmills.com/workouts/fitness-classes/the-trip/.
6. Jinger S. Gottschall and Bryce Hastings, "Immersive Cycling Environment Yields High Intensity Heart Rate Without High Perceived Effort In Novice Exercisers," *Medicine & Science in Sports & Exercise* 49, no. 5S (2017): 223, https://doi.org/10.1249/01.mss.0000517458.24189.cc.
7. https://www.lesmills.com/workouts/fitness-classes/the-trip/.

The Trip films take the participants through complex and elaborately designed virtual architecture that mixes strikingly picturesque and sometimes strangely metamorphosing cityscapes with semi-realistic natural vistas. While virtual humans can sometimes be seen, especially during the opening sequences of each session, they are otherwise rare during the actual exercise. The entire class is multimodal and performative in the sense that music and directives from the instructor accompany the visual and bodily experience.[8] The digital technology allows for a precise coordination of the physical exercise with the music and the virtual geography so that drops or rises in the rider's pulse match drops or rises in the musical beat and the virtual landscape, enhancing the immersive experience by building anticipation and motivating the rider to up their heart rate.[9]

A crucial element in many *The Trip* films is cultural heritage connected to past- or futurescapes. In other words, the virtual worlds travelled through are connected to the architecture of actual or imagined past or future periods, especially as this architecture and these periods have been imagined in literature, comics, cinema, and games. *The Trip 15: Amarna* thus takes the participant through Ancient Egyptian architecture and mixes contemporary tourism-related spaces with Egyptomania and futuristic scenery. *The Trip 16* takes place in a modernist American cityscape—complete with skyscrapers, trains, park landscapes, and gardens—while *The Trip 22* is an Orientalist presentation of "Arabian" architecture and North African landscapes mixed with fantasy futurism. In all cases, the films are accompanied by a wide range of modern music including funk, hip-hop, pop, trance, techno, and world music. At times, the soundscape thematically matches the visuals referenced. In *The Trip 23,* a journey through

8. Jørgen Bruhn and Beate Schirrmacher, "Intermedial Studies," in *Intermedial Studies: An Introduction to Meaning Across Media*, eds. Jørgen Bruhn and B. Schirrmacher (London and New York: Routledge, 2022), 3–27.
9. https://www.lesmills.com/nordic/fit-planet/fitness/the-trip-part-2/.

a hilly and verdant landscape with mostly African animals, is accompanied by clearly African-inspired world music. However, as we discuss below, the soundtracks may also furtively problematize normative narratives connected to specific cultural heritages.[10]

Empirical Study

Our first encounter with the material took place at a gym during an exercise class. At this gym, we were able to study the generated auditory and visual content of this virtual gym space as it was traversed by us and other participants. This participant observation made it possible to consider the relationship between this immersive environment and the collective physical exercise performed within it. This field study was conducted on March 9, 2020 at a gym in Kalmar, Sweden. The makeup of the class was not homogenous, but the majority of the participants were white, between the ages of twenty-five and fifty, and female. The room in which the class took place is purpose-built for this specific format with exercise bikes on a staggered platform facing a large, domed screen. When everyone was seated, the instructor dimmed the lights and began the presentation. The volume of the soundtrack was turned up and the actual exercise session began. Most participants in the class leaned to the right and left when the road meandered downhill, and the instructor encouraged such participatory and immersive behavior. At the end of the class, we were wet with perspiration and experienced the rush that comes from the release of natural endorphins. When the lights were turned up and participants left the studio, there was a sense of "runner's high" in the air from instructor and participants alike.

10. A list of all the music that accompanies the soundscapes in the various *The Trip* releases can be found here: https://seesaawiki.jp/tracklist/d/THE TRIP. *The Trip 14* contains a total of ten songs, but in this chapter we will consider only the first three songs.

To study the virtual and multimodal space in more detail, we also made use of the Les Mills website where *The Trip* films can be accessed online. This made it possible to examine the virtual environments and soundscapes in considerable detail. The detailed analysis of the images and the music was conducted over a longer period of time, during which we repeatedly watched and listened to the films on the computer screen.

The Cultural Heritage Aesthetics of Les Mills

All *The Trip* films begin with a relatively slow sequence during which the participants warm up but also get acquainted with the themed environment of the film. In *The Trip 14: Kairos*, this is initially an island with a sprawling abundance of white houses with blue roofs and balconies, red bougainvillea flowers climbing up the walls, and the characteristic bell towers of Greek Orthodox churches. The houses and a bright low sun reflect on the road, and to the participant's right, the sea can be gleaned (see image 3.1).

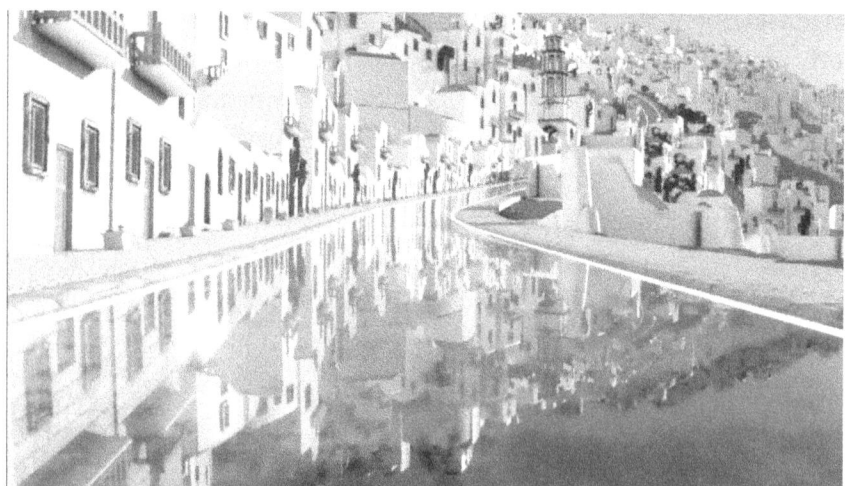

Image 3.1. *Virtual Greece at the beginning of the journey (screenshot from the film).*

Most participants will instantly identify the architecture as stereotypically Greek. The virtual environment references postcard depictions of Santorini and romanticized popular culture representations as seen in the film *Mamma Mia* (2008). This initial stage of the journey is accompanied by a sped-up version of Anderson .Paak's laid-back soul pop song "Off The Ground" which opens with the following lyrics:

> If it's really what you needed, love
> Baby, this right here's a one of one
> But you can get this hit whenever you want
> So here you are now
> And it's on now
> And it's on right now[11]

With this encouragement to stay in the moment, the participants travel through this empty, urban space towards a steep, downhill slope where the shining road drops down to ocean level, steering the participants towards another island topped by ruins of Greek temples and surrounded by enormous stone sculptures partially submerged into the sea. The road snakes into an underground cavern where other enormous stone faces can be seen, and, from there, the participants climb up into a landscape of imaginative classical architecture with numerous stone columns. Finally, the riders reach a plateau with revolving Greek statues, some of which are instantly recognizable and reappear throughout the video. They include the Doryphoros of Polykleitos, the Discobolus of Myron, the Apollo Belvedere by Leochares, and the Venus de Milo (see image 3.2).

11. The complete lyrics to this song can be found here: https://genius.com/Anderson-paak-off-the-ground-lyrics.

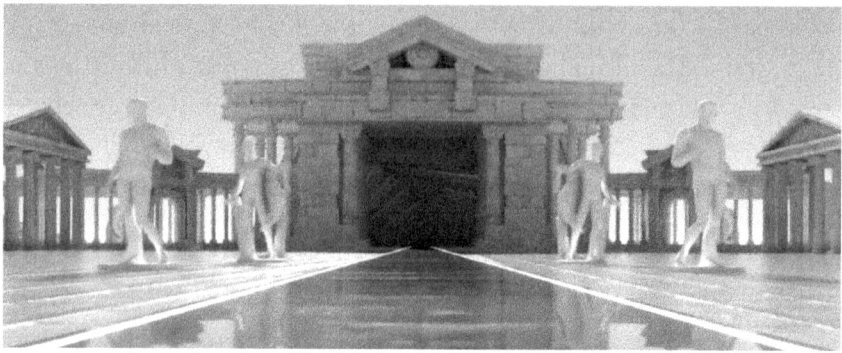

Image 3.2. *Ancient Greek architecture and statues (screenshot from the film).*

Further into the ride, participants enter a tunnel-like space where pentagonal walls seem to move and revolve around the road, possibly resembling geometrical shapes induced by psychedelic drugs such as LSD. This transition is accompanied by the irregular rhythms of alt-J's "Fitzpleasure," with absurdist lyrics that match the surreal behavior of the architecture.[12] The tunnel eventually opens up to a built indoor environment with many decorated arches and more sculptures, growing increasingly unreal.[13] When the participants make it out of the tunnel, the soundscape shifts to M.I.A.'s ska-influenced afro-punk "Double Bubble Trouble" whose lyrics tell the participants that, "UH OH you're in trouble."[14] This is a fitting auditory cue since the laws of physics now seem to have been suspended, presenting the participants with an even more surreal virtual world incorporating details of modern Greek architecture (see image 3.3).

12. The full lyrics can be found here: https://genius.com/Alt-j-fitzpleasure-lyrics.
13. The creators of this refer to such surreal consequences in *The Trip* films as going down "The Rabbit Hole." See: https://www.lesmills.com/nordic/fit-planet/fitness/the-trip-part-2/.
14. Full lyrics can be found here: https://genius.com/Mia-double-bubble-trouble-lyrics.

Image 3.3. Traveling through a surreal heritage landscape (screenshot from the film).

Houses now hang or grow from intersecting cobblestone roads, and during recuperative lulls in the exercise, the buildings swerve around their own axes, like clockwork. While still Greek, the environment is also reminiscent of the precise yet surreal and labyrinthine worlds created by Dutch artist M.C. Escher in paintings such as *Relativity* (1953). Eventually, the Greek architecture becomes completely detached from its stone foundations and revolves, free of gravity, in geometrical constellations around the participants.

The participants make their way through this imaginary environment and begin to climb a road into the sky, surrounded by flower garlands and balloons. The path meanders through another village and more revolving geometrical shapes, followed by a passage through abstract tunnels submerged under water, until the participants eventually again encounter enormous Greek sculptures, this time projected onto a shifting, pulsating, night-time universe (see image 3.4).

Image 3.4. Greek statues in space (screenshot from the film).

Toward the end of the session, after some more stretches dominated by moving geometrical patterns, the participants enter a free-floating, miles-long road constructed out of fantastical Classical architecture with many arches and pillars, flanked by hundreds of the same sculptures as seen before (see image 3.5).

Image 3.5. Framed by ancient Greek statues depicting Aphrodite (screenshot from the film).

Some of the same themes and shapes reoccur until the participants reach another assemblage of fanciful Classical architecture intermixed with sculptures and some olive trees before, at the very end, the world reshapes into something very similar to what the participants traveled through at the beginning of the class.

Traveling the Politics of Cultural Heritage

The idea of including Classical art and architecture as part of the scenery of a Greek island provides the participants with visual cues capable of distracting them from the sense of increasing exhaustion, thus continue the strenuous exercise. Even so, the imagery, like the lyrics of the songs playing in the background, does locate the participants in relation to specific cultural heritages and allows them to identify narratives related to this heritage. It can thus be argued that when the participants travel virtually through the Greek landscape, Ancient Greek architecture, and rows of animate buildings and sculptures, they also move through a series of widely admired and normative representations of the human body and through a similarly celebrated, if highly problematic and complex, ancient history.

While contemporary fitness culture emphasizes health and often tries to make such exercise fun,[15] physical appearance remains a primary pursuit. Indeed, as Roberta Sassatelli[16] argues, modern fitness gyms are essentially institutions that commodify the pursuit of a fit body. When *The Trip* is viewed as an element designed to assist in the creation of this body image, the representation of bodies within the virtual world comes into focus. The way that bodies are imagined and produced in modern gym culture has been the focus of significant scholarship, from Kenneth R. Dutton and Alan Klein's studies of masculinity and body building to Jesper Andreasson, Thomas Johansson, Anne Bolin, and Jane Granskog's more recent investigations of gender in the modern gym.[17] Much of this work understands the gym as a "venue for the construction of particular

15. Christina Hedblom, "'The Body is Made to Move': Gym and Fitness Culture in Sweden" (PhD diss., University of Stockholm, 2009).
16. Roberta Sassatelli, *Fitness Culture: Gyms and the Commercialisation of Discipline and Fun* (New York: Springer, 2010).
17. See Kenneth R. Dutton, *Perfectible Body: The Western Ideal of Male Physical Development* (New York: Continuum, 1995); Alan M. Klein, *Little Big Men: Bodybuilding Subculture and Gender Construction* (New York: State University of New York Press, 1993); Jesper Andreasson and Thomas Johansson, *The Global Gym: Gender, Health and Pedagogies* (Basingstoke: Palgrave Macmillan, 2014); and Anne Bolin and Jane Granskog, *Athletic Intruders: Ethnographic Research on Women, Culture, and Exercise* (New York: State University of New York Press, 2003).

gender identities."[18] In *The Trip 14*, the sculptures of three men and one woman are present throughout the visual experience. The digital nature of this world allows these sculptures to be reproduced ad infinitum. This means that they can be made to surround the participants and become moving walls, or they can be scaled-up into enormous entities that appear like towers. In this way, the sculptures can be said to merge with the architecture.

When the statues become part of the architecture of this virtual space, they also gender and politicize this architecture in ways that need to be considered. Two of the male sculptures are involved in athletic pursuits and the third is the god Apollo, standing erect with one arm raised. The female sculpture is of Aphrodite, the goddess of love and fertility, but unlike the male sculptures, this statue lacks arms and her posture does not signal strength or determination. Her physical appearance is, as a result, much less radiant and motivational in physical terms.[19] The comparative marginal presence of the female figure centers the white and athletic male sculptures and the idealized masculinity they represent. This masculinity, in turn, has a specific political and affective cultural heritage. These sculptures of athletic and powerful male figures have been embraced by a series of cultures and societies and they have been used to invest these cultures with certain content. The Romans were the first to admire the portrayal of the human body as it appeared in Greek sculptures. Indeed, most of these sculptures exist today only as Roman copies. In Renaissance Italy, sculptors produced bodies very similar to the Greek ideal, with Michelangelo's *David* as one of the most admired examples. As George Mosse[20] has shown, these sculptures were also central to the invention of what he refers to as "modern masculinity" that began to take form in Europe during the eighteenth and nineteenth cen-

18. Thomas Johansson, "Gendered Spaces: The Gym Culture and the Construction of Gender," *Young* 4. no. 3 (1996), 32.
19. The use of the armless Aphrodite as the single female figure does raise questions, especially as there are Greek statues of Athena that could have been used instead. Also, because the world of *The Trip* is virtual, it would have been possible to provide the statue of Aphrodite with arms and legs, just like how the architecture is restored in some of the spaces the participants move through.
20. George L. Mosse, *The Image of Man: The Creation of Modern Masculinity* (Oxford: Oxford University Press, 1998).

turies. In the early twentieth century, this white, muscular, and modern masculinity became part of a larger body cult in many European nations and in parts of the world controlled by European nation states. The most studied example from the 1920s and 1930s is perhaps in Germany where these statues were central to the construction of an imagined white, Aryan body against which a similarly imagined Jewish body could be produced.[21] However, the same type of body also became central to masculinity in many other nations. The point here is that when the participants move—in the pursuit of a fitter and better body—past row upon row of Greek statues, they also move through an idealized masculinity and across the specific heritage informed by it that has been shaping the fitness movement to the present day.[22]

The strange appearance of Ancient Greek art and architecture in *The Trip 14* is a visualization of this cultural heritage, of the idealized masculinities associated with it, and perhaps even of the types of statehood it has been used to legitimize. By moving through this virtual world, the participants thus also move through a complex and multilayered gendered and politicized context. This does not necessarily mean that participants internalize this landscape. While the sculptures are treated with a certain respect—they are copied, multiplied, enlarged, and made to revolve around their own axes, yet their bodies are never changed—their movement, like the movement of all architecture in the virtual workout experience, is absurd. The appearance of thousands of copies revolving like clockwork dismantles some of their iconic status and thus their potential and meaning as works of arts and as gendered and politicized icons. Frequently removed from the pedestal, they often appear more like bricks in a strange and moving wall than as objects of a normative artistic tradition.

21. Daniel Wildmann, "Desired Bodies: Leni Riefenstahl's Olympia, Aryan Masculinity and the Classical Body," In *Brill's Companion to the Classics, Fascist Italy and Nazi Germany*, eds. Helen Roche and Kyriakos N. Demetriou (Leiden: Brill, 2017), 60–81.
22. Ronny Trachsel, "Fitness und Körperkult. Entwicklungen des Körperbewusstseins im 20. Jahrhundert," In *Fitness. Schönheit kommt von aussen*, eds. Andreas Schwab and Ronny Trachsel (Bern: Palma-3-Verlag, 2003), 13–34.

The role that the music plays further problematizes any easy identification by the participants with the potentially conservative messages of the heritage portrayed in the film. While the cultural heritage that *The Trip 14* displays has in the past been folded into a politics where masculinity and whiteness are central, many of the songs that are part of the soundscape critically interrogate precisely these hegemonic categories. The best, but not only, example of this is British Sri-Lankan M.I.A.'s "Double Bubble Trouble." This is a fundamentally subversive song that, as the artist's own music video makes clear, explores friendships, drugs, gang violence, 3D printed guns, and the surveillance state as experienced by young people of color in the margins of UK society.[23] While the casual fitness participant unfamiliar with M.I.A.'s music may not pick up on the subversive nature of the lyrics, those who know her songs and who are aware of her politically radical position will likely be struck by the collision between the visual imagery and this particular soundscape. In this way, the normative and potentially conservative Greek cultural heritage presented in, but also manipulated by, the visual component of *The Trip* collides and merges with disruptive and agitational music associated with critical thinking and political engagement. Thus, this *The Trip* experience can be said to furtively explore the critical and democratic aspects that are also a heritage of classical antiquity.

Time Traveling in The Trip

While it is important to note the political dimension that the multimodal journey through a surreal ancient Greece in a modern soundscape activates, *The Trip 14*'s potential subversion of the heritage it employs in order to build motivation facilitates a different yet complementary experience. Whereas our earlier discussion related specifically to *The Trip 14* and connotations of certain themes of Classical Antiquity—with other trips having different themes and connotations that might deserve a

23. This self-directed video was initially censored by M.I.A.'s record label: https://www.theguardian.com/music/2014/may/20/mia-the-partysquad-double-bubble-trouble-video-watch.

critical discussion elsewhere—the following discussion can be related to all virtual workout experiences that immerse riders into environments incorporating cultural heritage, whether this is Ancient Egypt (*The Trip 15*), Arab North Africa (*The Trip 22*), or modern America (*The Trip 16*).

The immersive fitness regime of *The Trip* offers the rider a kind of time traveling experience that can be understood in relation to existing scholarship on the *Experience Economy* and various contemporary practices of engaging with the past.[24] Whereas the past has long been studied in cerebral ways, whether in its own right (for example on the historical significance of Classical Antiquity) or with the aim of political critique in contemporary society (for example on the consequences of some perceptions of Classical Antiquity), different forms of time traveling that abound in popular culture offer a fundamental alternative. They provide the participating individuals with embodied and sensual engagements with the past that supplement more established knowledge-oriented and critical approaches.[25]

Time travel experiences are most commonly directed "backwards" rather than "forwards" along the commonly imagined arrow of time stretching from the past to the future. Ranging from living history and historical re-enactment to movies, computer games, and themed environments set in the past, such time travels can be analyzed along different axes (see image 3.6). One dimension is the degree of lived experience and sincere transformation as opposed to playfulness and enjoyable imitation, the other the degree of collectivity versus individuality involved in practice.[26] Most forms of time travel combine different aspects. Immersive fitness rides, as discussed in the present chapter, combine the realms of playful imitation and sensual stimuli affecting some degree of transformation

24. See B. Joseph Pine II and James Gilmore, *The Experience Economy*, 2nd ed. (Boston: Harvard Business Review Press, 2011); Bodil Petersson and Cornelius Holtorf, eds., *The Archaeology of Time Travel: Experiencing the Past in the 21st Century* (Oxford: Archaeopress, 2017); and Cornelius Holtorf, "The Past as Carnival," review of *Die Stämme von Köln*, directed by A. Dreschke, 2010, *Time and Mind* 5, no. 2 (2012): 195–202.
25. Cornelius Holtorf, "Introduction: The Meaning of Time Travel," in *The Archaeology of Time Travel: Experiencing the Past in the 21st Century*, eds. Bodil Petersson and Cornelius Holtorf, (Oxford: Archaeopress, 2017), 4–9.
26. Holtorf, "Introduction: The Meaning of Time Travel," 12–13.

with a strong emphasis on individual enjoyment, albeit they assemble in a group. The riders consume the past (and occasionally the future) as a joyful but superficial backdrop of their trip, drawing on well-known clichés rather than on much (if any) historical research and scholarship (see image 3.6).

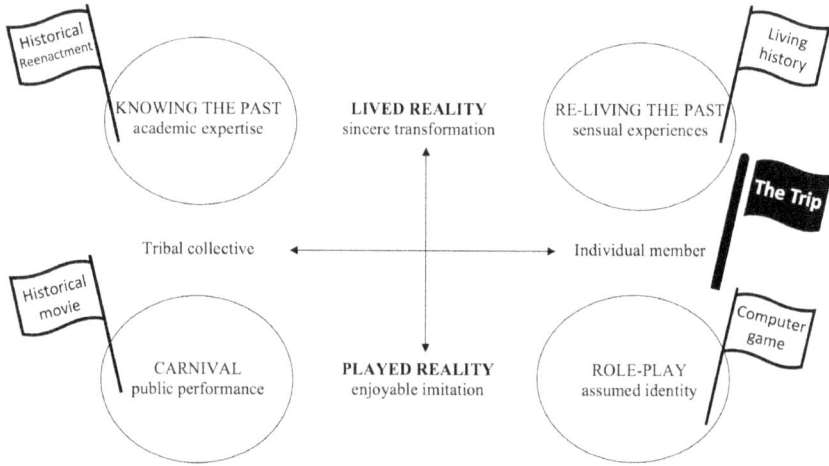

Image 3.6. A framework for understanding contemporary time travel and its various dimensions. Credit: Cornelius Holtorf, adapted from Holtorf, "Past as Carnival."

Many time traveling experiences, such as those provided by *The Trip*, are very accessible and do not rely on particular mental abilities or educational achievements. This is because, from the perspective of the participants, such experiences are fully embodied, witnessed with various senses, and generally multimodal. In the case of *The Trip*, the perception of traveling through different times and spaces is visceral because, as you are exercising, you are in motion and fully focused on sensual impressions. Evidently, these perceptions impact riders and enhance their fitness experience by making the workout more enjoyable and reducing the perceived intensity of the exercise session.[27] As we see it, this is not so much a stimulated mind pulling along a reluctant body as it is the combined outcome of mind, senses, and body stimulating each other.

27. Gottschall and Hastings, "Immersive Cycling."

A central aspect of many time travels and the key for effective immersion in any context is successful storytelling. As Scott Lukas puts it, "story is what holds a space together by linking elements, creating situations, establishing moods, and involving guests."[28] In fitness rides, the story is minimalistic, inviting participants on a solo bicycle trip through space and time. But the screen provides only the scenery for the real storyline that unfolds on each stationary bike where the rider is the hero fighting against a lack of motivation to exercise and their growing fatigue, eventually reaching the goal successfully and returning home with glory. In that sense, successful time travel and immersion can lead to physical and mental well-being. Arguably, through time travel experiences seemingly offering transportation to another time period, participants find health, purpose, and satisfaction in their present lives, and thus a bit of themselves they previously found they were lacking.[29]

From a cultural heritage perspective, it is worth adding that such transportation and time travel experiences are enabled by the presence of pastness, i.e., the perceived quality of something to be of the past (assuming the travel went "backwards" in time). Perceived pastness relies on several factors including the participants meeting their expectations about the past and the existence of a plausible storyline connecting then and now.[30] What people may or may not expect of the past or consider a plausible storyline is influenced by many social factors including upbringing, formal education, and popular culture. It is also possibly contentious, and therefore a legitimate object of critique (as exemplified in our earlier analysis of *The Trip 14*). Immersive fitness environments let us appreciate the power that lies in perceived pastness.

28. Scott A. Lukas, *The Immersive Worlds Handbook: Designing Theme Parks and Consumer Spaces* (New York and London: Focal, 2013), 155.
29. Holtorf, "Past as Carnival."
30. Cornelius Holtorf, "The Presence of Pastness: Themed Environments and Beyond," in *Staging the Past: Themed Environments in Transcultural Perspectives*, eds. Judith Schlehe, Michiko Uike-Bormann, Carolyn Oesterle, and Wolfgang Hochbruck (Bielefeld: Transcript, 2010), 23–40; Cornelius Holtorf, "Changing Concepts of Temporality in Cultural Heritage and Themed Environments," in *Time and Temporality in Theme Parks*, eds. Filippo Carlà-Uhink, Florian Freitag, Sabrina Mittermeier, and Ariane Schwarz (Hannover: Wehrhahn, 2017), 115–130.

Cultural Heritage and Immersive Fitness

In this chapter, we have discussed how cultural heritage transforms and operates within an immersive physical exercise workout. This transformation affects the individual riding a stationary bike through imaginary scenarios, but it also has larger ramifications in society. Whereas many healthy individuals are good for society as well, there is a collective dimension in which some underlying issues and values need to be problematized.

We noted first that immersive fitness, like cultural heritage, has both tangible and intangible dimensions. It relies on our senses, emotions, and perceptions while inherently relating to a stationary bike in a purpose-built fitness room, bodily effort, and increasing exhaustion. While enhancing physical and mental well-being, experiencing *The Trip* at a gym may also affect our values. Virtual heritage and heritage IRL are intimately connected, both in the perceptions of the individual, where sometimes they may be difficult to distinguish, and in their impact on society. With this in mind, it must be noted that *The Trip* uses various stereotypical representations of cultural heritage warranting a critical analysis of its ethics and politics. The way that ancient art and architecture are leveraged in *The Trip* may seem naïve and inconsequential, but it is hardly without consequence. In particular, the evocation, in a performative fitness context, of a certain (male) white body as represented and immortalized by Greek sculptures locates the participants in relation to a certain cultural heritage, and thus also to the way that this cultural heritage has been negotiated by more than 2,000 years of European and global history. By traveling through a virtual and immersive world made up of Greek cultural artifacts and architecture, the participants are also moving through ingrained and idealized ideas about masculinity and race. This does not mean, as we have argued, that these ideas are automatically internalized by the participants. The often-surreal playfulness of the visual experience and the sometimes-subversive music that accompanies the images can

potentially inspire participants to question these ideals and the role they have played for different national and imperial histories. To determine this precise effect, a much more substantial and empirical study than the one we conducted is needed.

We also propose that time traveling experiences evoking, for example, Ancient Greece and relying on pastness transform the experience of individual participants in fitness workouts. This can be related to fast-emerging multimodal technologies that revolutionize how cultural heritage affects people's experiences. For example, the Atelier des Lumières—an immersive art center which opened in 2018—uses a large number of projectors and powerful speakers in a largely empty, formerly industrial space in central Paris to surround freely-wandering visitors with imagery, music, and narration about artists such as Van Gogh, Gaudí, and Dalí.[31] These exhibitions do not use any original artifacts, but they succeed in providing large audiences with sensually mind-blowing experiences about art and heritage deriving from fast-emerging digital technologies. Although the approach is populistic and commodifies the fame of celebrity artists, it also provides feel-good experiences for many people—even without any physical workout.

These kinds of experiences have some profound implications and potential in the context of cultural heritage, a field now widely aspiring to be people-centered.[32] In particular, it may be that for cultural heritage to make a transformative impact on people and their life-worlds in the age of VR, we need to rethink key heritage concepts such as age-value and authenticity. Maybe the point of taking care of cultural heritage today is not to facilitate mental reconstructions of the past, drawing on original fabric appreciated for its age. Maybe it is to bring about powerful stories using state-of-the-art, multimodal techniques, to touch and inspire peo-

31. https://www.atelier-lumieres.com/en/home.
32. Sarah Court and Gamini Wijesuriya, "People-Centred Approaches to the Conservation of Cultural Heritage: Living Heritage," *ICCROM* (2015): 1–9, https://www.iccrom.org/sites/default/files/PCA_Annexe-2.pdf.

ple in the present. However we turn and twist it, the fact remains that when we "see" the past, we see something that is not actually there. The interesting question is therefore not which pasts we may have lost, but which pasts can be brought to life and what that means to us.[33]

It is evident that immersive fitness evoking cultural heritage and the past is not simply a curious and historically (somewhat) misinformed kind of escapism but rather the manifestation of an increasingly widespread and powerful cultural trend facilitated by emerging technologies. Different kinds of themed environments are challenging habits and assumptions about the world we inhabit.[34] These environments are increasingly virtual in one way or another, and they deserve thorough attention. Such attention should consider the perspective of individuals who navigate through imaginary pasts that impact on their well-being and their thinking about the present, and how new ways of being a citizen emerges out of the risks and opportunities connected to these different pasts. In all these ways, uses of cultural heritage and the creation of time travel experiences in emerging multimodal contexts ask us to navigate through ancient landscapes that are ultimately not about the past but about the future.

Acknowledgments

For suggestions and critical comments on a penultimate draft of this text we are grateful to our colleagues Karin Hallgren, Leila Papoli-Yazdi, and Emily Hanscam, and Jesper Andreasson.

33. See Holtorf, "Presence of Pastness," 26; Holtorf, "Changing Concepts," 125–127; and Cornelius Holtorf, "Perceiving the Past: From Age Value to Pastness," *International Journal of Cultural Property* 24, no. 4 (2017): 497–515.
34. See Judith Schlehe, Michiko Uike-Bormann, Carolyn Oesterle, and Wolfgang Hochbruck, eds., *Staging the Past: Themed Environments in Transcultural Perspective* (Bielefeld: Transcript, 2010); Filippo Carlà-Uhink, Florian Freitag, Sabrina Mittermeier, and Ariane Schwarz, eds., *Time and Temporality in Theme Parks* (Hannover: Werhahn, 2017); and Petersson and Holtorf, "Time Travel."

Bibliography

Adams, Marie Louise. "Objectified Bodies and Instrumental Movement: What Might Merleau-Ponty Say about Fitness Tracking." In S*port, Physical Culture, and the Moving Body: Materialism, Technologies, Ecologies*, edited by Joshua L. Newman, Holly Thorpe, and David L. Andrews, 69–86. New Brunswick, NJ: Rutgers University Press, 2020.

Andreasson, Jesper, and Thomas Johansson. *The Global Gym: Gender, Health and Pedagogies*. Basingstoke: Palgrave Macmillan, 2014.

———. "'Doing for Group Exercise What McDonald's Did for Hamburgers': Les Mills, and the Fitness Professional as Global Traveller." *Sport, Education and Society* 21, no. 2 (2016): 148–165.

Bolin, Anne, and Jane Granskog. *Athletic Intruders: Ethnographic Research on Women, Culture, and Exercise*. New York: State University of New York Press, 2003.

Bruhn, Jørgen, and Beate Schirrmacher. "Intermedial Studies." In *Intermedial Studies: An Introduction to Meaning Across Media*, edited by Jørgen Bruhn and B. Schirrmacher, 3–27. London and New York: Routledge, 2022.

Carlà-Uhink, Filippo, Florian Freitag, Sabrina Mittermeier, and Ariane Schwarz, eds. *Time and Temporality in Theme Parks*. Hannover: Werhahn, 2017.

Court, Sarah, and Gamini Wijesuriya. "People-Centred Approaches to the Conservation of Cultural Heritage: Living Heritage." *ICCROM* (2015): 1–9. https://www.iccrom.org/sites/default/files/PCA_Annexe-2.pdf.

Dutton, Kenneth R. *Perfectible Body: The Western Ideal of Male Physical Development*. New York: Continuum, 1995.

Francombe, Jessica. "'I Cheer, You Cheer, We Cheer': Physical Technologies and the Normalized Body." *Television & New Media* 11, no. 5 (2010): 350–366.

Gottschall, Jinger S., and Bryce Hastings. "Immersive Cycling Environment Yields High Intensity Heart Rate Without High Perceived Effort In Novice Exercisers." *Medicine & Science in Sports & Exercise* 49, no. 5S (2017): 223.

Hedblom, Christina. "'The Body is Made to Move': Gym and Fitness Culture in Sweden." PhD diss., University of Stockholm, 2009.

Holtorf, Cornelius. "The Presence of Pastness: Themed Environments and Beyond." In *Staging the Past: Themed Environments in Transcultural Perspective*, edited by Judith Schlehe, Michiko Uike-Bormann, Carolyn Oesterle, and Wolfgang Hochbruck, 23–40. Bielefeld: Transcript, 2010.

———. "The Past as Carnival." Review of *Die Stämme von Köln*, directed by A. Dreschke, 2010. *Time and Mind* 5, no. 2 (2012): 195–202.

———. "Changing Concepts of Temporality in Cultural Heritage and Themed Environments." In *Time and Temporality in Theme Parks*, edited by Filippo Carlà-Uhink, Florian Freitag, Sabrina Mittermeier, and Ariane Schwarz, 115–130. Hannover: Wehrhahn, 2017.

———. "Introduction: The Meaning of Time Travel." In *The Archaeology of Time Travel: Experiencing the Past in the 21st Century*, edited by Bodil Petersson and Cornelius Holtorf, 1–22. Oxford: Archaeopress, 2017.

———. "Perceiving the Past: From Age Value to Pastness." *International Journal of Cultural Property* 24, no. 4 (2017): 497–515.

Klein, Alan M. *Little Big Men: Bodybuilding Subculture and Gender Construction.* New York: State University of New York Press, 1993.

Lukas, Scott A. *The Immersive Worlds Handbook: Designing Theme Parks and Consumer Spaces.* New York and London: Focal, 2013.

Martin-Niedecken, Anna Lisa, and Elisa D Mekler. "The ExerCube: Participatory Design of an Immersive Fitness Game Environment." *Joint International Conference on Serious Games*, 2018.

Mosse, George L. *The Image of Man: The Creation of Modern Masculinity.* Oxford: Oxford University Press, 1998.

Petersson, Bodil, and Holtorf, Cornelius, eds. *The Archaeology of Time Travel: Experiencing the Past in the 21st Century.* Oxford: Archaeopress, 2017.

Pine II, B. Joseph, and Gilmore, James. *The Experience Economy*, 2nd edition. Boston: Harvard Business Review Press, 2011.

Sassatelli, Roberta. *Fitness Culture: Gyms and the Commercialisation of Discipline and Fun.* New York: Springer, 2010.

Schlehe, Judith, Michiko Uike-Bormann, Carolyn Oesterle, and Wolfgang Hochbruck, eds. *Staging the Past: Themed Environments in Transcultural Perspectives.* Bielefeld: Transcript, 2010.

Trachsel, Ronny. "Fitness und Körperkult. Entwicklungen des Körperbewusstseins im 20. Jahrhundert." In *Fitness. Schönheit kommt von aussen*, edited by Andreas Schwab and Ronny Trachsel, 13–34. Bern: Palma-3-Verlag, 2003.

Wildmann, Daniel. "Desired Bodies: Leni Riefenstahl's Olympia, Aryan Masculinity and the Classical Body." In *Brill's Companion to the Classics, Fascist Italy and Nazi Germany*, edited by Helen Roche and Kyriakos N. Demetriou, 60–81. Leiden: Brill, 2017.

The Theme Park Ride (In and of Itself) as a Cultural Form

An Investigation of Kinetics, Narrative, Immersion, and Concept

Scott A. Lukas

Introduction: The Meaning of the Ride

In July 1997, following my last months of employment as a training coordinator at Six Flags AstroWorld, I became aware of a horrible accident that took place at the theme park's Excalibur roller coaster. Due to management error related to an OSHA-required lockout/tagout procedure, a maintenance worker was struck and killed as the roller coaster was dispatched from the station.[1] The terrible incident became the subject of intense conversation among my AstroWorld social circle and the focus of multiple local and regional news cycles. The occurrence of a ride accident, whether resulting in injury or death, marks a curious and potentially informative context for the study of theme parks, generally, and rides, specifically. This particular study of the theme park ride begins with the ride accident as it illustrates the confluence of technology and culture, with all of its entailing contradictions and ambivalences. Since the time of my work as a training coordinator at AstroWorld, through the years of writing academic perspectives on theme parks, and now in

1. Scott A. Lukas, "The Theme Park and the Figure of Death," *InterCulture* 2, no. 2 (2005); OSHA, "Inspection Detail | Occupational Safety and Health Administration," *United States Department of Labor*, 1997, https://www.osha.gov/pls/imis/establishment.inspection_detail?id=123618464.

more contemporary periods of consulting for the themed- and immersive spaces industry, I have developed a perspective on theme park rides that balances their technological and cultural contexts with sensibilities developed from first-person or ethnographic perspectives as described by designers, operators, and theme park guests and fans, and even with constructions imagined from the vantage points of the rides themselves. As radical as it may sound to study the ride "in and of itself" as its own living, breathing, and conceptually salient entity, in an era in which the object of study has become known as a primarily superficial technological and amusement object, it is this research direction that is most necessary.

A "ride," etymologically dating to 1934, is defined as an "amusement park device," a definition which seems overly simplistic in terms of contemporary understandings of the term.[2] Rides include hundreds of types, ranging from iconic roller coasters, carousels, Ferris Wheels, dark rides, troikas (triple spinning rides), bumper cars, and drop rides, to more specific forms (denoted by a descriptive technological term or ride manufacturer name), including Waltzer, Tagada, UFO, orbiter, and helter skelter, among numerous others.[3] In contemporary times, this list has expanded to include rides that have a hybrid tendency in combining traditional amusement technology with video games, virtual and augmented reality, and multi-dimensional sensory designs. For all of the simplicity that is often attributed to them by academics and laypersons alike, the mere categorical and linguistic diversity of rides is an indication of the complex-

2. "Ride," *Online Etymology Dictionary*, https://www.etymonline.com/search?q=ride. It should be acknowledged that among theme park researchers there is general agreement that defining a ride—especially given its current status as a video game and VR-influenced entity—is a challenging undertaking. As well, it should be noted that researchers have suggested that there is a blurring that exists between the definition of a ride and that of an attraction, such as entertainment shows, performances, stunt shows, and the like. The hybridity of ride forms is recognized in the sections of this chapter that focus on film and video game influences.
3. Robert Cartmell, *The Incredible Scream Machine: A History of the Roller Coaster* (Bowling Green, OH: Amusement Park Books, 1987); Scott A. Lukas, *Theme Park* (London: Reaktion Books, 2008), 97–133; William Mangels, *The Outdoor Amusement Industry: From Earliest Times to the Present* (New York: Vantage, 1952); Sacha Szabo, *Rausch und Rummel: Attraktionen auf Jahrmärkten und in Vergnügungsparks. Eine soziologische Kulturgeschichte* (Bielefeld: transcript Verlag, 2015), https://doi.org/10.1515/9783839405666.

ity of the form being studied. Combining their technical and functional diversity with their relationship to theming, attraction design, and guest experience, we note that they are some of the most complex entities that exist in our amusement worlds.

This chapter develops a cultural understanding of the theme park ride—tracing the evolution of this technological, mechanical, and media form from its earliest instances at world's expositions and Coney Island amusement parks through its current transmediated and highly immersive examples. I chart the cultural, technological, and conceptual trajectories of the ride through an emphasis on four philosophical and conceptual eras: The Era of Kinetics (focusing on the machine), The Era of Narrative (emphasizing the influence of film on rides), The Era of Immersion (discussing the transformation of rides as video games), and The Era of the Transmechanical (in which the conceptual, existential, and transcendental contexts of rides are considered). Unlike chronological or historical epochs which consider such periods in their serial or evolutionary senses, the use of these eras is meant to focus the reader on conceptual, cultural, and methodological themes that have defined rides and that may allow future researchers opportunities for study that eschew the limited technological and consumerist foci often attributed to the research object.

The Era of Kinetics: Machine

One of the most seemingly profound descriptions of the amusement or theme park ride is that offered by technology—the material, engineered, and physics-based properties that appear to define numerous ride forms, especially the roller coaster. A brief perusal of the Internet using the search term "roller coaster" does not result in copious hits or results focused on operation and design, rather, a majority of results focus on the pleasures experienced on such rides and, most notably, the technical and scientific aspects of this iconic machine. One of the most common examples of the latter emphasis is a classroom activity that focuses on the

physics of roller coasters.[4] Such activities seek to meld students' interest in and excitement about roller coasters with the properties of engineering and physics, including speed, acceleration, and gravity, among other concepts. Related toys sold on Amazon, including the K'NEX Education STEM Explorations Roller Coaster Building Set, feature roller coaster cars without people, while other toys eschew cars for mere abstract marbles. Both toys, with their absent human riders, seem to suggest a disconnect of humans and pleasurable technology (if not a fear of it) as well as a need to reimagine the role, and indeed agency, of the roller coaster in the world as independent of human activity.[5] While it is understandable that the properties of physics evident in roller coasters should be the subject of awe, it is interesting to note that such a focus only solidifies the cultural construction of the roller coaster, and the ride more generally, as (primarily) an object of technology. As Heidegger warned, such a view of technology as an instrumental force of humans threatens to abnegate other meanings and constructions of our existence that may be imagined.[6]

In *The System of Objects*, Jean Baudrillard notes that "technicity calls forth systematic cultural connotation."[7] Not unlike Marx's description of a table that breaks free from its functional and material form to become a commodity object,[8] Baudrillard offers that technological objects eventually move beyond their functional or defined forms to become objects of culture, noted by their relationships to myth,[9] allegory, atmosphere, values, social forms, and even transcendence.[10] In terms of the ride, Baudrillard's emphasis on the transformative potential of material objects beyond their functionality or technology is quite significant. To return to the roller coaster, we note the object's intermingling with a cultural tension of technology and human experience. Our inability to see the

4. Louise Spilsbury and Richard Spilsbury, *Ride that Rollercoaster!: Forces at an Amusement Park* (Chicago: Heinemann, 2015).
5. Leo Marx, *The Machine in the Garden: Technology and the Pastoral Ideal in America* (New York: Oxford University Press, 2000).
6. Martin Heidegger, *The Question Concerning Technology and Other Essays* (New York: Harper & Row, 1996).
7. Jean Baudrillard, *The System of Objects* (London: Verso, 1996), 47.
8. Karl Marx, *Capital: A Critique of Political Economy, Volume 1* (New York: Vintage Books, 1977), 163.
9. Roland Barthes, *Mythologies* (New York: Hill & Wang, 2006).
10. Baudrillard, *The System of Objects*, 21, 47, 60, 79, 166.

roller coaster as anything other than its technological and engineering marvel suggests a psychological or existential gap between our enjoyment (*jouissance*) of the ride and its technological surplus. As Lacan, Žižek, and others have offered in terms of the *l'objet petit a*, there is a chasm that exists between ourselves and our experiences with the object at hand—the ride—and there is a certain symbolic surplus or excess that, though it escapes our understandings, makes for an apt focus for our analyses of the object.[11] As well, our inability to note the complexity of rides, as is the case with other machines and forms of technology in our world, results in our being unable to comprehend the complex energies and flows of such machines—whether these be technological, cultural, phenomenological, media-based, etc.—that provide opportunities for analyses of these forms of technology that eschew obvious meanings of function.[12]

Gazing at a machine like a roller coaster is, of course, a sight of incredible marvel. Iconic rides, including the Ferris Wheel, offer incredible alterations of human perspective for those riding, and they provide even those on the ground with a marvel to be witnessed.[13] The incredible visual and mechanical spectacles of rides like the roller coaster act as marketing opportunities for the contemporary theme park and as potential recruitment for park employees. Within the ride-training worlds of Six Flags AstroWorld, I became very familiar with the evocative semiotic mark that characterized the theme park ride. While some employees were hired on at the park to work in Grounds Quality or Security, many new hires said that they specifically wanted to work at AstroWorld in order to eventually become an operator of a roller coaster like the Texas Cyclone, Excalibur, or XLR-8. Within our training department, new employees underwent a general operations training that covered guest interaction strategies and

11. Jacques Lacan, *Ecrits: The First Complete Edition in English* (New York: Norton, 2006); Slavoj Žižek, *Looking Awry: An Introduction to Jacques Lacan through Popular* Culture (Cambridge, MA: The MIT Press, 2002).
12. Levi R. Bryant, *Onto-Cartography: An Ontology of Machines and Media* (Edinburgh University Press, 2014).
13. Steven Johnson, "Ferris Wheel: Scott A. Lukas and the History of Theme Parks," June 4, 2020, in *American Innovations,* produced by Wondery, podcast, 30:59.

OSHA safety procedures.[14] Following the operations training, employees did on-the-job training and shadowing at their ride location. After a specific period of training, the employees would return to our training center, and we would give them a quiz specific to each of the park's rides. For those training to become a CRA (Certified Ride Attendant), the training and quiz was much briefer than that related to CRO (Certified Ride Operator) training. A CRA was tasked with performing height checks, operating the unloading or loading platforms, and greeting guests and controlling queue lines at larger rides. The CRO was responsible for operating the ride, and their training included knowledge of a very lengthy (in some cases one-hundred pages or more) manual that covered all aspects of running the ride, including safety procedures and evacuations. At times, political dynamics related to decisions made by management in terms of which workers could train and become a CRO existed, especially for popular rides like the world-famous Texas Cyclone. As well, personal sensibilities about the perceived hierarchy in the park in terms of being selected for a more prestigious CRO position often resulted in bad feelings among workers.[15]

For many workers, the realities of on-the-job rides training at AstroWorld resulted in a highly technological focus. Part of the reason for this was the practicality of training and work that focused on the ride as a machine, especially as safety (of workers and guests) was such a predominant concern.[16] For other workers, including many in rides who were promoted to supervisory positions, the love of the machine took on personal levels. One such manager whom I knew eventually trained to operate one of the park's running steam locomotives—which was considered the most challenging "ride" in the park—while another frequently engaged me about the literature he read in terms of historic roller coasters in the United States. While technology was a predominant focus for AstroWorld's social

14. Scott A. Lukas, "An American Theme Park: Working and Riding Out Fear in the Late Twentieth Century," in *Late Editions 6, Paranoia within Reason: A Casebook on Conspiracy as Explanation*, ed. George Marcus (Chicago: University of Chicago Press, 1999), 405–428; Scott A. Lukas, "How the Theme Park Gets Its Power: Lived Theming, Social Control, and the Themed Worker Self," in *The Themed Space: Locating Culture, Nation, and Self*, ed. Scott A. Lukas (Lanham, MD: Lexington, 2007), 183–206.
15. Lukas, "How the Theme Park Gets Its Power."
16. Lukas, *Theme Park*, 117–118.

and organizational life, it was technological discourse tempered with elements that included personal relationships, (ride) history and nostalgia, and aspects of "emotional labor," such as war stories about dramatic work situations in one's ride location, that often dominated shared lived experiences at work.[17]

While much of the literature on theme parks and their rides suggests a certain mechanical nature that characterizes both the work of theme park employees and those guests who visit theme park rides and attractions,[18] reorienting this research vision of theme parks to the appreciation of the interpersonal dynamics and social intimacies is supported by the ethnographic observations of the quotidian activities of guests and workers.[19] Not unlike the rides of Coney Island amusement parks that provided opportunities for social effervescence over one hundred years ago, day-to-day operation of rides, after-hours employee-only rides parties in the park, and interaction with guests and park regulars all offered moments that prove the idea that forms of material culture (including machines) are capable of fostering and maintaining positive social dynamics.[20] I have referred to this context of sociality as a "social machine" in order to recognize that human dynamics relative to forms of park technology and machines are characterized by both spontaneous, expressive, and meaningful circumstances and dull, taxing, and alienating situations.[21] Assuming that Tayloristic, Disneyized, or McDonaldized qualities characterize all theme park human interactions that are grounded in mechanical and technological contexts is not supported by ethnographic observations of the social contexts of rides.[22]

17. Arlie Hochschild, *The Managed Heart: Commercialization of Human Feeling* (Berkeley: University of California Press, 2012); Lukas, "How the Theme Park Gets Its Power."
18. Stephen M. Fjellman, *Vinyl Leaves: Walt Disney World and America* (Boulder: Westview Press, 1992); John F. Kasson, *Amusing the Million: Coney Island at the Turn of the Century* (New York: Hill & Wang, 2002), 82; Norman M. Klein, *The Vatican to Vegas: A History of Special Effects* (New York: New Press, 2004), 11.
19. Lukas, *Theme Park*, 111, 115.
20. Lukas, *Theme Park*, 127–129; Daniel Miller, *The Comfort of Things* (Cambridge, UK: Polity, 2008), 1.
21. Lukas, *Theme Park*, 127.
22. Alan Bryman, *The Disneyization of Society* (London: Sage, 2004).

Of course, theme park rides do represent significant technological contexts that interface with cultural and philosophical concerns. As John Kasson noted in his study of Coney Island amusement parks, the numerous rides and electric lights of Coney not only suggested an interfacing of public amusement technology with everyday life (notably, the influence of transportation technology on amusement rides), they also ushered in a powerful aesthetic of spectacle, kinetics, and kinesthesia.[23] Additionally, as Lauren Rabinovitz has noted, one of the functions served by early twentieth-century amusement rides in the United States was to humanize emerging everyday technology along with the many "shocks of modernity" associated with this period.[24] While we should not ignore these significant technological trajectories of the ride, the construction of the amusement and theme park ride as a machine and object of pure technology has relegated other important cultural and philosophical issues to the background.

Returning to the tragic anecdote I mentioned earlier, in the aftermath of the Excalibur accident, some of the most common subjects of conversation among my AstroWorld colleagues were the specific dynamics of ride safety that were not followed during the incident. For any of us in operations training, our immediate contexts for the accident were the situations of the workers and procedures that were, or were not, followed. While the public often focuses on ride accidents as concerns of a technological nature, those in the industry understand that human error (whether of the guest or ride operator) is the primary reason for such accidents, not failed forms of technology. Curiously, and contrary to this fact, the ride accident may indeed be one case in which human actors attempt to imbue machines with negative values, even intent. Paralleling the Golden Age of Roller Coasters—a period in the 1920s in which a popular desire for roller coasters led to the existence of over 1,300 such

23. Kasson, *Amusing the Million*, 49, 66, 73–74; Tony Bennett, "A Thousand and One Troubles: Blackpool Pleasure Beach," in *The Birth of the Museum: History, Theory, Politics* (London: Routledge, 1995), 229–245; Michael DeAngelis, "Orchestrated (Dis)Orientation: Roller Coasters, Theme Parks, and Postmodernism," *Cultural Critique*, no. 37 (1997).
24. Lauren Rabinovitz, *Electric Dreamland: Amusement Parks, Movies, and American Modernism* (New York: Columbia University Press, 2012), 12.

rides in the United States[25]—concerns emerged about rides, as well as the amusement venues that enclosed them, that ranged from polemics related to the immortality and vice that some believe were associated with them,[26] as well as the dangers that some felt were connected with such machines. During this period (in 1922), an editorial from *Engineering News-Record* spoke so harshly of such devices that its author called for a most dramatic measure: "Complete abolition of amusement machines is the only dependable guarantee against their dangers."[27] Amusement abolitionists and reformers, no doubt, had legitimate reasons to fear the effects of rides, especially the roller coaster. The infamous Crystal Beach Cyclone (1926–1946) was built by the legendary designer Harry G. Traver and was a ride that, due to its intense g-forces and design, led to numerous injuries and one (rider-related) death, an ironic fact given that the ride's safety was marketed to the public. In fact, the roller coaster included a nurse stationed at the unloading platform whose presence led to lowered insurance costs for Crystal Beach.[28] Amusement and theme park rides have maintained collective social interest not only for their mechanical thrills but also due to the ways in which they intertwine with our intimate lives, including, as in these contexts of death, their existential potentials.[29]

In the short story "MONSTER: The Roller Coaster," author B.J. Novak depicts a fictional meeting of the late artist Christo with twelve focus group members who are asked to ride and rate a roller coaster designed to represent everyday life. During the focus group session, some of the people "didn't like all the ups and downs," while others hated the constant "going in circles."[30] Others found the first half more fun than the second. In the end, when asked about the name of the roller coaster, some wanted

25. Judith Adams, *The American Amusement Park Industry: A History of Technology and Thrills* (Boston: Twayne, 1991), 17.
26. Rabinovitz, *Electric Dreamland*, 44.
27. "Dangerous Amusement Devices," *Engineering News-Record* 88, no. 25 (June 22, 1922): 1022.
28. Richard W. Munch, *Harry G. Traver: Legends of Terror* (Mentor, OH: Amusement Park Books, 1982), 78.
29. Lukas, "The Theme Park and the Figure of Death"; Lukas, *Theme Park*; Scott A. Lukas, "The Dark Theme Park," *In Media Res*, September 21, 2020, http://mediacommons.org/imr/content/dark-theme-park.
30. B.J. Novak, "MONSTER: The Roller Coaster," in *One More Thing: Stories and Other Stories* (New York: Vintage Contemporaries, 2015).

to call it "Life," but the most popular choices were "Monster" and "MONSTER" (written in all caps). Novak's short, humorous story about a ride paralleling the ups and downs of life is especially apt as terms like "theme park" and "roller coaster" have become part of everyday vernacular and metaphor.[31] Rides, and their metonymic partners in theme parks, project an existential meaning that is often lost among researchers who have focused on mechanical contexts of such amusements and their related social dynamics. In a less humorous context, the George A. Romero film *The Amusement Park* (1975) uses amusement park rides and attractions as metaphors for aging, ageism, and elder abuse. Romero's horror narrative, not unlike similar themes developed in the films *Rollercoaster* (1977) and *Thrill* (1996), is more shocking given his skillful use of amusement park rides and attractions as machines of real and metaphorical terror. In addressing the existential and conceptual sides of rides, many of these fictional contexts remind us of a second significant era of the ride—its relationship to film.

The Era of Narrative: Film

A few years ago, while taking part in a German theme park studies group research trip (see image 4.1) to Phantasialand in Brühl, Germany, I had the opportunity to ride the park's Hollywood Tour. As described on the park's website, "This themed water ride gives the whole family the chance to relive from [sic] famous Hollywood scenes from a brand new perspective."[32] The ride, seemingly a similar version of Disney's The Great Movie Ride, employs multi-passenger boats to take guests on a slow and meandering journey through Hollywood movie history. Though I recognized a few of the films—*Jaws, Tarantula, Sinbad the Sailor, Frankenstein, 20,000 Leagues Under the Sea, Tarzan, The Wizard of Oz,* and *King Kong*—I found myself asking many of my German co-investigators which movie was being presented. To the credit of the ride's designers, the boat ride fea-

31. Lukas, *Theme Park*, 216.
32. Phantasialand, "Hollywood Tour – Phantasialand," https://www.phantasialand.de/en/theme-park/one-of-a-kind-attractions/hollywood-tour/.

tures some evocative cave scenography, immersive audio, and some aesthetic uses of lighting, but the overall effect of the ride—as an amalgam of film history and theme park rides—is to remind of the perilous relationship that may be noted in terms of cinema and theme park rides.[33]

The ride's use of incredibly sparse movie scenes—for example, the *Jaws*-themed portion includes memes of "fishing village" and "shark fin in water," among others—offers an opportunity to analyze the many forms of culture that impact our understandings of symbols and the nature of the symbolic order that is a part of the media and consumer worlds shared by film and theme parks.[34] In the ride's *Tarantula* scene, prior to entering the action involving a giant monster tarantula and a helicopter, the audio cues riders to the cinematic nature of the ride with the words "action," all the while presenting a movie crew to the left of the action that is engaged in creating the film. In this meta moment, the ride offers an opportunity to consider the issues of mediation, transmediation, and intellectual property that are intertwined in the study of the relationships of film and theme park rides. As well, a number of the film scenes include short actor dialogues from the films (spoken in German), though like the visual memes in *Jaws*, do not really establish much in terms of storytelling, either in reference to the film citations or the story of Hollywood Tour itself as a ride. The pacing of the ride, unlike other rides and many of the action films it portrays, is incredibly slow at twelve minutes, and one movie scene in particular—in which the monster from *King Kong* slowly torments a man on a boat with only a few audio grunts and some minor oscillating fingers as signs of Kong's "menace"—provides a sense of pure disconnection between the guest and the film portrayed and the ride that traverses the Hollywood scenes.

33. Florian Freitag, "Movies, Rides, Immersion," in *A Reader in Themed and Immersive Spaces*, ed. Scott A. Lukas (Pittsburgh: ETC Press, 2016), 125-130; Florian Freitag, "'Like Walking into a Movie': Intermedial Relations Between Theme Parks and Movies," *The Journal of Popular Culture* 50, no. 4 (August 2017): 704–722; Scott A. Lukas, "The Cinematic Theme Park," unpublished manuscript, 2009.
34. Victor Turner, *The Forest of Symbols: Aspects of Ndembu Ritual* (Ithaca, NY: Cornell University Press, 2002).

Image 4.1. Researchers from the German theme park studies group conduct in situ research at the Talocan ride at Phantasialand in Brühl, Germany. The ride has been noted as being the world's greatest flat ride, and it includes pyrotechnics, water, lighting, and sound effects, elements which suggest a significant impact of filmic effects on rides. Credit: Scott A. Lukas.

Following our group's debarking of the ride, as we would do all day on other rides, we discussed our impressions of the ride, issues of immersion, and comparisons with other rides, such as the Great Movie Ride. My immediate feeling upon completing the ride experience was that the "brand new perspective" described by Phantasialand in its description of the ride was less a perspective derived from filmmaking or ride engineering, but psychology and philosophy. In the moment of the scene of Kong's oscillating fingers, I was struck at how uncanny it was. In Freud's sense of the uncanny (*unheimlich*), one notes "a hidden, familiar thing that has undergone repression and then emerged from it," while Jentsch offers the characteristic of being not at ease, not at home, a foreign quality, or "a lack of orientation."[35] The uncanny as embodied in this ride scene was the reduction of filmmaking's immersive narrative potentials and the theme park ride's ability to create corporeal, evocative, and sensory effects to a mere symbolic form. There was no movie magic in the films portrayed,

35. Sigmund Freud, "The Uncanny," in *The Standard Edition of the Complete Psychological Works of Sigmund Freud, Volume XVII (1917–1919): An Infantile Neurosis and Other Works* (London: Hogarth, 1955), 15; Ernst Jentsch, "On the Psychology of the Uncanny," *Angelaki: Journal of the Theoretical Humanities* 2, no. 1 (1997), 8.

nor any thrills from the slow-moving ride, instead, as Lacan noted of disruptions in the symbolic order, at certain moments individuals are reminded not of the thing itself as it is happening or unfolding, but of other contexts which are tied, as referents, to the symbols at play.[36] While many studies of the relationship between film and theme parks (and their rides) suggest a simplified form of mediation between these forms—noted in phrases like "riding the movie"[37]—as the unintentional forms of the uncanny on Hollywood Tour illustrate, the ways in which the conceptual, symbolic, technological, and immersive orders of films and rides interpenetrate one another are complex, multifaceted, and even contradictory.

In the early 1900s, a similarly jarring ride journey was offered to guests at the Pan-American Exposition of 1901 in Buffalo, New York. A Trip to the Moon, designed by the amusement architect and visionary Frederic Thompson, is considered by many to be the world's most significant early dark ride. As Woody Register describes, the ride—which included a spaceship suspended from wires—was revolutionary for its use of lighting, faux scenery and projections, and notable multi-sensory technologies including sound and blown air.[38] Following its appearance at the Pan-American Exposition of 1901, the ride was moved to George Tilyou's Steeplechase Park and, later, to Luna Park. In all of its versions, A Trip to the Moon was successful with guests not just due to the technological and media innovations that it included, but due to its relationship to storytelling and narrativization. Researchers have suggested that the ride's connection to

36. Lacan, *Ecrits*.
37. Janet Horowitz Murray, *Hamlet on the Holodeck: The Future of Narrative in Cyberspace* (Cambridge, MA: The MIT Press, 1997), 57; Fjellman, *Vinyl Leaves*, 11, 257.
38. Woody Register, *The Kid of Coney Island: Fred Thompson and the Rise of American Amusements* (New York: Oxford University Press, 2003), 69–75.

both literary (Jules Verne's *A Voyage to the Moon* and H.G. Wells' *The First Men in the Moon*) and filmic (*A Trip to the Moon* by Georges Méliès)[39] texts represents a significant moment in terms of the evolution of the amusement and theme park ride.[40]

Register's focus on the literary influences behind the A Trip to the Moon ride are particularly interesting for this study as they point to an often overlooked dynamic in the relationships of film and rides—that of the narrative. The inclusion of a narrative that depicts setting, characterization, and plot was a development that equally transformed film of the era (as it moved from films like those of the Lumière brothers that depicted a naturalized, and sometimes, non-narrative everyday life) and amusement park rides (that often relied on pure mechanical force devoid of narrative of storytelling) of the era. Clearly, A Trip to the Moon broke with the conceptualization of the ride as a pure form of technology—a "rigid machine" that declines the possibility of the ride even having narrative or storytelling functions beyond those of its pure mechanical state.[41] The attraction illustrates the early signs of the ride's later evolution as both a filmic entity and a transmediated property, especially in the intertextuality of the form that it shares with literature and film, and in its overall framing as a "text" to be shared among media forms.[42] This sharing among media forms will result in later dynamics of ride and filmic remaking,[43] including

39. It should be recognized that a number of researchers have suggested that Méliès's *A Trip to the Moon* influenced Thompson's ride of the same name. I have been unable to find written documentation of Thompson stating that the film had a direct effect on the ride. Nevertheless, connections of these two media forms focused on a similar subject seem worthy of consideration.
40. Judith Maloney, "Fly Me to the Moon: A Survey of American Historical and Contemporary Simulation Entertainments," *Presence: Teleoperators and Virtual Environments* 6, no. 5 (1997), 565–580; Angela Ndalianis, "Dark Rides, Hybrid Machines and the Horror Experience," in *Horror Zone: The Cultural Experience of Contemporary Horror Cinema*, ed. Ian Conrich (London: I.B. Tauris, 2010), 25, 23; Register, *The Kid of Coney Island*, 72.
41. Bryant, *Onto-Cartography*, 16, 23, 24.
42. Lukas, *Theme Park*, 212–245.
43. The use of the term "adaptation" to describe many of the media relationships in this chapter—including those specific to theme parks, film, and video games—may serve to conceal or obscure the uncanny, and sometimes contradictory, relationships between media forms that appear to be "adapted." The etymology of this word suggests joining, fitting, and adjusting, which may be seen by some as a rather harmonious process as a theme park ride becomes a film or a film becomes a theme park ride. "Adaptation," *Online Etymology Dictionary*, https://www.etymonline.com/word/adaptation#etymonline_v_25997. Considering the relationships, borrowings, and intertextual mingling

intermediality and transmediation (such as in the *Pirates of the Caribbean* and *Jungle Cruise* media universes), films imitating rides (as in the use of Sensurround low-frequency audio effects in the theatrical film *Rollercoaster*), the growth of ride-video game hybridity, and increasing influences of transmedia on these many connected media forms.[44]

One of the most significant concerns in terms of the evolution of the ride as a filmic entity has been what may be called a "shared spatial aesthetic" or "sensorial reorientation" between rides and film.[45] As Rabinovitz has noted in her study of the evolution of early 1900s American amusement, a shared simultaneity of moviegoing and amusement park going provided opportunities for the expectations of guests (who today desire filmic approaches in theme park rides) to be developed in those earlier times.[46] There is a variety of comparisons that have been made in terms of the ride-film symbiosis that has been noted since the days of A Trip to the Moon. As already discussed, forms of narrativization (in which a "rigid" ride machine is given narrative development) and storytelling are noted in both film and ride forms. In some cases, as in transmedia developments in media, stories are multi-spatial and polyvocal as fans are asked to consider narratives that span multiple media forms (such as in the Harry

of these media forms and their stories and narratives more in terms of "remaking" (etymologically implying a movement of forces back and forth, movement away, and undoing) may allow us to see, as Freitag suggests, that the process of inter- and transmediality is never a one-to-one dialogue between different media forms. Freitag, "'Like Walking into a Movie'"; Scott A. Lukas, "A Case for Remakes, the State of 'Re,'" unpublished manuscript, 2013.

44. Scott A. Lukas, "Horror Video Game Remakes and the Question of Medium: Remaking Doom, Silent Hill, and Resident Evil," in *Fear, Cultural Anxiety and Transformation: Horror, Science Fiction and Fantasy Films Remade*, eds. Scott A. Lukas and John Marmysz (Lanham, NH: Lexington, 2009), 221–242; Scott A. Lukas, "Theming and Immersion in the Space of the Future," in *A Reader in Themed and Immersive Spaces*, ed. Scott A. Lukas (Pittsburgh: ETC Press, 2016), 289–300; Bobby Schweizer and Celia Pearce, "Remediation on the High Seas: A Pirates of the Caribbean Odyssey," in *A Reader in Themed and Immersive Spaces*, ed. Scott A. Lukas (Pittsburgh: ETC Press, 2016), 95–106.

45. Vince Dziekan and Joel Zika, "The Dark Ride: The Attraction of Early Immersive Environments and Their Importance in Contemporary New Media Installations," *Mesh Issue #18: Experimenta Vanishing Point* (2005): 21; Rabinovitz, *Electric Dreamland*, 11.

46. Rabinovitz, *Electric Dreamland*, 19.

Potter transmedia universe).[47] Specific technological and technical similarities of the two forms—including pacing, editing, camera angles and perspective, staging, lighting and design, and sound effects—have also been noted as major transmediated connections.[48] These borrowings are made even more significant in the third iteration of the ride as a video game in which transmediated and technological interplay continues to evolve.[49] An additional significant context is the degree to which individual rides cinematically relate to other rides, attractions, and themelands in the theme park as a whole and the role that workers play in forms of acting and themed dramaturgy that augment the filmic effects of rides.[50] While these significant forms of transmediation and dialogue between film and theme park rides should maintain a significant hold on our research agendas, we should be weary of simplifications that emerge in the tendency to assume one-to-one borrowing, seamless and invisible forms of adaption or remaking in the two forms, and unproblematized notions of shared media synergy.[51] In fact, to return to the work of Lacan and his notion of "the beyond-of-the-signified" and, in this case, the circumstance of the creation and diffusion of the object called "ride," we should be encouraged to understand how the transformations of the ride described in this work are emblematic of the general conditions of transmediation and virtuality. The synergies of the ride and transmedia are not only reflections of Lacan's Symbolic—especially as they illustrate a realm of conceptual meaning that eludes us infinitely—they are indications of

47. Henry Jenkins, *Convergence Culture: Where Old and New Media Collide* (New York: New York University Press, 2008); Henry Jenkins, Sam Ford, and Joshua Green, *Spreadable Media: Creating Value and Meaning in a Networked Culture* (New York: New York University Press, 2013); Rebecca Williams, *Theme Park Fandom: Spatial Transmedia, Materiality and Participatory Cultures* (Amsterdam: Amsterdam University Press, 2020).
48. J. David Bolter and Richard A. Grusin, *Remediation: Understanding New Media* (Cambridge, MA: The MIT Press, 1999); Fjellman, *Vinyl Leaves*; Freitag, "Movies, Rides, Immersion"; Freitag, "'Like Walking into a Movie'"; Lukas, *Theme Park*, 126; Maloney, "Fly Me to the Moon"; Murray, *Hamlet on the Holodeck*; Ndalianis, "Dark Rides"; Jessica Balanzategui and Angela Ndalianis, "'Being Inside the Movie': 1990s Theme Park Ride Films and Immersive Film Experiences," *The Velvet Light Trap* 84 (Fall 2019): 18–33.
49. Bobby Schweizer, "Visiting the Videogame Theme Park," *Wide Screen* 6, no. 1 (2016).
50. Lukas, "How the Theme Park Gets Its Power," 183, 191–194.
51. As Freitag notes, a theme park—like theater, cinema, and opera—functions as a hybrid medium, a composite medium, or even a meta-medium. One immediate concern of its trans- and intermediality and its relationship with other media like cinema is the "indirect participation of a distinct medium in an artifact that is realized in another medium." Freitag, "'Like Walking into a Movie,'" 706, 708. See also, Freitag, "Movies, Rides, Immersion"; Lukas, *Theme Park*, 126; Lukas, "The Cinematic Theme Park."

the challenging role offered to the theorist of the transmediated ride as she is conceptually pulled by the *objet petit a* and a desire to understand the ride's "otherness," to consider the multiple, contradictory, and elusive meanings that emerge in the apotheosis of the ride as a transmediated and virtual form.[52]

Borrowing from music and the distinction of absolute and program music, we may speak of the ride's tension as a device that oscillates between a mechanical, un-themed, thrilling focus and a narrative-based, story-driven, themed experience. In my ethnographic experiences at AstroWorld, a common experience for our training department staff was to refer to the inferiority of Disney rides through the claim that they weren't rides at all. All of the theming, storytelling, and transmedia augmentation common in Disney rides was argued to be distracting for guests who want to experience the pure kinetics, adrenaline, and thrills of a non-narrativized, non-story-based AstroWorld ride.[53] In a psychoanalytical sense, we were dealing with the perceived lack of Disney capital and IP (intellectual property) at our park by focusing on the "arbitrary" nature of Disney ride semiotics.[54] Thus, we return to a tension noted in the distinctions between the Ride as Machine and the Ride as Film. The arbitrary (Saussuarian) narratives that develop in the midst of the film-ride relationship also remind of the idea of the power of "dream objects" as they relate to human involvement in such ride narratives.[55] As the example of Disney ride inferiority at AstroWorld illustrates, the stories

52. Jacques Lacan, *The Seminar of Jacques Lacan: Book VII: The Ethics of Psychoanalysis 1959–1960* (New York: Norton, 1997); Bolter and Grusin, *Remediation*, 83; Žižek, *Looking Awry*.
53. It should be noted that this situation is also descriptive of the general differences between amusement and theme parks. While an amusement park is often a collection of rides that are typically un-themed or not given a narrative or storyline—and in which the rides and attractions themselves are not bound up in larger narratives, such as those of themelands—a theme park is viewed as a space that takes full advantage of narratives, stories, and themes that help situate and orient the guest in its spaces. See Lukas, *Theme Park*.
54. Baudrillard, *The System of Objects*; Mike Featherstone, *Consumer Culture and Postmodernism* (Los Angeles: Sage, 2007), 88.
55. Baudrillard, *The System of Objects*, 177. Saussure's notion of the arbitrary nature of language, namely the idea of there being no motivated or intrinsic connection between signifier and signified, contrasts with semiotic approaches like those of Charles Sanders Pierce and others who suggest more motivated or natural connections between signifier and signified. For more, see Ferdinand de Saussure, *Course in General Linguistics* (Peru, IL: Open Court, 1998); and Hubert Kowalewski, "Against Arbitrariness: An Alternative Approach Towards Motivation of the Sign," *Public Journal of Semiotics* 6, no. 2 (2015): 14–31.

116 The Theme Park Ride (In and of Itself) as a Cultural Form

told (and not told) through rides mark a significant connection of the ride with its "audience," not unlike the audience or interpretive communities implied in literature with reader-response theory.[56] As a dream object, a ride not only reminds us of the powerful narratives that are told about (and through) rides but how a ride (to predict the era of the Ride as Transmechanical) provides levels of transcendence for both its related human communities and, perhaps, itself, in terms of Object Oriented Ontology.[57]

Image 4.2. A still from the official program, Luna Park: The Electric City by the Sea. Credit: Public Domain.

The pictured image (see image 4.2) is one example of the status of a ride as it achieves the state of a dream object. This particular image of a page featuring A Trip to the Moon is from the longer official Luna Park program. I obtained this piece of Coney Island memorabilia following a very intense and expensive bidding war with other potential buyers on the popular eBay platform. During a recent, near evacuation due to a wildfire

56. Stanley Fish, *Is There a Text in This Class? The Authority of Interpretive Communities* (Cambridge, MA: Harvard University Press, 2003).
57. Barthes, *Mythologies;* Baudrillard, *The System of Objects*, 79; Graham Harman, *Object-Oriented Ontology: A New Theory of Everything* (New York: Pelican, 2018); Susan Stewart, *On Longing: Narratives of the Miniature, the Gigantic, the Souvenir, the Collection* (Durham: Duke University Press, 1993), 175; Williams, *Theme Park Fandom*.

near my home, this was one of the prized objects that I chose to pack in the car in case of evacuation. It was, and still is, a cherished amusement park item that, in my mind, maintains a great deal of mana, authority, or power, as it reflects back on the era of classic amusement rides like A Trip to the Moon. For many fans, designers, and ride workers, my obsessive experience with a piece of ride memorabilia would likely not seem that bizarre. As many researchers of antiques and material culture have noted, certain objects carry with them a remainder of what they were once connected to—an authentic projection to the past that still gives the holder of the object a sense of power in the present.[58] For many ride (and more general theme park) fans, forms of material culture (such as in examples of Disneyana collecting of pins or other park memorabilia and in examples of the hoarding of theme park maps and press kits), the creation of scale roller coaster models (or even backyard, full-sized working versions of them), memories of theme park visits or first-person ride experiences (including those documented on YouTube and theme park blogs),[59] and the experiences themselves involved in seemingly obsessive visiting of theme parks and riding of their rides (as in the case of groups like ACE, the American Coaster Enthusiasts or RCCGB, the Roller Coaster Club of Great Britain), all point to a certain form of material and experiential fandom that has developed in the synergies of film and rides.[60]

While the fans of theme park rides are perhaps not as dedicated as Trekkers, Comic Con attendees, or fans of particular movies, transmedia franchises, or celebrities, they share with these others a clear purpose that is founded on the machines, experiences, technologies, and stories that are developed in the unique worlds of theme parks and their attractions.[61] For cultural critics, the level of dedication of such fans is a cause

58. Stewart, *On Longing*, 175.
59. An interesting version of the experiential rides video is the project initiated by Joel Zika which attempts to document vanishing dark rides through high-tech, 3D video recordings. "This Unique Project Is Using Virtual Reality to Document the Fast-Disappearing Haunted Rides of America," *Outlook India*, July 27, 2020.
60. Lukas, *Theme Park*, 212–245; Williams, *Theme Park Fandom*.
61. Many theme park researchers would, in fact, argue that theme park fandom does represent a very committed and engaged community that parallels these other communities. See Williams, *Theme Park Fandom*.

for concern.[62] While enamored with the theme park dream object, we face dangers similar to those noted in cinematic spectatorship. As some have suggested, the pleasure of film and its immersive sense of transparency may result in an inability to identify the ideological layers that exist beneath the film.[63] The next section on the theme park as video game will address the dangers of immersion that are present in moments of media "hallucination," but, in short, we may say that the dangers of interfacing with rides—like those of viewing films—have led some to suggest that the technology of rides, their connection to consumerist values, and their overall hegemony as realized in passive and nonautonomous riders results in problematic socio-political and ideological conditions.[64] Of course, such views seem to ignore the ways in which participants in consumerist and entertainment activities like those of theme parks do display agency and autonomy in terms of their interfacing with the various forms of material culture, technology, media, and theme park narratives.[65] Some examples of such agency are the many fan petitions and active social media and journalistic engagements related to concerns about the racist and sexist narratives of beloved Disney rides like Splash Mountain, Pirates of the Caribbean, and Jungle Cruise.[66]

Perhaps in line with what the poet Hölderlin offered in "Patmos," "But where the danger is, also grows the saving power": we should both admire and be cautious of the sorts of theme park dream objects that float in and out of our consciousness. One possibility for future studies of the interfacing of film and theme park rides is the growing movement that has included focus on the performative sides of rides and their related themed

62. Scott A. Lukas, "Judgments Passed: The Place of the Themed Space in the Contemporary World of Remaking," in *A Reader in Themed and Immersive Spaces*, ed. Scott A. Lukas (Pittsburgh: ETC Press, 2016), 257–268.
63. Jean-Louis Baudry, "Ideological Effects of the Basic Cinematographic Apparatus," *Film Quarterly* 28, no. 2 (Winter 1974-1975), 39–47; Murray, *Hamlet on the Holodeck*; Sherry Turkle, ed. *Simulation and Its Discontents* (Cambridge, MA: The MIT Press, 2009).
64. Fjellman, *Vinyl Leaves*, 11; Klein, *The Vatican to Vegas*, 1, 8, 11.
65. Lukas, "Judgments Passed"; Scott A. Lukas, "A Consumer Public Sphere: Considering Activist and Environmental Narratives in the Contexts of Themed and Consumer Spaces," in *Environmental Philosophy, Politics, and Policy*, ed. John Duerk (Lanham, MD: Lexington, 2021), 159–176; Williams, *Theme Park Fandom*.
66. Katie Scott, "Disney to Change Splash Mountain Theme amid Outcry over 1946 Movie," *Global News*, June 25, 2020, https://globalnews.ca/news/7107801/splash-mountain-changing/.

venues, including discussions of dramaturgy, theatricality, and performance theory.[67] As related to political and hegemonic concerns, analyses of ride narratology and performativity might interface with important questions that have been raised in terms of theme park rides and their impacts on individual freedom and autonomy.[68] Combining these foci, we might imagine that future studies of the ride will emphasize the ethnographic experiences of rides while also paying close attention to critical cultural and political analyses of narratives, dramaturgy, and stories. Such research emphases are especially valuable as rides have now moved into a new era in which they are interfacing with the immersive technologies of video games and virtual and augmented reality—a potentially even more immersive and ideologically problematic medium than film.

The Era of Immersion: Video Games

One of the greatest immersive rides that I have experienced is no longer in existence. In 2019, I paid my admission to take part in the Void Secrets of the Empire experience at the Venetian Las Vegas.[69] Like many contemporary transmedia rides, the Void promised an experience that was immersive. Its opening experience paralleled the establishing videos that accompany the queues and waiting areas that one expects prior to boarding a ride, but what took place in the moments following a short *Star Wars* video was entirely unexpected. A ride attendant gets me situated with equipment that includes VR goggles, stereoscopic sound technology near the ears, and a bodysuit that includes haptic response devices that I would later discover are used to indicate an enemy weapon's hit to my avatar. Following some instructions from the attendant, I was led into the first of many rooms that are all themed with the *Star Wars* transme-

67. Filippo Carla and Florian Freitag, "Ancient Greek Culture and Myth in the Terra Mítica Theme Park," *Classical Receptions Journal* (2014): 1–18; Jennifer A. Kokai and Tom Robson, eds. *Performance and the Disney Theme Park Experience: The Tourist as Actor* (Cham, Switzerland: Palgrave Macmillan, 2019); Ariane Schwarz, "Staging the Gaze - The Water Coaster Poseidon as an Example of Staging Strategies in Theme Parks," in *Time and Temporality in Theme Parks*, eds. Filippo Carlà-Uhink, Florian Freitag, Sabrina Mittermeier, and Ariane Schwarz (Hannover: Wehrhahn, 2017); Maurya Wickstrom, *Performing Consumers: Global Capital and Its Theatrical Seductions* (New York: Routledge, 2006).
68. Fjellman, *Vinyl Leaves*.
69. Austin Craig, "Will The VOID, the Utah Based Global Leader in Location-Based VR, Survive the Pandemic?" *Tech Buzz News*, October 13, 2020, https://techbuzz.news/will-the-void-die-by-covid-/.

dia brand. At this point, my VR goggles are completely covering my eyes and I experience a sense of disorientation as I am immersed in the ride's scenography. When instructed, I pick up a laser assault rifle that I would need to complete the gaming experiences in Secrets of the Empire. The most uncanny aspect of the initial moments of the ride was the presumed open-world/sandbox freedom of walking within the spaces of the drama and the fact that I was able to touch objects (like the robot R2-D2) and actually feel those objects with my hands. During a few moments, I raise my VR visor to discover dull, gray painted walls and a similarly undetailed shape of R2-D2 without any of the visual adornments that I note when I pull my VR visor back down. As I move through the many sets of the experience, I have the feeling that I am moving through an actual series of spaces, and as enemy Stormtroopers shoot at me, I feel a slight jolt through the haptic technology of my suit. While I have the sensation of walking through an expansive series of spaces, I later discover that I have been walking in a circle and subject to a technique called redirected walking.[70]

Following my visit to the Void, I had hoped to return and experience this new virtual- and game-based ride (often called a LBVR, or location-based virtual reality ride) with one of the other software possibilities—notably, a horror experience focused on the World's Columbian Exposition of 1893. Unfortunately, some two years later and well into the COVID-19 pandemic, I discovered that the Las Vegas location of the Void, along with all other locations, had been permanently shuttered. The Void represented something that I had begun to research in 2015 at the IAAPA (The International Association of Amusement Parks and Attractions) Expo in Orlando, Florida.[71] At that time, I had started to note that the attractions being displayed at the many industry booths and demonstrations were beginning to focus on a hybridity of ride and video game. It appeared

70. For more on the interplay of the physical and virtual components of the Void, see Rachel Metz, "Inside the First VR Theme Park," *MIT Technology Review*, December 15, 2015, https://www.technologyreview.com/2015/12/15/71958/inside-the-first-vr-theme-park/.
71. Scott A. Lukas, "Theming and Immersion in the Space of the Future."

that the entire lexicon expressed by the amusement industry was reflecting new tendencies—those moving beyond the potentials of film and now marking a desire for greater interactivity, new perspectives, and possibilities for non-linear and customizable guest experiences.

In the early 1900s, and much earlier in amusement history than has been imagined, one notes the development of an amusement rides and attractions arms race or a focus on achieving the greatest level of "infinite variety" at the many competing parks of Coney Island.[72] Steeplechase impresario George Tilyou realized the fickle nature of amusement park guests and understood the need to up the competition with a Ferris Wheel many feet taller than the competitor's or an immersive dark ride more immersive, spectacular, and thrilling than that of the neighboring amusement park.[73] In the contemporary transmedia world of theme parks, the desire for greater amusement and entertainment variety for guests is also fueled by an understanding of incredible competition among media forms. NordicTrack iFIT home exercise equipment, new interactive home media like Netflix's *Black Mirror: Bandersnatch* (an interactive, choose-your-own-adventure-styled film), advances in PlayStation and Xbox gaming systems, and the growth of augmented and virtual reality technologies and spaces (such as Facebook's Horizon Workrooms metaverse) are examples of transformations of media and experience that are occurring in sectors outside of, yet connected to, the spaces of theme parks.[74] As many have noted, a general push for gamification in our consumer and media worlds has led to notable transformations in the nature of theme parks and their ride experiences.[75]

72. Edo McCullough, *Good Old Coney Island: A Sentimental Journey into the Past* (New York: Fordham University Press, 2000), 309.
73. Ibid., 155.
74. Scott A. Lukas, "COVID-19 and Immersion: Physical, Virtual, and Home Spaces," *Journal of Themed Experience and Attractions Studies*, no. 2 (2022).
75. Lance Hart, "Ready Player One? The Rise of Theme Park Gamification," *Blooloop*, February 11, 2021; Schweizer, "Visiting the Videogame Theme Park"; Ellen Lupton, *Design Is Storytelling* (New York: Cooper Hewitt Smithsonian Design Museum, 2017).

Fear the Walking Dead Survival in Las Vegas, Nevada, is an example of a new ride that illustrates many tendencies of gamification and ride-video game hybridity. Not unlike the fate of the Void, Fear the Walking Dead Survival did not last the test of time and closed less than two years after opening. While Fear the Walking Dead Survival opened in a small space, it offered opportunities of transmedia connection that have become popular with Disney and Universal theme parks, including the *Avatar*, *Star Wars*, and Harry Potter franchises. Using the media world of *The Walking Dead* as a backdrop, the attraction included a number of new experiential and media features that suggest the direction of today's emerging ride-video game theme park. The experience began with an interior setting with live actors who established some of the zombie escape narrative that took place in the remainder of the ride. Additional spaces within Fear the Walking Dead Survival included a maze, a brief escape room puzzle, and a finale that combined a dark ride with a FPS (first-person shooter) video game experience. While *The Walking Dead* fans' and other guests' reactions to the experience was mixed, Fear the Walking Dead Survival exhibited the understanding that contemporary rides and their amusements must follow a much more hybrid and multi-experiential path than previous rides.

As the theme park ride continues its journey, the transformations noted are directly referenced in industry displays and presentations, like those noted at IAAPA, and in corporate marketing materials. In fact, many ride manufacturers, such as Sally Rides, directly identify this shift to more gamified and virtual ride experiences on their websites:

> Classic Storytelling—sit back, relax and get lost in an imaginative story complimented with beautiful set pieces and animatronics.
>
> Interactive Gaming—practical targets and vivid scenery boost repeat ridership and friendly competition.
>
> Mixed-Media—combining storytelling, interactive media, and immersive environments to create a larger-than-life experience.[76]

76. "Interactive Dark Rides for Museums, Exhibits, Theme Parks & More," *Sally Dark Rides,* 2021 https://www.sallydarkrides.com/dark-rides.

With the exception of the "mechanical ride," Sally's typology of dark rides parallels the eras of the theme park ride discussed in this work. As well, the focus on interactive gaming and mixed media illustrates the understanding that today's theme park experience is notably different than that of the earlier eras of rides. Some of the many tendencies noted in the evolution of the ride-video game hybrid include augmented reality and apps (such as in lessening queue line boredom by extending gamification to smart phone experiences); multi-sensory and new immersive technologies (noted in the Avatar Flight of Passage ride at Disney's Animal Kingdom, which includes haptic, multi-sensory, and virtual reality experiences); video game perspectives and experiences (including expansion of the popularity of first-person shooter genres on rides);[77] greater focus on guest goals, quests, and problem solving (such as in immersive escape rooms); and non-linear forms of storytelling and desires for open-world or sandbox styled experiences (including more customized and guest-driven storytelling, perhaps mimicking the Ocean Medallion by Princess Cruises and its big-data and sensor driven technologies and those that reflect "open work" tendencies).[78] Complications of the COVID-19 pandemic of 2019 and onward will, no doubt, continue to have a dramatic impact on all aspects of amusement and entertainment attraction design,[79] but many of the transformations noted in this era of the theme park ride connect with possibilities of adaptation found during the COVID-19 pandemic, most notably the movement of more forms of entertainment to hybrid, or even fully virtual, experiences and metaverses (such as Swamp Motel's online immersive escape room/theatrical experiences).[80]

77. Scott A. Lukas, "Behind the Barrel: Reading the Cultural History of the Gun in Video Games," in *Joystick Soldiers: The Military/War Video Games Reader*, eds. Nina Huntemann and Matt Payne (New York: Routledge, 2008), 75–90.
78. Umberto Eco, *The Open Work* (Cambridge, MA: Harvard University Press, 1989).
79. Scott A. Lukas, "On Architecture, Entertainment, and Discomfort," *The Right Angle Journal* 3, no. 4 (Summer 2020), 6–8; Lukas, "COVID-19 and Immersion."
80. Katie Collins, "Swamp Motel's Escape Room/Scavenger Hunt Mashup Is the Most Fun I've Had in a Year," *CNET*, March 14, 2021.

As noted, future instances of the ride-video hybrid will tap into the powerful potentials found at the intersections of fandom, convergence culture, spreadable media, and transmedia.[81] Studies of the transmedia influences on contemporary theme park rides have noted that the connections of rides to narrative spaces (and all of their auto-textual poaching, transmedia referencing, and citations) provide for both storytelling and technological experiences that did not exist in the amusement worlds of the past.[82] In a world more and more characterized by forms of remediation—in which we note more complex intermingling of subject, object, and medium and a self that exists through networks of transmediated associations—the types of rides that will be developed will certainly be founded on many of these possibilities.[83] With such developments, researchers of these rides, media forms, and their guest experiences will need to take into account these complex contexts and the "saturated" guests who take part in them.[84] As noted in the final section of this chapter, attention to such complexities within methodological worlds of Object Oriented Ontology (OOO) and Actor-Network Theory (ANT) may be warranted.

For some, however, the excitement about the contemporary ride's transmediated nature may not be reason for celebration. As noted with the Void, Fear the Walking Dead Survival, and the video-game-based DisneyQuest before them, the lives of the ride-video game's hybrid form have often been short. In a transmedia world, successes in one media form or genre do not guarantee successes in another, even if familiarity with the narrative worlds shared by the media are noted in those experiencing the different forms.[85] One notable issue is the degree to which "mediaplay" (as in gameplay) translates from one form to the other.

81. Jenkins, *Convergence Culture*; Jenkins, Ford, and Green, *Spreadable Media*; Williams, *Theme Park Fandom*.
82. Schweizer and Pearce, "Remediation on the High Seas"; Hal Sundt, "The Quest for the Best Amusement Park Is Ever-Changing and Never-Ending," *The Ringer*, February 20, 2020.
83. Bolter and Grusin, *Remediation*, 58, 232.
84. Kenneth J. Gergen, *The Saturated Self: Dilemmas of Identity in Contemporary Life* (New York: Basic Books, 2000).
85. Lukas, "Behind the Barrel"; Lukas, "Horror Video Game Remakes"; Ndalianis, "Dark Rides"; Schweizer, "Visiting the Videogame Theme Park."

In 2008, during a behind-the-scenes tour of Disney's Toy Story Midway Mania ride at Walt Disney World, I spoke with a number of industry and academic researchers of theme parks who noted concerns with the ride's interactive form of video game gun as being too "gamelike" and distracting in terms of their expectations with traditional dark rides. In their minds, it appeared that the ride's appeal to gaming drew attention to itself both as a conceptual category and a technological form that did not authentically capture the enjoyable essences of either rides or video games. I was not surprised to hear these critiques of the ride, especially since notions of video games as "killing machines" were in vogue during this period,[86] but what did surprise me was the unwillingness of some of these observers to see Disney's Toy Story Midway Mania ride as merely the latest form of the theme park ride's evolution. An important reminder in this instance of ride-game synergy is that—not unlike notions of authenticity in philosophy in which one imagines the creation of an authentic self, fashioned in ways unencumbered by outside or inauthentic influences—future synergies of rides, media forms, and technologies could be developed in senses that avoid the breakdowns in the suspension of disbelief noted by riders experiencing Toy Story Midway Mania.[87]

Not unlike these concerns with the ride-video game hybrid form, many contemporary social critics have decried the theme park and its rides for their involvement in "the replacement of reality with selective fantasy."[88] Beginning in the 1900s with the proto-theme parks of Coney Island, social critics expressed concern about these parks, their attractions, and the direction they were taking society. One polemic written by the Russian author Maxim Gorky noted danger in the intoxicating and hallucinogenic potentials of Coney Island's amusements. As he wrote:

86. Dave Grossman and Gloria DeGaetano, *Stop Teaching Our Kids to Kill: A Call to Action Against TV, Movie, and Video Game Violence* (New York: Three Rivers Press, 2001).
87. Charles Guignon, *On Being Authentic* (New York: Routledge, 2004).
88. Ada Louise Huxtable, *The Unreal America: Architecture and Illusion* (New York: New Press, 1997), 14.

Everything whirls and dazzles, and blends into a tempestuous ferment of fiery foam. The visitor is stunned; his consciousness is withered by the intense gleam; his thoughts are routed from his mind; he becomes a particle in the crowd. People wander about in the flashing, blinding fire intoxicated and devoid of will. A dull-white mist penetrates their brains, greedy expectation envelops their souls.[89]

Many years after Gorky's words were written, popular films like *Westworld* (1973) and *Futureworld* (1976) expressed a growing collective view that the immersive potentials of theme parks may result in disastrous effects on society. Taken as a metaphor of concern about the dangers of immersive technology, a later film, *Escape from Tomorrow* (2013), famous for its guerrilla filming techniques that included shooting segments of the film at Disneyland and Walt Disney World without permission from the Walt Disney Company, includes a memorable scene in which it is revealed to the protagonist that Epcot's Spaceship Earth is the site in which elaborate psychological experiments are being conducted on him—notably, through Disney's numerous rides and attractions. The dangers that theme parks represent to the consciousness of the guest, as expressed in all of these films, confirm many of the views of contemporary researchers who have suggested that duplicity, hegemony, and consumerist domination are foundations of experiences within theme parks.[90]

The dangers suggested by such critiques of the dreamlike and potentially hegemonic qualities of theme park entertainment—especially as rides and their video gaming technologies offer greater technological persuasion, more potent suspension of disbelief, and less transparency[91]—are certainly valuable considerations for future theme park and video game research.[92] At the same time, it is important to recall that the immersive media that takes shape in the Era of Immersion may also be noted for its potentially therapeutic and empathic qualities. Due to their immersive nature, many forms of virtual and augmented reality offer possibilities

89. Maxim Gorky, "Coney Island," *The Independent*, August 8, 1907.
90. Fjellman, *Vinyl Leaves*, 358; Huxtable, *The Unreal America*; Kasson, *Amusing the Million*, 81–82.
91. Murray, *Hamlet on the Holodeck*, 23, 28.
92. Scott A. Lukas, "Questioning 'Immersion' in Contemporary Themed and Immersive Spaces," in *A Reader in Themed and Immersive Spaces*, ed. Scott A. Lukas (Pittsburgh: ETC Press, 2016), 115–123.

of creating psychological, physiological, interpersonal, and existential modes of being that may be in line with notable educational or social justice goals.[93] In fact, one possible renegotiation of the embedded argument about the blurring of lines between entertainment and education in theme parks (notably, in the discussions of "edutainment" in Disney theme park rides and attractions)[94] may be found in additional considerations of the specific media, technological and entertainment forms, and experiences noted in this contemporary evolution of the ride. Especially in the era of the Anthropocene, it may be high time to reorient consumer and entertainment practices to activist realms—what I have called a "consumer public sphere."[95] Serious gaming, which aims to use the immersive and engagement potentials of traditional video games for social justice purposes, is one video game form that could be incorporated in new theme park rides such that they begin to reflect more critical and political forms of play.[96] The famous artist Banksy's *Dismaland* (created in Somerset, England, for a period in 2015) suggests an interesting connection of serious social critique and the theme park form.[97] While Banksy's site featured more critical art forms and installations than rides, its use of the theme park and its attractions as a meta-commentary on both society and the theme park form offers insights into the most current era of the theme park ride—that of concept and transcendence.

93. Bolter and Grusin, *Remediation*, 246; Lukas, "A Consumer Public Sphere"; Jane McGonigal, *Reality Is Broken: Why Games Make Us Better and How They Can Change the World* (New York: Penguin, 2011).
94. Lukas, "A Consumer Public Sphere"; Mike Wallace, *Mickey Mouse History and Other Essays on American Memory* (Philadelphia: Temple University Press, 1996).
95. Scott A. Lukas, "Controversial Topics: Pushing the Limits in Themed and Immersive Spaces," *Attractions Management* 20, no. 4 (2015), 50–54; Scott A. Lukas, "Dark Theming Reconsidered," in *A Reader in Themed and Immersive Spaces*, ed. Scott A. Lukas (Pittsburgh: ETC Press, 2016), 225–235; Lukas, "A Consumer Public Sphere."
96. Mary Flanagan, *Critical Play: Radical Game Design* (Cambridge, MA: The MIT Press, 2013); McGonigal, *Reality Is Broken*; Patrick Jagoda, *Experimental Games: Critique, Play, and Design in the Age of Gamification* (Chicago: University of Chicago Press, 2020).
97. Florian Freitag, "Critical Theme Parks: Dismaland, Disney and the Politics of Theming," *Continuum* 31, no. 6 (2017), 923–932.

The Era of Concept: The Transmechanical

The story of artist Gaëlle Engel is one that suggests new trajectories in terms of the evolution of the theme park ride. Engel is one of many worldwide who experience objectum sexuality, or a romantic and sexual attraction to inanimate objects. In the case of the artist, she has entered into a romantic relationship with the Sky Scream roller coaster at Holiday Park in Haßloch, Germany. According to Engel, "Sky Scream inspires me a lot in everything I write and draw," and she claims that through collecting memorabilia of the roller coaster, and, more specifically, through models and reproductions of the ride, the two have conceived children.[98] While some would debate the nature of this relationship, it illustrates how the theme park ride has achieved a state of transcendence, in the etymological meaning of "surmounting, rising above," and "beyond."[99] As well, it suggests a possible apotheosis of ride fandom and the deep and emotional connections that many people, such as members of ACE, establish with rides.

A second story parallels the case of people who fall in love with theme park rides, in this case illustrating the perceived human limits of ride experiences. Following my participation at a theme park industry consultation retreat in the 2010s, I was enjoying drinks with a number of the attendees when I became most intrigued with an individual who began to speak about possible new directions for rides at their company's theme parks and entertainment venues. While the other attendees were addressing ride theming and transmedia integration opportunities for new projects, this individual, who is a designer and engineer, suggested the unimaginable: the company should seriously consider designing rides that defy Newton's law of universal gravitation. None of the attendees besides me seemed surprised with his statement, and I could only engage in internal dialogue and ask, "Did he just say that?!" His bold vision of the theme park rides of the future reminded me of other imaginations

98. Hannah Frishberg, "Woman Says She Found True Love, Had Children with Rollercoaster," *New York Post*, March 12, 2021.
99. "Transcendence," *Online Etymology Dictionary*, https://www.etymonline.com/word/transcendence#etymonline_v_39333.

of spectacular and fantastical machines. *The Centrifuge Brain Project*—a short 2011 film by the German artist Till Nowak—imagines impossible amusement rides that defy gravity and safety conventions for the purpose of exploring life's everyday problems. While Nowak acknowledges that the film and its seven rides are fantastical creations, he has suggested that people would build such devices if it were physically possible to do so.[100] Not unlike the Euthanasia Coaster created by Julijonas Urbonas, which features seven roller coaster elements designed to humanely kill people through lethal g-forces,[101] *The Centrifuge Brain Project* is a conceptual undertaking that both illuminates unspoken existential constructions of rides and analyzes perceived limits of ride design and human experience (see image 4.3).[102]

Image 4.3. A schematic for the High Altitude Conveyance System, one of seven rides created by Till Nowak for the film The Centrifuge Brain Project. Credit: Till Nowak, used with permission.

100. Tytti Ollila, "Till Nowak Makes Impossible Possible," *GBTimes*, April 1, 2014.
101. Blake Butler, "A Roller Coaster Designed to Kill People," *Vice*, December 4, 2014.
102. Additional lethal or impossible roller coasters have been created with popular roller coaster design software, such as *RollerCoaster Tycoon* (1999–). In one case, a designer created a roller coaster that was 210 days long and that killed riders due to starvation. In addition to these projects, others like the *Journal of Ride Theory* zine have ruminated on the topic of death and theme park rides. Matthew Hughes, "Let's Face It: The Best Part of *RollerCoaster Tycoon* Was Killing Tourists," *The Next Web*, September 29, 2017; Dan Howland, *Journal of Ride Theory Omnibus* (Portland: Ride Theory Press, 2004).

Conceptual ride projects also remind of the symbolic gaps or limits in terms of the signification of human amusement, pleasure, and entertainment. As has been discussed in the literature on rides, the presupposition that all theme park and ride activities will follow a "riskless risk" model in which guests experience thrill and danger without actually being hurt or killed is sometimes not a given.[103] As the tragic example at AstroWorld reflects, there is never a guarantee that the pleasure of riding a ride will not result in injury, even if that injury is death. Connecting such human tragedy to the conceptual projects of Nowak and Urbonas, we discover that such impossible projects have actually been built. The design of the Verrückt water slide at Schlitterbahn Kansas City and the many deliberately dangerous and fatal rides at Action Park in Vernon Township, New Jersey (profiled in the 2020 documentary *Class Action Park*), remind, in unfortunate senses, of the limitations of humans in terms of their technological and mechanical constructions. Our primary approach to thinking of rides as instrumental objects of pleasure (and monetary and branded rewards) and not as philosophical, conceptual, or metaphorical figures has certainly led to a curious opportunity in which we now attempt to reverse this course.[104]

The most current era of the ride is that of the transmechanical—referring to a state in which the ride moves beyond its own conceptualization, even its human determinations. To say that a theme park ride is to be understood "in and of itself" is to engage in philosophical and methodological activity that will initially seem absurd. Conceptually, this move is, in a sense, one to affirm that the robots of *Westworld* and *Futureworld* did take over the world and negate the human agency that created them—not literally, but metaphorically as we come to a realization that the theme park ride has entered a state in which it suggests transcendence beyond the interpretations, analytical models, and conceptual viewpoints that have been previously defined for it. Within the worlds of critical art

103. Russel B. Nye, "Eight Ways of Looking at an Amusement Park," *The Journal of Popular Culture* 15, no. 1 (June 1981), 63–75.
104. Heidegger, *The Question Concerning Technology*. The inappropriate design and testing of the ride at Schlitterbahn led to the death of one individual and the filing of criminal charges against three Schlitterbahn employees. In terms of Action Park, it is reported that five fatalities and hundreds of other injuries occurred as a result of the dangerous ride designs and unsafe conditions of the park.

and social science, two burgeoning movements provide opportunities for future studies of rides (and theme parks) as transmechanical entities. Prior conceptualizations of rides and theme parks have either literally viewed these devices (and their human users) as mechanical or have offered interpretations and analyses of them that avoid understandings of what anthropologists call the "emic" or insider's view—that is looking at rides as complex objects that interface with the world, human actors, and other machines, objects, ideas, and memes.[105] The social science movement known as Actor-Network Theory (ANT) offers an opportunity to reframe the study of rides and theme park objects in ways that offer symmetry in terms of analysis.[106] Traditional studies of theme parks have placed human agency and, notably, the critical lens of the social critic/analyst at the center of such studies, as opposed to viewing each object within theme parks through networks of reciprocal and co-equal associations or "unified realities."[107]

An important reorientation of the movement to view rides "in and of themselves" is to reframe the mode of analysis and description from, conceptually, an active voice to what anthropologist Steven A. Tyler and others have noted as the middle voice.[108] In the middle voiced perspective, the presumed actor or agent in the study (the cultural anthropologist) is not envisioned as that which has power over the object (as in the active voice's subject-object relationship). Instead, the analyst is one of many actors within the field of study and is thus part of the field and its processes, as opposed to being the dominant actor within it (in German, the verb *sich rasieren* comes to mind as meaning not "I am shaving my face," but "I am in the process of shaving with my face involved"). In addition, the art movement known as Object Oriented Ontology (OOO) follows a similar path of ANT and the middle voice in

105. Heidegger, *The Question Concerning Technology*.
106. Bruno Latour, *Reassembling the Social: An Introduction to Actor-Network-Theory* (Oxford: Oxford University Press, 2007).
107. Harman, *Object-Oriented Ontology*; Lukas, "Judgments Passed"; Scott A. Lukas, "Research in Themed and Immersive Spaces: At the Threshold of Identity," in *A Reader in Themed and Immersive Spaces*, ed. Scott A. Lukas (Pittsburgh: ETC Press, 2016), 159–169.
108. Steven Tyler, "Them Others - Voices without Mirrors," *Paideuma: Mitteilungen Zur Kulturkunde* 44 (1998): 31–50; Lukas, "Research in Themed and Immersive Spaces."

terms of refocusing analytical and methodological perspectives necessary for a transmechanical understanding of the theme park ride. OOO "is dedicated to exploring the reality, agency, and 'private lives' of nonhuman (and nonliving) entities—all of which it considers 'objects'—coupled with a rejection of anthropocentric ways of thinking about and acting in the world."[109] OOO has also been conceptualized as a sort of "alien phenomenology" that addresses how non-human objects and entities experience the world.[110] As the transmechanical era of rides is developed, the insights of ANT, the middle voice, and OOO may play primary roles in terms of shifting methodological and conceptual focus.

Some critiques of ANT and OOO offer that the approaches seek to imbue non-human, and even non-living, actors with consciousness, agency, and intent. While it is a mistake to attribute such a focus to these movements, the critique provides an interesting opportunity to actually imagine the unimaginable and to project what the evolution of the theme park ride might entail one-hundred, two-hundred, or even more years from now. It is not a mistake that many popular theme park simulation games like *RollerCoaster Tycoon* and *Theme Park* (1994) place a primary player and gaming emphasis on the situation of addressing entropy in theme parks—including out-of-control, bored, and fickle guests, and ride breakdowns and accidents.[111] One of the tensions reminded in the transmechanical era is that the ride and all of its associated connections to the theme park as a whole is imagined as a device that cannot fail, unlike the imaginary constructions of video game simulators. The many versions of *Westworld* suggest a point in popular amusements in which the robotic pleasure and entertainment devices created for humans actually achieve consciousness, agency, and intent and reach the theoretical point of sin-

109. Dylan Kerr, "What Is Object-Oriented Ontology? A Quick-and-Dirty Guide to the Philosophical Movement Sweeping the Art World," *Artspace*, April 8, 2016, http://www.artspace.com/magazine/interviews_features/a-guide-to-object-oriented-ontology-art.
110. Ian Bogost, *Alien Phenomenology, or, What It's like to Be a Thing* (Minneapolis: University of Minnesota Press, 2012).
111. Péter Kristóf Makai, "Three Ways of Transmediating a Theme Park: Spatializing Storyworlds in Epic Mickey, the Monkey Island Series and Theme Park Management Simulators," in *Transmediations: Communication Across Media Borders*, eds. Niklas Salmose and Lars Elleström (New York: Routledge, 2019), 164–185.

gularity. The notion of a robot (or a ride) achieving a point of transcendence in which it develops autonomy from its human creation may seem like one of these fictional and futuristic visions, but the development of new ride technology noted with Universal, Disney, and other major theme park corporations illustrates such a future possibility.

Recent patents and subsequent rides and attractions developments at some theme parks include sophisticated sensors, big data integrations, artificial intelligence, and emotion-monitoring technologies that allow rides, attractions, and themelands to track, respond to, and customize the individual experiences of guests.[112] Augmented and virtual reality technologies allow for forms of near "total immersion" in which it is possible to imagine the theme parks of the future as completely seamless and vivid dreams, not unlike the worlds imagined by cyberpunk author William Gibson or those noted in Terence McKenna's "psychedelic society." One emerging context of total immersion is the platform suggested by Facebook (now Meta) called the Metaverse, which has been described as "a world of endless, interconnected virtual communities."[113] Current and upcoming immersive venues, including Area 15 in Las Vegas, Disney's *Star Wars*: Galactic Star Cruiser immersive hotel, and Kind Heaven in Las Vegas (possibly, though unlikely, under development), will include technological, performative, and dramaturgical approaches, along with hybrid rides and attractions designs that will offer guests opportunities to nearly escape reality at each waking moment.[114] In addition to these public entertainment spaces, transformations within home entertainment and living—including more immersive exercise equipment like NordicTrack iFIT and immersive video gaming and virtual reality devices—suggest that devices of the home will not only resemble (if not replace) public theme park rides, attractions, and associated entertainment machines, they may also achieve a future state of singularity and, through their immersive simulations, a possible Omega Point in terms of shared human

112. Richard Bilbao, "Disney Patent Would Alter Rides Immediately Based on Passenger Emotions," *Orlando Business Journal*, January 30, 2017.
113. Peter Weber, "How Facebook's Metaverse Could Change Your Life," *The Week*, November 28, 2021; Lukas, "Questioning 'Immersion'"; Scott A. Lukas, *The Immersive Worlds Handbook: Designing Theme Parks and Consumer Spaces* (New York: Focal Press, 2013), 203–204.
114. Lukas, *The Immersive Worlds Handbook*, 204.

and machine consciousness.[115] While these visions of the theme park ride may seem fantastical, greater imagination of the evolving trajectories of these machines may only assist researchers of the future in finally writing an evolutionary and cultural account of human-ride interrelationships that is as immersive, thrilling, provocative, and transcendent as the earliest Coney Island amusements.

Bibliography

Adams, Judith. *The American Amusement Park Industry: A History of Technology and Thrills.* Boston: Twayne, 1991.

"Adaptation." *Online Etymology Dictionary.* https://www.etymonline.com/word/adaptation#etymonline_v_25997.

Balanzategui, Jessica, and Angela Ndalianis. "'Being Inside the Movie': 1990s Theme Park Ride Films and Immersive Film Experiences." *The Velvet Light Trap* 84 (Fall 2019): 18–33.

Barthes, Roland. *Mythologies.* New York: Hill & Wang, 2006.

Baudrillard, Jean. *The System of Objects.* London: Verso, 1996.

Baudry, Jean-Louis. "Ideological Effects of the Basic Cinematographic Apparatus." *Film Quarterly* 28, no. 2 (Winter 1975-1974): 39–47.

Bennett, Tony. "A Thousand and One Troubles: Blackpool Pleasure Beach." In *The Birth of the Museum: History, Theory, Politics*, 229–45. London: Routledge, 1995.

Bilbao, Richard. "Disney Patent Would Alter Rides Immediately Based on Passenger Emotions." *Orlando Business Journal*, January 30, 2017.

Bogost, Ian. *Alien Phenomenology, or, What It's like to Be a Thing.* Minneapolis: University of Minnesota Press, 2012.

Bolter, J. David, and Richard A. Grusin. *Remediation: Understanding New Media.* Cambridge, MA: The MIT Press, 1999.

Bryant, Levi R. *Onto-Cartography: An Ontology of Machines and Media.* Edinburgh University Press, 2014.

Bryman, Alan. *The Disneyization of Society.* London: Sage, 2004.

Butler, Blake. "A Roller Coaster Designed to Kill People." *Vice*, December 4, 2014.

Carla, Filippo, and Florian Freitag. "Ancient Greek Culture and Myth in the Terra Mítica

115. Pierre Teilhard de Chardin, *The Phenomenon of Man* (London: Collins, 1975).

Theme Park." *Classical Receptions Journal* (2014): 1–18.

Cartmell, Robert. *The Incredible Scream Machine: A History of the Roller Coaster*. Bowling Green, OH: Bowling Green State University Popular Press, 1987.

Collins, Katie. "Swamp Motel's Escape Room/Scavenger Hunt Mashup Is the Most Fun I've Had in a Year." *CNET*, March 14, 2021.

Craig, Austin. "Will The VOID, the Utah Based Global Leader in Location-Based VR, Survive the Pandemic?" *Tech Buzz News*, October 13, 2020. https://techbuzz.news/will-the-void-die-by-covid-/.

"Dangerous Amusement Devices." *Engineering News-Record* 88, no. 25 (June 22, 1922): 1022.

DeAngelis, Michael. "Orchestrated (Dis)Orientation: Roller Coasters, Theme Parks, and Postmodernism." *Cultural Critique*, no. 37 (1997).

Dziekan, Vince, and Joel Zika. "The Dark Ride: The Attraction of Early Immersive Environments and Their Importance in Contemporary New Media Installations." *Mesh Issue #18: Experimenta Vanishing Point* (2005): 19–22.

Eco, Umberto. *The Open Work*. Cambridge, MA: Harvard University Press, 1989.

Featherstone, Mike. *Consumer Culture and Postmodernism*. Los Angeles: Sage, 2007.

Fish, Stanley. *Is There a Text in This Class? The Authority of Interpretive Communities*. Cambridge, MA: Harvard University Press, 2003.

Fjellman, Stephen M. *Vinyl Leaves: Walt Disney World and America*. Boulder: Westview Press, 1992.

Flanagan, Mary. *Critical Play: Radical Game Design*. Cambridge, MA: The MIT Press, 2013.

Freitag, Florian. "'Like Walking into a Movie': Intermedial Relations between Theme Parks and Movies." *The Journal of Popular Culture* 50, no. 4 (August 2017): 704–22.

———. "Critical Theme Parks: Dismaland, Disney and the Politics of Theming." *Continuum* 31, no. 6 (2017): 923–32.

———. "Movies, Rides, Immersion." In *A Reader in Themed and Immersive Spaces,* edited by Scott A. Lukas, 125–30. Pittsburgh: ETC Press, 2016.

Freud, Sigmund. "The Uncanny." In *The Standard Edition of the Complete Psychological Works of Sigmund Freud, Volume XVII (1917–1919): An Infantile Neurosis and Other Works*, 217-56. London: Hogarth, 1955.

Frishberg, Hannah. "Woman Says She Found True Love, Had Children with Rollercoaster." *New York Post*, March 12, 2021.

Gergen, Kenneth J. *The Saturated Self: Dilemmas of Identity in Contemporary Life*. New York: Basic Books, 2000.

Gorky, Maxim. "Coney Island." *The Independent*, August 8, 1907.

Grossman, Dave, and Gloria DeGaetano. *Stop Teaching Our Kids to Kill: A Call to Action Against TV, Movie, and Video Game Violence*. New York: Three Rivers Press, 2001.

Guignon, Charles. *On Being Authentic*. New York: Routledge, 2004.

Harman, Graham. *Object-Oriented Ontology: A New Theory of Everything*. New York: Pelican, 2018.

Hart, Lance. "Ready Player One? The Rise of Theme Park Gamification." *Blooloop*, February 11, 2021.

Heidegger, Martin. *The Question Concerning Technology and Other Essays*. New York: Harper & Row, 1996.

Hochschild, Arlie. *The Managed Heart: Commercialization of Human Feeling*. Berkeley: University of California Press, 2012.

Howland, Dan. *Journal of Ride Theory Omnibus*. Portland: Ride Theory Press, 2004.

Hughes, Matthew. "Let's Face It: The Best Part of RollerCoaster Tycoon Was Killing Tourists." *The Next Web*, September 29, 2017.

Huxtable, Ada Louise, ed. *The Unreal America: Architecture and Illusion*. New York: New Press, 1997.

"Interactive Dark Rides for Museums, Exhibits, Theme Parks & More." *Sally Dark Rides*. 2021. https://www.sallydarkrides.com/dark-rides.

Jagoda, Patrick. *Experimental Games: Critique, Play, and Design in the Age of Gamification*. Chicago: University of Chicago Press, 2020.

Jenkins, Henry. *Convergence Culture: Where Old and New Media Collide*. New York: New York University Press, 2008.

Jenkins, Henry, Sam Ford, and Joshua Green. *Spreadable Media: Creating Value and Meaning in a Networked Culture*. New York: New York University Press, 2013.

Jentsch, Ernst. "On the Psychology of the Uncanny." *Angelaki: Journal of the Theoretical Humanities* 2, no. 1 (1997): 7-16.

Johnson, Steven. "Ferris Wheel: Scott A. Lukas and the History of Theme Parks." June 4, 2020, in *American Innovations*. Produced by Wondery, podcast, 30:59.

Kasson, John F. *Amusing the Million: Coney Island at the Turn of the Century*. New York: Hill & Wang, 2002.

Kerr, Dylan. "What Is Object-Oriented Ontology? A Quick-and-Dirty Guide to the Philosophical Movement Sweeping the Art World." *Artspace*, April 8, 2016. http://www.artspace.com/magazine/interviews_features/a-guide-to-object-oriented-ontology-art.

Klein, Norman M. *The Vatican to Vegas: A History of Special Effects*. New York: New Press, 2004.

Kokai, Jennifer A., and Tom Robson, eds. *Performance and the Disney Theme Park Experience: The Tourist as Actor*. Cham, Switzerland: Palgrave Macmillan, 2019.

Kowalewski, Hubert. "Against Arbitrariness: An Alternative Approach Towards Motivation of the Sign." *Public Journal of Semiotics* 6, no. 2 (2015): 14–31.

Lacan, Jacques. *The Seminar of Jacques Lacan: Book VII: The Ethics of Psychoanalysis 1959–1960*. New York: Norton, 1997.

———. *Ecrits: The First Complete Edition in English*. New York: Norton, 2006.

Latour, Bruno. *Reassembling the Social: An Introduction to Actor-Network-Theory*. Oxford: Oxford University Press, 2007.

Lukas, Scott. "On Architecture, Entertainment, and Discomfort." *The Right Angle Journal* 3, no. 4 (Summer 2020): 6–8.

———. "An American Theme Park: Working and Riding Out Fear in the Late Twentieth Century." In *Late Editions 6, Paranoia within Reason: A Casebook on Conspiracy as Explanation*, edited by George Marcus, 405–28. Chicago: University of Chicago Press, 1999.

———. "Behind the Barrel: Reading the Cultural History of the Gun in Video Games." In *Joystick Soldiers: The Military/War Video Games Reader*, edited by Nina Huntemann and Matt Payne, 75–90. New York: Routledge, 2008.

———. "A Case for Remakes, the State of 'Re.'" Unpublished manuscript, 2013.

———. "The Cinematic Theme Park." Unpublished manuscript, 2009.

———. "A Consumer Public Sphere: Considering Activist and Environmental Narratives in the Contexts of Themed and Consumer Spaces." In *Environmental Philosophy, Politics, and Policy*, edited by John Duerk, 159–76. Lanham, MD: Lexington, 2021.

———. "Controversial Topics: Pushing the Limits in Themed and Immersive Spaces." *Attractions Management* 20, no. 4 (2015): 50–54.

———. "Covid-19 and Immersion: Physical, Virtual, and Home Spaces." *Journal of Themed Experience and Attractions Studies* 2, no. 1 (2022).

———. "The Dark Theme Park." *In Media Res*, 2020. http://mediacommons.org/imr/content/dark-theme-park.

———. "Dark Theming Reconsidered." In *A Reader in Themed and Immersive Spaces*, edited by Scott A. Lukas, 225–35. Pittsburgh: ETC Press, 2016.

———. "Horror Video Game Remakes and the Question of Medium: Remaking Doom, Silent Hill, and Resident Evil." In *Fear, Cultural Anxiety and Transformation: Horror, Science Fiction and Fantasy Films Remade*, edited by Scott A. Lukas and John Marmysz, 221–42. Lanham, NH: Lexington, 2009.

———. "How the Theme Park Got Its Power: The World's Fair as Cultural Form." In *Meet Me at the Fair: A World's Fair Reader*, edited by Celia Pearce, 395–407. Pittsburgh: ETC Press, 2013.

———. *The Immersive Worlds Handbook: Designing Theme Parks and Consumer Spaces*. New York: Focal Press, 2013.

———. "Judgments Passed: The Place of the Themed Space in the Contemporary World of Remaking." In *A Reader in Themed and Immersive Spaces*, edited by Scott A. Lukas, 257–68. Pittsburgh: ETC Press, 2016.

———. "Questioning 'Immersion' in Contemporary Themed and Immersive Spaces." In *A Reader in Themed and Immersive Spaces*, edited by Scott A. Lukas, 115–23. Pittsburgh: ETC Press, 2016.

———. "Research in Themed and Immersive Spaces: At the Threshold of Identity." In *A Reader in Themed and Immersive Spaces*, edited by Scott A. Lukas, 159–69. Pittsburgh: ETC Press, 2016.

———. *Theme Park*. London: Reaktion Books, 2008.

———. "The Theme Park and the Figure of Death." *InterCulture* 2, no. 2 (2005).

———. "Theming and Immersion in the Space of the Future." In *A Reader in Themed and Immersive Spaces*, edited by Scott A. Lukas, 289–300. Pittsburgh: ETC Press, 2016.

Lupton, Ellen. *Design Is Storytelling*. New York: Cooper Hewitt Smithsonian Design Museum, 2017.

Makai, Péter Kristóf. "Three Ways of Transmediating a Theme Park. Spatializing Storyworlds in Epic Mickey, the Monkey Island Series and Theme Park Management Simulators." In *Transmediations: Communication Across Media Borders*, edited by Niklas Salmose and Lars Elleström, 164–85. New York: Routledge, 2019.

Maloney, Judith. "Fly Me to the Moon: A Survey of American Historical and Contemporary Simulation Entertainments." *Presence: Teleoperators and Virtual Environments* 6, no. 5 (1997): 565–80.

Mangels, William. *The Outdoor Amusement Industry: From Earliest Times to the Present*. New York: Vantage, 1952.

Marx, Karl. *Capital: A Critique of Political Economy, Volume 1*. New York: Vintage Books, 1977.

Marx, Leo. *The Machine in the Garden: Technology and the Pastoral Ideal in America*. New York: Oxford University Press, 2000.

McCullough, Edo. *Good Old Coney Island: A Sentimental Journey into the Past*. New York: Fordham University Press, 2000.

McGonigal, Jane. *Reality Is Broken: Why Games Make Us Better and How They Can Change the World*. New York: Penguin, 2011.

Metz, Rachel. "Inside the First VR Theme Park." *MIT Technology Review*, December 15, 2015. https://www.technologyreview.com/2015/12/15/71958/inside-the-first-vr-theme-park/.

Miller, Daniel. *The Comfort of Things*. Cambridge, UK: Polity, 2008.

Munch, Richard W. *Harry G. Traver, Legends of Terror*. Mentor, OH: Amusement Park Books, 1982.

Murray, C.H. *Luna Park: The Electric City by the Sea, Official Program*. Brooklyn: Eagle Press, 1903.

Murray, Janet Horowitz. *Hamlet on the Holodeck: The Future of Narrative in Cyberspace*. Cambridge, MA: The MIT Press, 1997.

Ndalianis, Angela. "Dark Rides, Hybrid Machines and the Horror Experience." In *Horror Zone: The Cultural Experience of Contemporary Horror Cinema*, edited by Ian Conrich, 11–26. London: I.B. Tauris, 2010.

Novak, B.J. "MONSTER: The Roller Coaster." In *One More Thing: Stories and Other Stories*. New York: Vintage Contemporaries, 2015.

Nye, Russel B. "Eight Ways of Looking at an Amusement Park." *The Journal of Popular Culture* 15, no. 1 (June 1981): 63–75.

Ollila, Tytti. "Till Nowak Makes Impossible Possible." *GBTimes*, April 1, 2014.

OSHA. "Inspection Detail | Occupational Safety and Health Administration." *United States Department of Labor,* 1997. https://www.osha.gov/pls/imis/establishment.inspection_detail?id=123618464.

Phantasialand. "Hollywood Tour – Phantasialand." https://www.phantasialand.de/en/theme-park/one-of-a-kind-attractions/hollywood-tour/.

Rabinovitz, Lauren. *Electric Dreamland: Amusement Parks, Movies, and American Modernism*. New York: Columbia University Press, 2012.

Register, Woody. *The Kid of Coney Island: Fred Thompson and the Rise of American*

Amusements. New York: Oxford University Press, 2003.

"Ride." *Online Etymology Dictionary*. https://www.etymonline.com/search?q=ride.

de Saussure, Ferdinand. *Course in General Linguistics*. Peru, IL: Open Court, 1998.

Schwarz, Ariane. "Staging the Gaze – The Water Coaster Poseidon as an Example of Staging Strategies in Theme Parks." In *Time and Temporality in Theme Parks*, edited by Filippo Carlà-Uhink, Florian Freitag, Sabrina Mittermeier, and Ariane Schwarz. Hannover: Wehrhahn, 2017.

Schweizer, Bobby. "Visiting the Videogame Theme Park." *Wide Screen* 6, no. 1 (2016).

Schweizer, Bobby, and Celia Pearce. "Remediation on the High Seas: A Pirates of the Caribbean Odyssey." In *A Reader in Themed and Immersive Spaces*, edited by Scott A. Lukas, 95–106. Pittsburgh: ETC Press, 2016.

Scott, Katie. "Disney to Change Splash Mountain Theme amid Outcry over 1946 Movie." *Global News*, June 25, 2020. https://globalnews.ca/news/7107801/splash-mountain-changing/.

Spilsbury, Louise, and Richard Spilsbury. *Ride That Rollercoaster!: Forces at an Amusement Park*. Chicago: Heinemann, 2015.

Stewart, Susan. *On Longing: Narratives of the Miniature, the Gigantic, the Souvenir, the Collection*. Durham: Duke University Press, 1993.

Sundt, Hal. "The Quest for the Best Amusement Park Is Ever-Changing and Never-Ending." *The Ringer*, February 20, 2020.

Szabo, Sacha. *Rausch und Rummel: Attraktionen auf Jahrmärkten und in Vergnügungsparks. Eine soziologische Kulturgeschichte*. Bielefeld: transcript Verlag, 2015. https://doi.org/10.1515/9783839405666.

Teilhard de Chardin, Pierre. *The Phenomenon of Man*. London: Collins, 1975.

"Transcendence." *Online Etymology Dictionary*. https://www.etymonline.com/word/transcendence#etymonline_v_39333.

Turkle, Sherry, ed. *Simulation and Its Discontents*. Cambridge, MA: The MIT Press, 2009.

Turner, Victor. *The Forest of Symbols: Aspects of Ndembu Ritual*. Ithaca, NY: Cornell University Press, 2002.

Tyler, Steven. "Them Others – Voices without Mirrors." *Paideuma: Mitteilungen Zur Kulturkunde* 44 (1998): 31–50.

"This Unique Project Is Using Virtual Reality to Document the Fast-Disappearing Haunted Rides of America." *Outlook India*, July 27, 2020. https://www.outlookindia.com/outlooktraveller/explore/story/70713/americas-haunted-rides-can-now-be-enjoyed-on-vr.

Wallace, Mike. *Mickey Mouse History and Other Essays on American Memory*. Philadelphia: Temple University Press, 1996.

Wickstrom, Maurya. *Performing Consumers: Global Capital and Its Theatrical Seductions*. New York: Routledge, 2006.

Williams, Rebecca. *Theme Park Fandom: Spatial Transmedia, Materiality and Participatory Cultures*. Amsterdam: Amsterdam University Press, 2020.

Žižek, Slavoj. *Looking Awry: An Introduction to Jacques Lacan through Popular Culture*. Cambridge, MA: The MIT Press, 2002.

VI. POSTHUMAN VIRTUALITIES

Gods of the Sandbox

Animal Crossing: New Horizons and the Fluidity of Virtual Environments

Daniel Vella

Introduction

In a review of *Animal Crossing: New Horizons* (*AC:NH*) (2020)[1], the critic Steven Scaife lays out the long-standing appeal of the *Animal Crossing* (2001–) series of life simulation games:

> Through minutes that pass by in real time and activities that change based on month or time of day, the games cultivate a sort of relationship between players and the virtual space they eventually inhabit. We come to know its layout and its occupants, moving around the place and helping to maintain it.[2]

The *Animal Crossing* game series arrests the forward-moving, goal-oriented spatial practices that tend to define players' engagement with virtual environments. Rather than having the player traverse the landscape, venturing to one new locale after another until they get to the end of the game, they invite the player to stay in place. Their real-time clock structures practices of lingering, repetition, and habit. Players will become intimately acquainted with the paths between their in-game house, the town hall, and the shop. They will learn by heart the fruit-picking route

1. Nintendo EPD, *Animal Crossing,* Nintendo, Switch, 2020.
2. Steven Scaife, "Review: *Animal Crossing: New Horizons* Makes You the God of the Sandbox," *Slant Magazine,* April 12, 2020, https://www.slantmagazine.com/games/review-animal-crossing-new-horizons-makes-you-the-god-of-the-sandbox/.

they follow every three days; every sight and sound in the village will gain the affectionate glow of familiarity. In these ways, the village becomes a rich placescape mapped out by habit and familiarity of practice,[3] and *Animal Crossing* players experience a phenomenological sense of inhabitation of the virtual community they inhabit as "home."[4]

However, among other new features to the series, *AC:NH* grants players far-reaching, terraforming abilities, allowing them to reorganize the topography of their island at will. These features, Scaife argues, result in a fundamental shift in players' relations to the place of their virtual community, undermining this sense of inhabitation:

> Eventually, you get game-changing terrain tools to freely remap the cliffs and the water, and at that point the only thing holding your island together is any attachment you've fostered with the way things have looked for the many prior hours of play. And maybe we choose to keep things the way they are, despite the power to reshape and remake however we please. Enough of *Animal Crossing: New Horizons* is still measured and thoughtful enough to foster those connections that make the series so refreshing and vital. But it also feels tainted, with its world so much more blatantly at your mercy. Rather than a newcomer to a simulated community that was there before you, you're now the god of the sandbox.[5]

In *AC:NH,* "landscape" becomes a verb rather than a noun. With the player having near-absolute power to reshape their island at will, the spatial qualities which structure its placeness are stripped of their staying power.

This chapter takes *AC:NH* as representative—in its infinite and effortless malleability—of a fluidity that is characteristic of virtual environments as such. This fluidity of virtual environments, I argue, is both a product and a representation of a particular contemporary ontological organi-

3. Edward S. Casey, *Getting Back into Place: Towards a Renewed Understanding of the Place-World* (Bloomington, IN: Indiana University Press, 1993), 28–29.
4. Daniel Vella, "There's No Place Like Home: Dwelling and Being at Home in Digital Games," in *Ludotopia: Spaces, Places and Territories in Computer Games,* ed. Espen Aarseth and Stephan Günzel (Bielefeld: Transcript Publishing, 2019), 141–166; Gracie Lu Straznickas, "Not Just a Slice: *Animal Crossing* and a Life Ongoing," *Loading…The Journal of the Canadian Games Association* 13, no. 22 (2020): 72–88.
5. Scaife, "Review."

zation of the world, and of human being-in-the-world. By this understanding of the world, which I unpack with reference to the work of contemporary philosophers Byung-Chul Han and Federico Campagna, time is no longer understood as an extended duration within which cause and effect link up but is fragmented into isolated moments of pure present. Simultaneously, the world is similarly "cut up" into discrete units that can be replaced, reorganized, and replicated at will. In reflecting, and embodying, this contemporary enframing of the world, these virtual environments become non-places—possibility spaces which only accrue placeness in the momentary pauses between their fluid reconfigurations, enacting a play of placeness which I discuss in relation to two archetypical places of play: the sandbox and the playground.

Fluid Placescapes

Much writing on the virtual spaces of digital game worlds has tended to catalogue, or describe, the different topologies, features, and qualities of these spaces[6] and the ways these elements—say, maze structures[7] or open-world topographies[8]—shape the dynamics of the player's being in the space. It is not the case, though, that every game gives the player a fixed topography to navigate. In their proposed classification system for digital games, Christian Elverdam and Espen Aarseth list "environment dynamics" as one of the criteria, distinguishing between games with free, fixed, or no environment dynamics. By this criterion, games with free environment dynamics are those in which "the player is allowed to make additions or alterations to the game space."[9]

6. Mark J.P. Wolf, "Inventing Space: Towards a Taxonomy of On- and Off-Screen Space in Video Games," *Film Quarterly* 51, no. 1 (1997): 11–23, https://doi.org/10.2307/1213527; Michael Nitsche, *Video Game Spaces: Image, Play and Structure in 3D Worlds* (Cambridge, MA: The MIT Press, 2008); Gordon Calleja, *In-Game: From Immersion to Incorporation* (Cambridge, MA: The MIT Press, 2011), 78–85; Mathias Fuchs, *Phantasmal Spaces: Archetypical Venues in Computer Games* (London: Bloomsbury, 2019).
7. Alison Gazzard, *Mazes in Videogames: Meaning, Metaphor and Design* (Jefferson, NC: McFarland, 2013).
8. Marc Bonner, "The World-Shaped Hall: On the Architectonics of the Open World Skybox and the Ideological Implications of the 'Open World Chronotope,'" in *Game/World/Architectonics*, ed. by Marc Bonner (Heidelberg: Heidelberg University Press, 2021), 65–98.
9. Christian Elverdam and Espen Aarseth, "Game Classification as Game Design: Construction Through Critical Analysis," *Games and Culture* 2, no. 1 (2007): 3–22, 9.

A number of digital games present the player with the means to work their will upon the landscape, rendering it fluid and changeable. In this regard, *Populous* (1989)[10] is recognized as sui generis. The player is cast as a god watching over a tribe, and the game grants them the power to reshape the landscape at will by raising or lowering the terrain or creating swamps, land bridges, or volcanoes to suit their tribe's needs. *Civilization* (1991)[11] and its sequels allow the player to reshape their worlds in the shape of the Anthropocene, turning grasslands into fields, laying roads and railways, building mines, and so on. Taking this even further, *Startopia* (2001),[12] which positions the player as the manager of a space station hosting various alien races, gives players control of a biodeck—an artificial biome over which they are granted complete control—with the ability to freely determine terrain height, water level, moisture, and temperature, and to thereby reshape the ecosystem at will.

These are examples of what Georgia Leigh McGregor calls "creation space," "where the player creates all or part of game space as part of gameplay."[13] However, none of these games—nor other examples, such as *Lemmings* (1991)[14] or *The Sims* (2000),[15] that Elverdam and Aarseth and McGregor respectively cite—are virtual worlds that the player inhabits in a phenomenological sense. Since these are not games which position the player in an embodied ludic subjectivity,[16] the conditions are not met for the player to experience a sense of being-there. The player is not given an avatarial body to anchor their phenomenological relation to the game world—there is no mechanism of "incorporation," a term used by Gordon Calleja to refer to the player's experiential sense of inhabiting a game world as an embodied being. Given that, as the philosopher Edward S.

10. Bullfrog Productions, *Populous,* Electronic Arts, Amiga, 1989.
11. MicroProse, *Civilization,* MicroProse, PC, 1991.
12. Mucky Foot Productions, *Startopia,* Eidos Interactive, PC, 2001.
13. Georgia Leigh McGregor, "Situations of Play: Patterns of Spatial Use in Videogames," *Situated Play: Proceedings of DiGRA 2007 Conference,* Tokyo: 537–545, 539, http://www.digra.org/wp-content/uploads/digital-library/07312.05363.pdf.
14. DMA Design, *Lemmings,* Psygnosis, Amiga, 1991.
15. Maxis, *The Sims,* Electronic Arts, PC, 2000.
16. Daniel Vella, "Who am 'I' in the Game? A Typology of the Modes of Ludic Subjectivity," *Proceedings of the 1st International Joint Conference of DiGRA and FDG,* Dundee, 2016: 3, http://www.digra.org/wp-content/uploads/digital-library/paper_234.pdf.

Casey observes, "place is what happens between body and landscape,"[17] with no embodied presence, the player does not feel like they are in the virtual space of these games. Instead, the player interacts with the virtual space from a disembodied position that transcends the space. Appropriately, *Populous* and its successors belong to a genre called "god games."

On the other hand, games like *AC:NH, Minecraft* (2011),[18] *Dragon Quest Builders,*[19] and *LEGO® Worlds*[20] embody the player in landscapes that can be taken apart and reassembled however the player desires. Here—at least in theory—creation space is inhabited, with players having an active, bodily existence in the form of their avatar in a virtual environment they have extensive capabilities to reshape.

Bjarke Liboriussen's ethnographic study of a community of self-styled "builders" in *Second Life* (2003)[21] demonstrates the appeal of inhabiting such malleable virtual spaces. The members of this particular virtual world community found a purpose for their being-in-the-virtual-world, specifically in the building of a "castle," a project which they understood as process rather than as end result—for these players, "the building understood as *activity* is never over."[22] Rather than making possible the achievement of a final, desired form, the malleability of the virtual world—even within the constraints of the intersubjective, communal nature of the project—becomes an end in itself, allowing for a seemingly infinite play of making and remaking of place.

17. Casey, *Getting Back into Place,* 29.
18. Mojang Studios, *Minecraft,* Mojang Studios, PC, 2011.
19. Square Enix, *Dragon Quest Builders* (2016), Square Enix, PlayStation 4, 2016.
20. Traveller's Tales, *LEGO® Worlds,* Warner Bros. Interactive Entertainment, PlayStation 4, 2017.
21. Linden Lab, *Second Life,* Linden Lab, PC, 2003.
22. Bjarke Liboriussen, "Collective Building Projects in *Second Life*: User Motives and Strategies Explained from an Architectural and Ethnographic Perspective," in *Virtual Worlds and Metaverse Platforms: New Communication and Identity Paradigms,* ed. Nelson Zagalo, Leonel Morgalo, and Ana Boa-Ventura (Hershey, PA: Information Science Reference, 2012): 33–46, 39.

Such examples foreground, in a particularly explicit way, the fact that virtual environments are marked by a "fluidifying sway."[23] We encounter the actual world we live in as an extent of undeniable, material facticity that is, by and large, fixed. While it is certainly possible for us to undertake to change our physical environment in some way—for example, by building a house or laying out a garden—such changes are generally difficult to realize, requiring a significant investment of time and effort, and are hard to reverse. By contrast, nothing in the virtual domain—not the environment and not our being within it—needs to take a fixed shape. Everything can change from one minute to the next, choices can be made, unmade, and remade: cause need not necessarily link with effect. Everything is fluid and changeable, and, indeed, this "fluidization" is a defining characteristic of the virtual.[24]

This malleability is a big part of the appeal of such virtual worlds. It is thanks to this fluidity of form that virtual environments, and the virtual subjectivities through which we inhabit such environments, can become the loci for existential experiments. In virtual environments, we can test out possibilities of being, reconfigure the contours of our virtual home, and change our habits and practices without any of the commitment or investment that such changes would involve in our embodied existence in the actual world.

Nonetheless, there is another side to this coin. Quite apart from any specific experiment of being we can choose to settle into in a given virtual environment, these domains give us the experience of that malleability itself—of inhabiting a place defined by its lack of fixity and resistance—that we can freely remake to our own purposes.

23. Stefano Gualeni and Daniel Vella, *Virtual Existentialism: Meaning and Subjectivity in Virtual Worlds* (Basingstoke: Palgrave Macmillan, 2020), 113.
24. Pierre Lévy, *Becoming Virtual: Reality in the Digital Age,* trans. Robert Bononno (New York and London: Plenum Trade, 1998), 27.

Inevitably, the way we relate to, and inhabit, such a place is going to be radically different to the ways in which we fit ourselves to the facticity of whatever actual place we call home. To be in a place, Casey writes, is to be "subject to its power"[25]—it is to fit oneself to the contours of that place, to learn the paths across it and the actions it affords. Stay in that place long enough and those paths and actions become habitual, giving us the "felt familiarity" which relates to the places in which we dwell.[26] With virtual places, matters seem different. On the one hand, the fluidity of the virtual placescape is defined by the opening up of a seemingly infinite array of possibilities to be explored. On the other hand, this lack of solidity results in a lack of commitment and spatiotemporal stability and the devaluing of any given configuration inherent in privileging this fluidity itself. And yet, though this might appear to stand in stark contrast to the relative fixity and resistance of the physical world, this fluidity reflects crucial aspects of our contemporary relationship to the actual world, as identified in the work of the contemporary philosophers Byung-Chul Han and Federico Campagna. In order to better understand the significance of these fluid virtual worlds, then, we should engage briefly with their respective works. Specifically, in the next sections of this chapter, I engage with Han's writing on the spatiotemporal discontinuities of our present being-in-the-world and Campagna's highlighting of the logic of measure as an ontological principle.

Spatiotemporal Discontinuity

In his book *The Scent of Time,* Byung-Chul Han describes what he perceives as a contemporary crisis of human being-in-the-world. The way in which the world is organized into a meaningful, coherent shape in our experience, he argues, is "based on temporal extension, on interconnections between temporal horizons."[27] The present connects to the past through memory and to the future through projects, commitments, or the anticipation of change. In this way, each moment of our experience is a part of a recognizable form. These forms can be cyclical, as in mythic

25. Casey, *Getting Back into Place,* 23.
26. Ibid., 116.
27. Byung-Chul Han, *The Scent of Time,* trans. Daniel Steuer (Cambridge: Polity Press, 2017), 5.

time, with the predictable succession of the seasons, of sowing and harvest, and the rhythm of familial generations, or they can be linear, as in the teleological idea of historical progress or of advancing on a lifelong career path—in either case, there is a comprehensible shape connecting the present moment to spans of the past and the future.

In our present socio-cultural moment, however, our experience of temporal extension has broken down. Everything can be made, unmade, and remade at will. Our past choices do not form a commitment to be honored in the present—their consequences can simply be deleted. Things appear literally "out of nowhere" which were not anticipated in the past because there was nothing in the placescape of our lived experience that gave rise to them through chains of causality or intention. In the same way, our present actions lose their connections to the future. The other side of the coin of freedom is disposability—an endless starting-over—and a lack of orientation resulting from the absence of fixed prospects. As a result, we find ourselves in what Han calls "atomized time."[28] Instead of a present that is always connected to a past and a future, we find ourselves living "life as a directionless sequence of present moments" in a galaxy of "point-like presences between which there is no longer any temporal attraction."[29]

For Han, this atomization of time is inseparable from a breakdown of space. Just as we no longer have to wait until a certain time of day for our favorite TV shows to air, thanks to the instant availability of content on streaming services, distances are erased by instantaneous communication and intercontinental travel. By boarding a plane in Frankfurt and disembarking in Tokyo, there is no sense of spatial continuity or connection between the two spaces, as there would be between the start and end point of a walk. Experientially, we are simply in one place and then the other. We are never "on the way" to something, we never "wait"—the path, the in-between places disappear. Instead, everything is present at the same time; everywhere can be instantaneously accessed, the list of flight departures on an airport monitor the equivalent of the list of TV

28. Han, *The Scent of Time,* 18.
29. Ibid., 5.

shows instantly available to stream. And the technologies and conceptualities of the virtual are intrinsic to this: Pierre Lévy, in fact, speaks of the virtual as enacting a process of "deterritorialization," a breakdown of spatial and temporal unity.[30] This immediate availability of everything removes the spatial directionality of the path, or the temporal directionality of a goal or of waiting—all of which, apart from everything else, are structures of continuity. As Han writes,

> A space made up of possibilities for further connection does not have any continuity. In it, again and again, decisions are made anew, and new possibilities are pursued, making time discontinuous. No decision is final. What is suspended is linear, irreversible time.[31]

Everything, everywhere, all of the time.[32] In Han's words, "everything has the opportunity, even *must* have the opportunity, of becoming part of the present."[33] Despite the "leisurely pace" and intentionally slow movement that is characteristic of the *Animal Crossing* series,[34] *AC:NH* certainly embodies this: you can carry full-grown trees in your pockets to instantly plant them anywhere on your island, and you can choose to erase rivers, lakes, and cliffs, or bring them into being. Every possibility for your island's landscape can be immediately available.

However, when every option is available to us at any time, we become restless, literally unsettled—actual conditions and situations are overshadowed by the multitude of possibilities. As a result, "nothing is incisive, nothing final . . . due to the excessive number of possible connections, i.e. possible directions, things are rarely ever completed."[35]

30. Lévy, *Becoming Virtual,* 30.
31. Han, *The Scent of Time,* 39.
32. It is unsurprising that this phrase suddenly appears to define the cultural zeitgeist. In comedian Bo Burnham's film *Inside*—arguably as significant an artefact of pandemic-era cultural life as *AC:NH*—the song "Welcome to the Internet" summarizes the appeal (and the danger) of perpetually connected existence with the promise of "a little bit of everything all of the time." Meanwhile, at the time of writing, the film *Everything Everywhere All at Once* (2022) draws upon another increasingly ubiquitous trope—that of an infinite multiverse of possible worlds of which the actual world is only one configuration.
33. Han, *The Scent of Time,* 41.
34. Straznickas, "Not Just a Slice," 76.
35. Han, *The Scent of Time,* 25.

Playing any of the earlier *Animal Crossing* games, I knew that however long I would continue to inhabit that virtual community, the river flowing through it would continue to follow the same path to the same sea, and the line of cliffs on the north side of the island would remain an impassable boundary around which I would have to shape my journey as I pursue the day's errands. In *AC:NH,* this is no longer the case. If I find a ridge of cliffs tiresome to walk around, or if a river is proving to be an obstacle for a building project, I can immediately redraw the features of the landscape by placing or removing bodies of water, cliffs, and paths as I see fit. If I do not like how the changes turn out, it is trivial to undo the changes or to try again.

Certainly, reflecting Martin Heidegger's observation that "building is really dwelling,"[36] the process of building was always a key part of the player's inhabitation of their Animal Crossing village. One could lay down bridges to connect opposite riverbanks, for example, and choose where to place public buildings. Such construction projects, however, required the player to gather significant amounts of in-game resources—sometimes requiring a few days' work—and were subject to a waiting period of at least one real-time day even after the requisite resources were available. This remains the case with similar building projects in *AC:NH.* By contrast, there is no resource cost for terraforming interventions and no waiting period: every imaginable configuration of the player's island is instantly and effortlessly available.

Because of this, there is no sense of inhabiting a place in the sense of responding to the givenness of the landscape. The frequent changes a player is likely to will upon their island—when even the slightest whim can be accommodated in this regard—means that no single configuration of the island is likely to linger long. Players can take on a grand terraforming project, grow bored with it, abandon it halfway, and reshape the island in such a way as to leave no trace of it—all in the span of a couple of hours. In this light, it is likely the player will absorb an unsettled

36. Martin Heidegger, "Building Dwelling Thinking," in *Basic Writings,* ed. David Farrell Krell (London and New York: Routledge, 2004): 347–363, 350.

sense of the temporariness of their island, reflecting a contemporary culture of transience and fluidity in which, as Han writes, "ideally, a change of direction is possible at any time. There is no finality. Everything is kept in limbo."[37]

The World of Measure

While Han identifies an existential crisis in our lived world, Federico Campagna argues that, at the core of this crisis, there lies a specific ontological understanding of the world. Campagna argues that the hegemonic "reality-system" that holds sway in our present moment—the implicit set of foundational principles by which we, as a culture, understand the world, but which are so fundamental that they simply appear as the natural way the world is—is one he calls "Technic." In this way of organizing the world, the "basic ontological principle" is "measure."[38] By this term, Campagna refers, as one would imagine, to the logic of quantification and the idea that everything is measurable and reducible to numerical value—a logic we see at work in the contemporary ubiquity of practices of the quantified self, in the Google Scholar-aided quantification of academic impact, and in countless other examples.

However, for Campagna, the idea of measure goes far beyond that. First of all, he argues, "the notion of measure consists in the original act of 'cutting up' the world, in a manner that makes it available to be infinitely recombined."[39] The continuity of the world, of things and existents, of space and time, is divided up into points and organized into distinct and clearly defined categories (the organization of living things, in their infinite variation, into discrete species can be taken as an example of this). As with Han, we have here a process of atomization of our lived reality, as the world is fragmented into a set of discrete units of measure.

37. Han, *The Scent of Time*, 39.
38. Federico Campagna, *Technic and Magic: The Reconstruction of Reality* (London: Bloomsbury Academic, 2018), 34.
39. Ibid.

"Measure," however, not only "cuts up" the world into categories, but also organizes these categories into a grammar of functional positions in a system. As a result, an object's category—the position it fills within the system—becomes more important than the existence of the individual thing. As Campagna says, with "measure" as a basic ontological principle, we "move from an ontology of unique and irreducible 'things,' to an ontology of positions in a series. Through this process, 'things' are reduced to equivalent units, which are present in the world only in as much as they are able to activate such grammatical positions."[40]

Campagna illustrates this point in relation to the organization of conservation and biodiversity discussions around the discourse of extinction. Such a discourse, he argues, grants no importance to the uniqueness of life that a given individual of a species represents. Instead, the importance is granted to the species-category itself. It is the category that is deemed worthy of preservation, not any of the actual lives grouped within it. This, Campagna argues, "reflects the silent consensus over a reality-system that sees serial positions such as species, as more 'real', and thus worthier of protection, that individual living things."[41] To return to an earlier example, we can also consider how, on streaming services, the unique qualities of a particular film appear to be far less important than its capacity to occupy specific category tags.

The logic of measure is, of course, the founding principle of the idea of the "digital." Digitality, after all, is based upon the rendering of information as a set of discrete, quantifiable units. To digitize a physical image (say, a painting) means to cut it up into a number of discrete pixels, each of which has a numerically defined color value in a defined series. In 8-bit color, for example, there are 256 possible color values that each pixel can take; in 24-bit color, by combining 256 possible values for each channel—red, blue, and green—each pixel can have one of 16,777,216 possible values.

40. Ibid.
41. Ibid., 39.

Obviously, in addition to "cutting up" the painting into discrete data points, a great deal is lost in such a translation. Even with the millions of possible color values in 24-bit color depth, some of the richness of color in a painting will be lost, with a smooth, organic transition between two colors rendered as a series of steps between discrete color values, and the texture and tactility of the paint will not be visible and so on. As Campagna writes, the ontology of measure smooths out the "chaos of the existent."[42]

To draw a line back to Han, what is smoothed out and elided in the language of measure—what marks the uniqueness of individual entities—often depends upon the specificity of their spatiotemporal positioning: their history, their locality. Torn from their anchorings in spatial and temporal extension, Han argues, things lose their "thingness" and become information that "can be stored and arbitrarily retrieved. If things are deprived of memory, they become information or commodities. They are pushed into a time-free, ahistorical space."[43]

At the limit point, measure leads us to the deeply-held belief that "the whole of the existent coincides with the reach of the language of information technology."[44] In other words, measure as a reality-system contains within it the concealed, but foundational, assumption that what is "real" about a thing in the world is only that which can be measured and categorized according to the digital logic of information. Everything else—which encapsulates the uniqueness of the existent—is dismissed, no longer being considered a part of reality.

Games like *AC:NH* and *Minecraft* can be taken as representations of this world of measure par excellence. It is no accident that they give us virtual worlds that are neatly cut up into squares or blocks. Just like a painting reduced to a grid of discrete pixels in its digitized form, these games give us digitized landscapes composed of discrete data points. In both games, a minimal unit of landscape is a square or cube that can be identified by

42. Ibid., 33.
43. Han, *The Scent of Time,* 6.
44. Campagna, *Technic and Magic,* 41–42.

its numerical value on two or three axes and that can take one out of a series of discrete values. A block in *Minecraft*, for example, can be a dirt block, a sand block, a stone block, a coal ore block, and so on—each is a discrete ontological value, with none of the fine gradations that might exist, for instance, in the geological makeup of a cubic meter of actual rock, between dirt, stone, and any ores that may be present. Any act of building simply involves changing blocks from one value to another (say, excavating a dirt block, thereby replacing it in that position in the game world's three-dimensional grid of blocks with an air block and then using up one stone value from the player's inventory to fill that same position in the grid with a stone block). All blocks that carry the same ontological value—all dirt blocks, for example—are precisely identical. There is no difference between one block and another of the same ontological value, and no uniqueness. Just like the toy building blocks that *Minecraft* in particular seems to explicitly refer to, they exist only to be (re)configured.

As a result, there is no value attached to any individual block. The value, instead, lies in the category itself. If the player needs a stone block to complete a building project, any individual stone block is as good as another—what matters is the category, not the individual block, which only has value insofar as it constitutes an increase in the player's stockpile of resources in the relevant category.[45] Likewise, in *AC:NH,* if you accidentally smash one of the six starting boulders on your island while getting resources out of it, it doesn't matter: another one will spawn overnight. The position of "boulder" in the system of your island has been refilled, and you are unlikely to care that it's not the same boulder.

45. Daniel Vella, "The Wanderer in the Wilderness: Minecraft, Proteus and Being in the Virtual Landscape," *Proceedings of the Philosophy of Computer Games Conference 2013*, Bergen, https://gamephilosophy2013.w.uib.no/files/2013/09/daniel-vella-the-wanderer-in-the-wilderness.pdf.

The Sandbox and the Playground

The instant availability of everything, the capacity to make and unmake at will, the resulting atomization of time, the "cutting up" of place into discrete, infinitely re-combinable units, the importance of the category over the unique thing—these describe the world as seen by Han and Campagna, and they certainly describe the virtual worlds we encounter in games like *AC:NH*.

As Scaife observed in his review, if there is any place that the game can be compared to, it is not a community with a life of its own that extends beyond the individual, but a sandbox. The sandbox is a non-place, a possibility space which is potentially anything, but it is difficult to imagine any of these potentials coalescing and lingering long enough to accrue placeness.

AC:NH, along with *Minecraft* and many of the other games listed above, invites players to build—suggesting, again, as per Heidegger, the existential linkage between dwelling and building—but what can one build in a sandbox? Nothing except a sandcastle, and a sandcastle is only a cultural metaphor for impermanence: they "fall into the sea eventually," they are what "the shimmering waves break," as Jimi Hendrix and Joanna Newsom, respectively, sing.

Of course, a particular constellation of objects brought into being in one such virtual world might form a temporary arrangement that suggests certain action possibilities and ways of being. In *AC:NH,* a semicircle of stone stools set around a campfire on a small peninsula jutting out into the sea, for example, could become a place for visiting friends to gather (see image 5.1), forming a place of habit in the virtual world that addresses players' needs for socialization, particularly at a time when lockdowns made it difficult to meet friends in person.[46] In this way, we could speak of temporary place-bubbles that hold their shape long

46. Joanna E. Lewis, Mia Trojovsky, and Molly M. Jameson, "New Social Horizons: Anxiety, Isolation, and *Animal Crossing* During the COVID-19 Pandemic," *Frontiers in Virtual Reality* 2 (2021). https://doi.org/10.3389/frvir.2021.627350.

enough to register as places, emerging out of the primordial ooze of the sandbox. Yet, these are unlikely to last long. Over and above the action possibilities suggested by a particular configuration of forms within it, the actions the sandbox affords, after all, are making and unmaking.

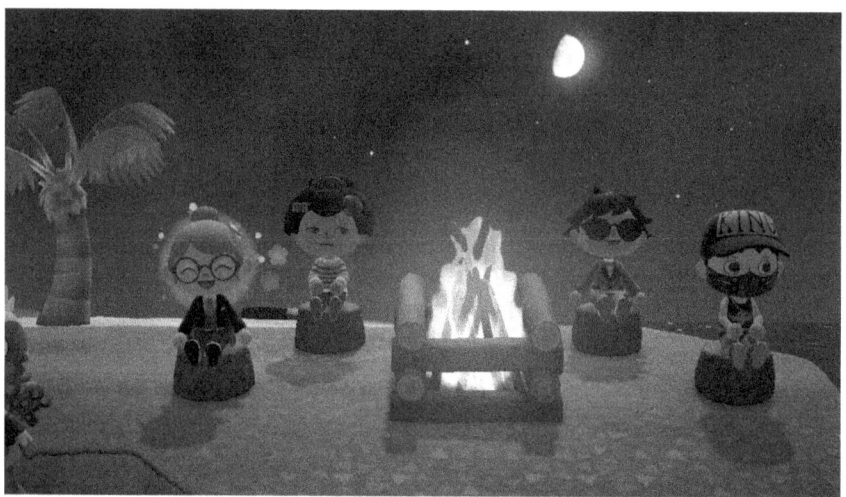

Image 5.1. *AC:NH. Seats around a campfire—a gathering-place for visiting friends. Image by author.*

Of course, as I have pointed out, virtual worlds in general are already more fluid and malleable, and less enduring, than the actual world. These games only push the fluidity of virtual worlds to its logical extension, giving us worlds in which nothing is of consequence.

Having said that, we do find lingering traces of other temporalities in *AC:NH*: the seasons change. Unless you wish to mess around with the system clock on your Nintendo Switch console, it is necessary to wait for a particular month to add certain fish or insects to your museum collection. Even if the game does not fully engage with the slow cyclicality of sowing, growth, and harvest in the same way as farming simulations like *Harvest Moon* (1998), plants take their time to grow, even if at a greatly accelerated pace: you plant an orange tree today with the expectation of picking fruit in three days' time. As with all plans, this requires commitment. It requires a span of time as a path between the seed of the plan

and its fruition. And, as Scaife points out in his review, it is likely players will eventually form an attachment to certain configurations of their island landscape—habit and repetition breeding familiarity and a sense of habitation that arrests the drive towards constant re-making.

As a thought experiment, it would be possible to imagine a version of *Animal Crossing* in which this temporality is extended even further—in which trees age every month, if they are not cut down, growing gnarly and venerable; in which rocks that are not broken up gather moss over the years, rather than players being able to craft a ready-made mossy rock to decorate their garden with.

At that point, though, it would be pertinent to ask: why not go out and tend to an actual garden, instead? Maybe to emphasize this stability of placeness is to turn away from the specificity of the virtual, which—as I pointed out earlier—lies precisely in such fluidity. Moreover, we could well argue that it is precisely this fluidity—this flux between possibilities—that makes these virtual environments into "playful" places. The philosopher Hans-Georg Gadamer wrote about play as a "to-and-from movement," a wavering between possibilities and arrangements, like the play of waves on the shore moving back and forth, drawing ephemeral lines in the sand that are just as quickly erased and redrawn.[47] Perhaps we could say that what we have in the sandbox is a play of place, a wavering of place-forms that momentarily emerge from, and just as quickly retreat back into, the sea of possibilities, just as a set of building blocks are unlikely to retain a single configuration for very long.

Yet again, this provides a marked contrast with the kinds of places we dedicate to play in the actual world—a sandbox is very different from a playground. Playgrounds tend to be definite places, featuring quite a fixed range of structures, constructions, paths, and spaces. To return to Casey's words, when we play in a playground, we are subject to its power. The games we play in a playground might change, we might think of new patterns of behavior, new things to play, but these are all a result

47. Hans-Georg Gadamer, *Truth and Method,* trans. Joel Weinsheimer and Donald G. Marshall (London: Bloomsbury Academic, 2013): 108.

of our bodily engagement with the affordances of those structures and constructions. Even the playful relation to place inherent in the Situationist practices of the *flâneur* or the *derivé*—the conscious bracketing of everyday assumptions about urban places to open oneself up to new, unexpected possibilities as an act of resistance[48]—are relations to a fixed topography and placescape.

If you think back to the favorite playground of your childhood, its placeness is beyond question. You can map it out, you can describe the practices that made it a place for you, the practices that, through return and repetition to a place that endured, grew into habit. The shiny metal slide that was too hot to touch in the summer sun and the way it forced you to slide with your knees and arms up, the cement planters behind which you could hide in a game of hide and seek, and so on.

These are not limitations to our freedom to play. On the contrary, these are the facticities in relation to which we are free to play—they are what gives us something to play with. Eugen Fink wrote that play is always about the encounter with "resisting beings," the physical toys, playthings, or objects that structure play practices as free responses to their material contingencies, affordances, and limitations.[49] The playground, as with all places, is a resisting place. Where there is no material resistance, where we can will existents into and out of existence, there is no definite existential form to our being, and, as result, there is no place.

Similarly, in the realm of digital games, Olli Tapio Leino speaks of the "gameplay condition" as the condition of being subject to a game's digital materiality, which resists the player's projects and materially upholds the results of their decisions and choices.[50] Where there is no material resistance, where we can will existents into and out of being, there is no gameplay condition.

48. Guy Debord, "Theory of the Derivé," in *Situationist International Anthology,* ed. and trans. Ken Knabb (Berkeley, CA: Bureau of Public Secrets, 1981): 50–54.
49. Eugen Fink, "Oasis of Happiness: Thoughts Toward an Ontology of Play," in *Play as Symbol of the World and Other Writings,* ed. and trans. Ian Alexander Moore and Christopher Turner (Bloomington: Indiana University Press, 2015): 14–31, 24.
50. Olli Tapio Leino, "Understanding Games as Played: Sketch for a First-Person Perspective for Computer Game Analysis," *Philosophy of Computer Games 2009 Proceedings,* Oslo: 12.

One might well argue that this is something of an overstatement. Far from being immaterial, a sandbox is defined precisely by the material that constitutes it, and to play in a sandbox is literally to get your hands dirty with material sand. Likewise, there are hard limitations to what the player can and cannot do with their *AC:NH* island. Certain decorative items are rare and hard to obtain, and the player's landscaping plans must fit within the strict grid-based layout and limited space of their island, often requiring non-trivial consideration and thought on the part of the player. It is not surprising, given this observation, that members of the *AC:NH* online community often share videos of their landscaping efforts with an indication of the number of hours of work involved in their creation,[51] an observation which also returns us to the sense of "landscape" as an activity, and to Liboriussen's remarks regarding the act of building in virtual worlds as a self-perpetuating process performed for its own sake.

In these ways—as well as in the remnants of structured temporalities I have described above—*AC:NH* does continue to offer enough resistance and fixity to support placeness, especially if it is in the player's inclination to settle into a particular arrangement for their island landscape. This sense of the virtual environment as a stable and comprehensible placescape, however, remains in constant tension with the fluidity resulting from its existence as a set of discrete, infinitely re-combinable units, every possible combination of which is virtually present—adjacent to whatever particular configuration is currently realized.

51. To give only a couple of examples, we can mention YouTube user Chase Crossing's video "This is What 915 Hours Looks Like," uploaded on June 21, 2020, YouTube video, https://www.youtube.com/watch?v=eBA1uOjux0c, which, at the time of writing, has a tally of 2.4 million views; and user zoenotzoey's video "my five star island tour / animal crossing new horizons," uploaded on June 7, 2020, YouTube video, https://www.youtube.com/watch?v=WosVOABaTqI, which lists, in the description, that it is the result of "400 hours" of play.

Conclusions

Games like *AC:NH, Minecraft,* and *Dragon Quest Builders,* with their infinitely malleable landscapes, are not virtual places to be inhabited, nor playgrounds whose material resistance suggest playful responses. They are virtual sandboxes, inviting us to engage in the practice of making and remaking representations of place, fully participating in—and taking to its limit—the inherent fluidifying sway of the virtual. Accordingly, they encourage playful experimentation—it is hardly surprising that the player communities that coalesce around such games tend to be built around the sharing and appraisal of players' creative efforts.[52] To return to McGregor's term, these sandboxes are creation spaces—what is deemed to be worth sharing with the community is the crafted space not as a lived place, but as an inert, created object, an exhibition of the player's skill, creativity, and agency.

At the same time, as with any simulation, it is worth interrogating the representation of world and place that these virtual environments constitute and the foundational assumptions about "world" and "place" they embody. What virtual interiorities do these game worlds build in our experience?

What we find, in this case, are worlds "cut up" by the ontology of measure, reduced to discrete identical categories wherein no individual existent has value except as an instance of its category to be stockpiled, stripped of any meaning outside the logic of quantification: worlds that offer no material resistance to our will; worlds in which there is never any span of time between wanting something and getting it; worlds where there is no planning, no projecting into the future, no bonds of commitment, and no memory of habit where everything can be changed from one moment to the next. This is not to diminish the specific joy and wonder that such virtual worlds can, and do, give rise to—the joy of unfettered creative work and achievement, or what we could tentatively call an aes-

52. Sean C. Duncan, "*Minecraft*: Beyond Construction and Survival," *Well-Played—A Journal on Video Games, Value and Meaning* 1, no. 1 (2011): 1–22; Maria Cipollone, Catherine Schifter, and Rick A. Moffat, "*Minecraft* as a Creative Tool: A Case Study," *International Journal of Game-Based Learning* 4, no. 2 (2014): 1–14.

thetics of possibility. Nor is it to deny that there might well be tendencies towards the stabilization of more or less fixed placescapes as players grow attached to their own efforts or the contingencies and emergent habits of a particular arrangement. However, the affordances of these virtual worlds pull away from such stability, reminding us all the time that we do not need to commit, that there are other possibilities. What they give us is the aridity and lifelessness of the non-place that is the sandbox, standing in reserve for the player to make something out of it without having much of a say in the matter, unequal partners subjected to the player's agency.

This, as I have argued, does not make the virtual worlds of these games exceptional. It is in the nature of the virtual to multiply worlds, to put into question the singularity of the actual and the resistance of its facticity, to give us the illusion that we can inhabit every possible world at once, should we so wish, and to represent everything in the digital language of quantification in such a way as to make it infinitely available and re-combinable. Moreover, *AC:NH, Minecraft,* and other similar games structure a relation between the particular, realized configuration of place the player inhabits at any given time and the nebulous cloud of possible other configurations that the island's interchangeable units of landscape could be arranged into, which mirrors the relation of the virtual to the actual. In this way, virtual worlds are both a product of the reality-system and mode of being that Han and Campagna identify as being central to our contemporary moment, and a perfect representation of it.

Bibliography

Bonner, Marc. "The World-Shaped Hall: On the Architectonics of the Open World Skybox and the Ideological Implications of the 'Open World Chronotope.'" In *Game/World/Architectonics,* edited by Marc Bonner. Heidelberg: Heidelberg University Press, 2021: 65–98.

Bullfrog Productions. *Populous.* Electronic Arts. Amiga. 1989

Burnham, Bo. *Inside.* Netflix. 2020.

Calleja, Gordon. *In-Game: From Immersion to Incorporation.* Cambridge, MA: The MIT Press, 2011.

Campagna, Federico. *Technic and Magic: The Reconstruction of Reality.* London: Bloomsbury Academic, 2018.

Casey, Edward S. *Getting Back into Place: Towards a Renewed Understanding of the Place-World.* Bloomington: Indiana University Press, 1993.

Cipollone, Maria, Catherine Schifter, and Rick A. Moffat. "*Minecraft* as a Creative Tool: A Case Study." *International Journal of Game-Based Learning* 4, no. 2 (2014): 1–14.

Chase Crossing. "This is What 915 Hours Looks Like." Uploaded on June 21, 2020. YouTube video. https://www.youtube.com/watch?v=eBA1uOjux0c.

Debord, Guy. "Theory of the Dérive." In *Situationist International Anthology,* edited and translated by Ken Knabb. Berkeley, CA: Bureau of Public Secrets, 1981: 50–54.

DMA Design. *Lemmings.* Psygnosis. Amiga. 1991.

Duncan, Sean C. "*Minecraft*: Beyond Construction and Survival." *Well-Played—A Journal on Video Games, Value and Meaning* 1, no. 1 (2011): 1–22.

Elverdam, Christian, and Espen Aarseth. "Game Classification as Game Design: Construction Through Critical Analysis." *Games and Culture* 2, no. 1 (2007): 3–22.

Fink, Eugen. "Oasis of Happiness: Thoughts Toward an Ontology of Play." In *Play as Symbol of the World and Other Writings,* edited and translated by Ian Alexander Moore and Christopher Turner. Bloomington: Indiana University Press, 2015: 14–31.

Fuchs, Mathias. *Phantasmal Spaces: Archetypical Venues in Computer Games.* London: Bloomsbury, 2019.

Gadamer, Hans-Georg. *Truth and Method.* Translated by Joel Weinsheimer and Donald G. Marshall. London: Bloomsbury Academic, 2013.

Gazzard, Alison. *Mazes in Videogames: Meaning, Metaphor and Design.* Jefferson, NC: McFarland, 2013.

Gualeni, Stefano, and Daniel Vella. *Virtual Existentialism: Meaning and Subjectivity in Virtual Worlds.* Basingstoke: Palgrave Macmillan, 2020.

Han, Byung-Chul. *The Scent of Time.* Translated by Daniel Steuer. Cambridge: Polity Press, 2017.

Heidegger, Martin. "Building Dwelling Thinking." In *Basic Writings,* edited by David Farrell Krell. London and New York: Routledge, 2004: 347–363.

Kwan, Daniel, and Daniel Scheinhert, dir. *Everything Everywhere All at Once.* A24. 2022.

Leino, Olli Tapio. "Understanding Games as Played: Sketch for a First-Person Perspective for Computer Game Analysis." *Philosophy of Computer Games 2009 Proceedings*, Oslo.

Lévy, Pierre. *Becoming Virtual: Reality in the Digital Age.* Translated by Robert Bononno. New York and London: Plenum Trade, 1998.

Lewis, Joanna E., Mia Trojovsky, and Molly M. Jameson. "New Social Horizons: Anxiety, Isolation, and *Animal Crossing* During the COVID-19 Pandemic." *Frontiers in Virtual Reality* 2 (2021). https://doi.org/10.3389/frvir.2021.627350.

Liboriussen, Bjarke. "Collective Building Projects in *Second Life:* User Motives and Strategies Explained from an Architectural and Ethnographic Perspective." In *Virtual Worlds and Metaverse Platforms: New Communication and Identity Paradigms,* edited by Nelson Zagalo, Leonel Morgalo, and Ana Boa-Ventura. Hershey, PA: Information Science Reference, 2012: 33–46.

Linden Lab. *Second Life.* Linden Lab. PC. 2003.

Maxis. *The Sims.* Electronic Arts. PC. 2000.

McGregor, Georgia Leigh. "Situations of Play: Patterns of Spatial Use in Videogames." In *Situated Play: Proceedings of DiGRA 2007 Conference*, Tokyo: 537–545, 539. http://www.digra.org/wp-content/uploads/digital-library/07312.05363.pdf.

MicroProse. *Civilization.* MicroProse. PC. 1991.

Mojang Studios. *Minecraft.* Mojang Studios. PC. 2011.

Mucky Foot Productions. *Startopia.* Eidos Interactive. PC. 2001.

Nintendo EPD. *Animal Crossing.* Nintendo. Switch. 2020.

Nitsche, Michael. *Video Game Spaces: Image, Play and Structure in 3D Worlds.* Cambridge, MA: The MIT Press, 2008.

Scaife, Steven. "Review: *Animal Crossing: New Horizons* Makes You the God of the Sandbox," *Slant Magazine,* April 12, 2020. https://www.slantmagazine.com/games/review-animal-crossing-new-horizons-makes-you-the-god-of-the-sandbox/.

Square Enix. *Dragon Quest Builders*. Square Enix. PlayStation 4. 2016.

Straznickas, Gracie Lu. "Not Just a Slice: *Animal Crossing* and a Life Ongoing." *Loading…The Journal of the Canadian Games Association* 13, no. 22 (2020): 72–88.

Traveller's Tales. *LEGO® Worlds*. Warner Bros. Interactive Entertainment. PlayStation 4. 2017.

Vella, Daniel. "The Wanderer in the Wilderness: *Minecraft, Proteus* and Being in the Virtual Landscape." *Proceedings of the Philosophy of Computer Games Conference 2013*, Bergen. https://gamephilosophy2013.w.uib.no/files/2013/09/daniel-vella-the-wanderer-in-the-wilderness.pdf.

———. "There's No Place Like Home: Dwelling and Being at Home in Digital Games." In *Ludotopia: Spaces, Places and Territories in Computer Games,* edited by Espen Aarseth and Stephan Günzel, 141–166. Bielefeld: Transcript Publishing, 2019.

———. "Who am 'I' in the Game? A Typology of the Modes of Ludic Subjectivity." *Proceedings of the 1st International Joint Conference of DiGRA and FDG,* 2016, Dundee. http://www.digra.org/wp-content/uploads/digital-library/paper_234.pdf.

Wolf, Mark J.P. "Inventing Space: Towards a Taxonomy of On- and Off-Screen Space in Video Games." *Film Quarterly* 51, no. 1 (1997): 11–23.

Zoenotzoey. "my five star island tour / animal crossing new horizons." Uploaded on June 7, 2020. YouTube video. https://www.youtube.com/watch?v=WosVOABaTqI.

Space at Hand
Ever Nearer to HALF-LIFE

Michael Nitsche

Introduction

Design approaches for game spaces have largely been driven by a human-centered perspective. This includes approaches adapted from other media, such as film[1] or architecture.[2] Arguments would follow player-centric game design[3] or procedural media specifics.[4] Others led to the notion of a possibility space that offers players room to explore. Those arguments remain useful for many conditions, but this chapter will argue that the emergent qualities of VR spaces offer a glimpse into spatial engagement that can shift the center away from the player and to the objects they handle. Through new embodied interaction with digital objects, players can form their own sub-spaces within modern game worlds within which the role of the active object is growing. To argue for such a shift, the argument will first clarify two key concepts at work in the construction of space in games: the enacted creation of game worlds through performative action and the spatial relations that have become more prevalent through virtual reality (VR). Following this consolidation of key

1. Mark J.P. Wolf, "Inventing Space: Toward a Taxonomy of On- and Off-Screen Space in Video Games," *Film Quarterly* 51, no. 1 (1997): 11–23, https://doi.org/10.2307/1213527.
2. Michael Nitsche, *Video Game Spaces: Image, Play, and Structure in 3D Worlds* (Cambridge, MA: MIT Press, 2009).
3. Steffen Walz, *Toward a Ludic Architecture: The Space of Play and Games* (Pittsburgh, PA: ETC Press, 2010).
4. Clara Fernández-Vara, José Pablo Zagal, and Michael Mateas, "Evolution of Spatial Configurations in Videogames," *DiGRA 2005 Conference: Changing Views—Worlds in Play.*

terminology is a short breakdown of a sample case. Valve's *HλLF-LIFE* game series serves as a reference point to trace the emergence of what we might call "space-at-hand." These spaces are most visible in the VR instance of *HλLF-LIFE: Alyx* where they extend the earlier series' spatial designs. This chapter briefly looks at how space evolved from the contested space nature of the original *HλLF-LIFE* to the gradual object integration in *HλLF-LIFE 2* to the novel conditions of the VR world. Applying concepts from performance studies, these features are further discussed in reference to object performance to ultimately describe some key qualities and design opportunities of the identified design space. This should inform further discussions on the spatial design of VR worlds and their relation to earlier virtual space concepts. Central to this discussion is one particular quality of VR spaces: it is within graspable reach of the player. VR poses many design challenges, from perception to navigation, and the notion of space-at-hand is presented here as yet another one that will hopefully inform game design and criticism.

Actions in Space

Video game worlds unfold through action. As players contribute their activity and help the text evolve, as interfaces operate, as the code executes, games are enacted.[5] Action is not limited to any single component in this assembly but includes all partners involved. This has rightly been identified as a performative moment in which the elements of the game interoperate as a textual machine.[6] As a result, scholars have developed different interaction design approaches,[7] dramaturgical concepts,[8] and frameworks[9] to gameplay as performance. The technologies and research foci of such work varies widely but the central argument of an unfolding

5. Alexander Galloway, *Gaming: Essays on Algorithmic Culture* (Minneapolis: University of Minnesota Press, 2006).
6. Espen J. Aarseth, *Cybertext: Perspectives on Ergodic Literature* (Baltimore: The John Hopkins University Press, 1977).
7. Steve Benford and Gabriella Giannachi, *Performing Mixed Reality* (Cambridge, MA: The MIT Press, 2011).
8. Rebecca Rouse, "Partners: Human and Nonhuman Performers and Interactive Narrative in Postdigital Theater," *Proceedings of ICIDS*, 2018, 369–382.
9. Clara Fernández-Vara, "Play's the Thing: A Framework to Study Videogames as Performance," *Proceedings of the 2009 DiGRA International Conference: Breaking New Ground: Innovation in Games, Play, Practice and Theory.*

performative action remains, and it serves as one tier onto which the following argument will build. Just like game play and interaction design, performance relies on action. At its core is not a prefabricated kernel but the in-the-moment construction of a performative expression; Schechner termed it an "actual."[10] At this moment, the action assembles to a shared artistic expression. Schechner's own perspective centers on the human performers, producers, and audiences, and he emphasizes the fluidity between different roles. Audience members might become performers, performers might source the underlying text, producers might turn into actors.[11] These moments of fluid construction always also include the material conditions of the surroundings, such as staging elements from lights to sounds to effects, as well as countless material items from make-up, to scenery, to props, to costumes. As will be argued below, the material agency of these non-human components in the production must be recognized as active contributions in performance and thus in performative space enaction. This changes the way we approach VR design.

The second foundation of this chapter regards challenges in human computer interaction (HCI) design that affect the spatial relations between players and digital objects in VR. As bodies are tracked in more detail and we approach full-bodied immersion in virtual worlds, players not only encounter digital landscapes or architectures anew, but they also need to deal with virtual objects and tools that have moved from the hands of their former player avatars to seemingly their own. Whether it is through motion tracking or specialized interfaces, our relations to the virtual objects in VR have expanded to a new nearness, and VR has brought digital spaces closer to us. Freundschuh and Egenhofer reviewed a wide range of spatial concepts in global information systems (GIS) to suggest six different spaces based on scale and spatial experience: "manipulable object space (smaller than the human body), non-manipulable object space (greater than the human body, but less than the size of a building), environmental space (from inside-of-building spaces to city-size spaces), geographic space (state, country, and continent-size spaces), panoramic

10. Richard Schechner, *Performance Theory* (New York: Routledge, 2003).
11. Richard Schechner, *Performance Studies: An Introduction,* 4th ed. (New York: Routledge, 2020).

space (spaces perceived via scanning the landscape), and map space."[12] Their work was central to Barba and Marroquin as they discussed a hierarchical, spatial design concept for interaction design in mixed reality (MR).[13] Freundschuh and Egenhofer had suggested three original distinctions between their six spaces: manipulability, locomotion, and size. To those, Barba and Marroquin added the role of boundaries, a form of clear separation of one space from another. Boundaries emphasize the transitioning between spaces which relativizes the role of scale. GIS and MR systems usually build on the scale of the human body and its relation to the surroundings: they might show one's position on a map, for example. Yet, this relation is optional in virtual game spaces. In VR, one could be a giant able to lift buildings or a god creature able to form whole landscapes with a sweep of one's hand. Or one might be crawling amongst the bugs of a virtual meadow. Figural here means "at hand," but the scale relationship of that hand to the given virtual world is flexible. It can change over the course of the interaction, it can be massive, microscopic, or hybrid.[14] It is the interaction design that co-defines what is figural, not the physical human body alone. With scale being so variable, the boundaries assist as a "threshold where the representation triggers different cognitive processes, conceptions of space, and associated abilities."[15] As the language of VR has not consolidated itself and the "associated abilities" are still in flux, it faces challenges across all ranges of spatial conceptions and abilities, including navigation[16] or the use of maps.[17] To tackle the boundaries between the "conceptions of space," we will focus on the transition from navigable or environmental space to panoramic and, eventually, to manipulable space. To support this theoretical argument, the text

12. Scott M. Freundschuh and Max J. Egenhofer, "Human Conceptions of Spaces: Implications for Geographic Information Systems," *Transactions in GIS* 1, no. 2 (1997): 361.
13. Evan Barba and Ramon Zamora Marroquin, "A Primer on Spatial Scale and its Application to Mixed Reality," *2017 IEEE International Symposium on Mixed and Augmented Reality (ISMAR)*, 100–110.
14. See the concept of "Worlds in Miniature" in Richard Stoakley, Matthew J. Conway, and Randy Pausch, "Virtual Reality on a WIM: Interactive Worlds in Miniature," *Proceedings of the SIGCHI Conference on Human Factors in Computing Systems*, 1995, 265–272.
15. Barba and Marroquin, "A Primer on Spatial Scale," 105.
16. Sibylle D. Steck and Hanspeter A. Mallot, "The Role of Global and Local Landmarks in Virtual Environment Navigation," *Presence* 9, no. 1 (2000): 69–83.
17. Weihua Dong, Tianyu Yang, Hua Liao, and Liqiu Meng, "How Does Map Use Differ in Virtual Reality and Desktop-based Environments?," *International Journal of Digital Earth* 13, no. 12 (2020): 1484–1503.

will build on a very short review of differences in spatial and interaction designs as they have emerged over the *HλLF-LIFE* series. *HλLF-LIFE* is chosen because it sidesteps the aforementioned variability of scale. In all existing canonical *HλLF-LIFE* installments, the player participates from a first-person view. The actual "size" of the virtual character might still be off (the original eye level of Gordon Freeman in *HλLF-LIFE* was 1.25 meters in the game's Hammer editor) but the player remains embodied through a relative virtual avatar in a human-like scale to the surrounding world.

Spaces of HALF-LIFE

At the time of this writing, the developer Valve's *HλLF-LIFE* series centers on three main canonical titles: *HλLF-LIFE* (1998), *HλLF-LIFE 2* (2004), and *HλLF-LIFE: Alyx* (2020), with two expansion "episodes" released for *HλLF-LIFE 2* and a range of additional mods and spin offs surrounding these core games. All three titles are critically acclaimed and have collected numerous awards throughout the years, and they play their part in the development of videogame cultures. All three titles belong to the genre of first-person shooter games and put the player into the role of a single character through whom one enacts the game space. Players see through the eyes of this character and are positioned within the game world by its virtual body. Locked into that perspective, players traverse game levels, encounter other characters, solve puzzles, and battle through countless hostile encounters. *HλLF-LIFE* takes these embodiment conditions to heart. In all three games, the unity of action, time, and space is largely left intact and no cut-scenes interrupt the unfolding events. Key elements of the gameplay involve fighting off various attacking aliens, navigating to pre-defined endpoints, interacting with non-player-characters (NPCs), and solving puzzle components.

Spatial design in the original HλLF-LIFE (1998) follows the "contested spaces"[18] level design. This spatial design "takes the player through a variety of atmospheres resulting in a rise and fall of dramatic tension."[19] The spatial exploration and progress through the dramatically structured environments are a substantial part of the gameplay experience. In typical first-person shooter fashion, players lack their own body but "hallucinate"[20] themselves into the game world of HλLF-LIFE. The game opens with the player embodying Gordon Freeman, a researcher on his way to work at an underground laboratory. Players find themselves alone on a mono-rail wagon, which descends into the mysterious Black Mesa research facility. They can navigate within the boundaries of the wagon and look around to witness activities in the facility, but they cannot influence them at this point. As a voice-over introduces the player to the facility, numerous tropes are established: the guards, the scientists, the haphazard nature of the research, the architecture. Once they leave the wagon, players will re-encounter these elements (and more) in their adventures. Except for the start-up and loading screens, the game unfolds in near temporal and spatial unity. In addition, the heads-up display is sparse. All of this further emphasizes the cohesion of the game world and the player's encounter with it. Interaction design within this encounter is largely immediate and supports a strong integration into the game world. This is reflected in the focus on an arsenal of weapons operated from a first-person point of view. Most weapons are guns that display direct impact. However, the signature weapon of HλLF-LIFE is the crowbar, which allows players to attack enemies at close range. This kind of design emphasizes Shneiderman's "direct manipulation" principles, formulated around the same time that HλLF-LIFE was developed and in the early years of HCI's emergence as its own domain.[21] Spatial interaction features continuous representation and favors physical actions over

18. Henry Jenkins and Kurt Squire, "The Art of Contested Spaces," In *Game On: The History and Culture of Video Games*, ed. Lucien King (New York: Universe, 2002), 64–75.
19. Ibid., 2
20. Olli Tapio Leino, "From Game Spaces to Playable Worlds," *Proceedings of the Philosophy of Computer Games Conference*, 2013, 2–4.
21. Ben Shneiderman, "Direct Manipulation for Comprehensible, Predictable and Controllable User Interfaces," *Proceedings of the 2nd International Conference on Intelligent User Interfaces*, 1997, 33–39.

Michael Nitsche

complex syntax, "whose effect on the object of interest is immediately visible."[22] Much of this approach governs the interaction in the game, whether this regards the way we navigate our player character through the game world or how he smashes enemies with the whack of a crowbar.

The opening of *HλLF-LIFE 2* (2004) welcomes the player back in the role of Gordon Freeman to take up arms once more. Once again, they are locked in a wagon en route to a critical location, this time the larger, outdoor space of City 17. The train ride is much shorter and the introduction sequence spans into a dismal train station that sets the mood for the oppressive regime that needs to be fought. Players leave the station through a turn stall that rotates as the virtual body of the main hero presses through it. This direct contact with the turn stall foreshadows a gradual emphasis on object interaction and spatial interaction. The game's level design continues the narrative architecture principles, further emphasizing the use of vistas, dramatic structures, or atmospheres to provide a cohesive and impactful game space for the player to act in.[23] Apart from the obvious graphical update, which supported better lighting as well as texturing, much of the core design remains in place, including the crowbar. Yet, some key differences in the players' spatial relations to the world stand out. The original *HλLF-LIFE* was built on a heavily modified Quake engine that allowed for limited inclusion of physics. In contrast, *HλLF-LIFE 2* uses the Source engine, which was developed by Valve in-house and supported more advanced physics in the game world. This added a new form of agency and changed the spatial relations between player and game world. Most importantly, the physics integration allowed for the new signature weapon of *HλLF-LIFE 2*: the Zero Point Energy Field Manipulator, or Gravity Gun. The Gravity Gun allowed players to pick up objects with the help of the gun mechanics and drop them onto other objects in the game world. Operating the Gravity Gun remains indebted to the principles of "direct manipulation," but its effects establish forces-within-forces of control. Instead of the immediate impact or collision control, the objects can gain a limited agency thanks to the better physics

22. Ibid., 33.
23. Teun Dubbelman, "Designing Stories: Practices of Narrative in 3D Computer Games," *Proceedings of the 2011 ACM SIGGRAPH Symposium on Video Games*, 37–41.

system. This is visible in the ragdoll physics of defeated soldiers tumbling down as much as it is in the flight paths of saw blades propelled by the Gravity Gun to cut through enemy limbs. Objects show effects onto other objects within the game world. This affects not only the player as an actor within the game world but also the bodies of the enemies, the saw blades, the containers, the energy cells, or whatever other object one picks up with the Gravity Gun. The Gravity Gun is instrumental in the final fight of the game, where only the objects of the antagonists are strong enough to destroy their doomsday machine. There are traces of agency in objects that do not rely on Artificial Intelligence but find their logic in relation to other objects in the virtual world, and players start to enact these objects. This agency is still limited and the player's engagement with them remains simplified. For example, collecting items such as ammunition from the ground is done by simply running over them, as was the case in the original HλLF-LIFE. Likewise, using the Gravity Gun still mimics the same basic operations of any other gun in the game and neither direct hand input nor other gestures are implemented.

HλLF-LIFE: Alyx (2020) continues many of the elements that were established in the earlier titles. This includes basic physics as part of the game world, first-person-only representation, continuity in space and time, and highly evocative dramatic level design. It opens with the player taking on the role of Alyx Vance, alone on a balcony overlooking an earlier version of the outskirts of City 17, a sprawling urban space occupied by the already established alien antagonistic force. It further emphasizes connections to the past games in its story—which works as a prequel to *HλLF-LIFE 2*'s events—experienced through the eyes of one of the secondary characters of that older title. As expected, the underlying engine, Source 2, provides updates for AI, graphics, and physics simulations, among other features. But the most significant shift is that *HλLF-LIFE: Alyx* is designed from the ground up as a VR-game. Its entire design was optimized for a VR experience. In the opening scene, the player finds themselves in the virtual body of Alyx and, through motion tracking, they can manipulate a radio nearby, grab the railing and lean over the balcony, pick up objects and use them, and affect the game space through their hand and body motions. Spatial navigation is performed either through

button controls or via teleporting, which changes the spatial experience of the game world significantly. Neither the crowbar nor the Gravity Gun are available in HλLF-LIFE: Alyx. Instead, it features two new signature interaction devices. The first is a pair of Gravity Gloves, reminders of the Gravity Gun's functionality, which allow the heroine to lift large objects and evoke a force to pull any distant object towards them (see image 6.1 right). The second is the Multi-tool, a scanning and hacking gizmo (see image 6.1 left), which Alyx already used as a non-player-character in HλLF-LIFE 2 to overcome obstacles through technical overrides. Now, it is under the control of the player, next to guns and grenades. Both allow for more direct object manipulation akin to puppetry and object performance, as this chapter will argue.

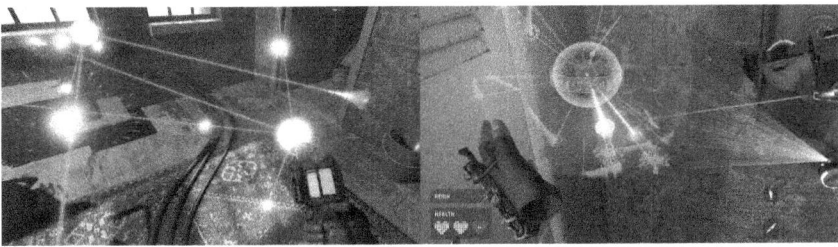

Image 6.1. HλLF-LIFE: Alyx: Aligning beams in space (left) and solving a globe puzzle (right).

These new interaction options are not just software-based: Valve released its own VR system, which includes the Valve Index controllers. These hardware input devices are tracked in space like other VR input devices, such as the HTC Vive controllers. They also include their own set of buttons, thumbstick, and capacitive touch to control movements, trigger actions, or sense other input. But in addition to these features, the Valve Index controller incorporates muscle sensors that track finger activity. The controllers are strapped to the player's hands to actively track the muscles on top of one's hands. Overall, they integrate a combination of motion sensing, button input, and muscle tracking. Players can trigger actions using buttons that might be associated with a tangible representation (as it is in the case of the gun trigger that is mirrored on the control device as a trigger button), control more abstract interaction designs (as it is in the case of spatial navigation using the joystick as input), control position and orientation through the tracked movement of the hand

in space (one aims or reaches in that way), and use the movement and muscle tracking options. This last option is key to the use of the Gravity Gloves. One points at an object in the distance, forces that object towards the player character by flicking the wrist, catches it by closing one's hand, and stores it into one's virtual backpack by throwing it over one's shoulder. Picking up game objects with the gravity glove is an embodied interaction that requires some effort, and this effort transcends into the role of the objects. *HλLF-LIFE: Alyx* can be played with other VR controllers, but this combined interaction design of novel hardware and innovative gameplay opens up a new spatial condition for the game series. Technically, players gain access to a space that is literally at their hands, and the game design actively supports the activation of this space. These spaces were only rudimentary in the first two titles, insofar as one could hit nearby obstacles or enemies with the crowbar and destroy them. Now, the use of this space-at-hand allows activation of objects within the world, of objects "at our hands." It shifts the spatial center closer to the hand and enriches the vocabulary of the nearby object's agency. It is an additive effect across the spatial scaling outlined by Freundschuh and Egenhofer. If the players read the environment as navigable dramatic space in *HλLF-LIFE* and further accept the operation of objects onto other objects in *HλLF-LIFE 2*, then the space-at-hand in *HλLF-LIFE: Alyx* brought controls ever closer to the embodiment to the player. This affects the first two concepts along the way. Players now can touch and explore the larger spaces through this closer one, understand them through the new lens, and read them as future spaces-at-hand. An alien tower looming in the distance is not only a visual landmark but a possible surface to be touched and examined. Its walls are not limited to collision barriers anymore, but they might include power cables that can be scanned and manipulated with the Multi-tool. Enriching the level of detail in the manipulable space establishes a new spatial agency in the game world. It also establishes new expectations, which can trigger a different perception of the overall game space and affect the experience throughout. The following section will trace the components of these new qualities for the performative nature of game worlds.

Object Performance in HALF-LIFE: Alyx

The novel interaction design of *HλLF-LIFE: Alyx* invites players to realize individual objects and their roles within the game spaces in ever more detail. Instead of an upscaling to a vast, open-world playground, this is a scaling up of detail in close quarters. It activates the spaces-at-our-hands and with this, it enhances the agency of the objects that operate in this closeness. We oscillate between what Heidegger termed "present-at-hand" and "ready-at-hand" as digital objects simulate a "handiness" (or Zuhandenheit) in which the thing's being "reveals itself by itself."[24] The performed space is renegotiated, and the digital objects manage to find their own agency within the game world, which is where the argument somewhat departs from the focus on handiness. Just as the game levels' architectures unfold following their own dramaturgy, so do the smaller objects at the scale of the players' hands. As objects gain more operations in the space-at-hand, interaction turns into critical object manipulation. In that way, spaces-at-hand are constructed through means of "material performance:" "At its simplest, this term assumes that puppets and other material objects in performance bear visual and kinetic meanings that operate independently of whatever meanings we may inscribe upon them in performance."[25] In these cases, the object does not center on optimized functionality but includes constant, individual "operations" that need to be renegotiated. Material performance allows the seemingly inert object to provide its own quality to the unfolding events. On the other end of the spectrum, this relates to approaches in new materialism that argue for "material agency,"[26] which sees objects as participants in the unfolding activity as much as humans.

In their current stage, the object performances in *HλLF-LIFE: Alyx* are still limited. They often manifest as puzzles with predefined end-states. These include disarming a tripmine, opening a container, or solving a wiring puzzle. Many of the more complex manipulable objects (a rotating globe,

24. Martin Heidegger, *Being and Time*, ed. J. Macquarrie and E. Robinson (London: SCM Press, 1962), 69.
25. Dassia N. Posner, Claudia Orenstein, and John Bell, eds. *Routledge Companion to Puppetry and Material Performance* (Florence, KY: Routledge, 2014), 5.
26. Jane Bennett, *Vibrant Matter: A Political Ecology of Things* (Durham: Duke University Press, 2010).

a globe with implemented obstacles, a virtual buzz wire game) are digital versions of existing tangible toys, and their logic is immediately accessible. Players might trace embedded virtual wirings in the walls of a game world segment, rotate light globes to navigate points over their surface, guide targets through a kind of mini obstacle course, or arrange beams within a 3D configuration. The variation of one's performance of these spaces is limited to finding the right solution to the given puzzle. Still, in the players' explorations of the object set ups and operations we find an activation of the virtual object through hand gestures. If the puzzle pieces are deliberate in their set up, the Gravity Gloves are much more open in their activation of in-game objects. They allow players to pull countless objects toward them, catch them, break them, throw them, or drop them in a kind of virtual jugglery. Even without the glove gadgets, players can pick up objects, push buttons, open doors, manipulate machinery, pick up markers, write on surfaces, and affect numerous objects within the game space. They actively perform the space-at-hand just as they had done with the larger-scoped spaces introduced in HλLF-LIFE and HλLF-LIFE 2. The closest performative relative to this kind of object manipulation is puppetry.

Puppeteers are used to relinquish control and commit to a constant dialogue with the puppet: "the puppeteer is playing with a certain lack of control, and experimenting with the different possibilities of the puppet while constantly being aware of how the puppet's structure determines movement."[27] The performer recognizes the material agency of the originally inanimate object and its significance for the unfolding performance. Mind you, the materiality of objects in HλLF-LIFE: Alyx is still limited. The puzzles consist mostly of ephemeral light projections, but they are still moved, aligned, rotated, grabbed, and manipulated much like puppet objects. Through these enacting performances, the objects gain their own agency through a kind of constant renegotiation. A "material agency" is being constructed as they are part of the gameplay enaction: "The essence of puppet, mask, and object performance (as countless pup-

27. John Bell, *American Puppet Modernism: Essays on the Material World in Performance* (New York: Palgrave Macmillan, 2008), 7.

peteers have said from their own experience) is not mastery of the material world but a constant negotiation back and forth with it."[28] One's own role as active player-actor is being enforced as much as the contribution of the material object in correspondence. Space-at-hand does the same for VR design. What was discussed as "environmental presence"[29] in HCI and game studies merges with a notion of "co-presence," namely a kind of being-there-together of human and virtual objects. So far, these effects were largely applied to social co-presence,[30] but the role of active objects that we spatially perform in spaces-at-hand extends this notion to the virtual objects and their materials. It is not only the other player who is realized but also the object in one's vicinity. In that way, agency finds a new level of detail in VR.

VR Object Spaces

Ultimately, the argument arrives at a design space for spaces-at-hand. It sketched out the evolution of this condition and introduced new materialism and object performance as theoretical references. There are two main threads to this argument. The first regards the expansion of space as a "closing in on the player." As the brief discussion of the HλLF-LIFE game series showed, its spatial design supports an increasing level of detail for object manipulation. This applies especially to the installment of HλLF-LIFE: Alyx. The new closeness and relation to the digital object operates through the dual effect of increasing embodiment and enhancing the agency of virtual objects. It is in the interplay of new object agency and the enacting hand that touches and manipulates in which new forms of interaction emerge. This leads to increased individual agency available to these objects through a form of digital puppetry, which presents the second core argument. With it, we can connect the

28. John Bell, "Playing with the Eternal Uncanny: The Persistent Life of Lifeless Objects," in *The Routledge Companion to Puppetry and Material Performance*, ed. Dassia N. Posner, Claudia Orenstein, and John Bell (Florence, KY: Routledge, 2014), 50.
29. Carrie Heeter, "Being There: The Subjective Experience of Presence," *Presence: Teleoperators and Virtual Environments* 1, no. 2 (1992): 262–271.
30. See Jari Takatalo, Jukka Häkkinen, Jeppe Komulainen, Heikki Särkelä, and Göte Nyman, "Involvement and Presence in Digital Gaming," *Proceedings of the 4th Nordic Conference on Human-computer Interaction: Changing Roles*, 2006, 393–396.

enactment of such spaces-at-hand to object-related performance practices. Interaction design, here, should be read as material or object performances, keeping in line with the notion that all spaces in video games are ultimately performed, but some are just closer to the hand than others. Such closeness in performance and manipulation provides the next addendum to the expanding natures of game spaces. As such, it offers its own qualities and reflections. As Bell notes for traditional puppetry, "our playing with objects allows us to come to terms with death."[31] If new materialism offers a theoretical lens to change human-object relations, then puppetry and manipulable spaces-at-hand provide the practical design arenas to explore them in VR games. That does not make designing for VR easier, but hopefully more meaningful.

31. Bell, *American Puppet Modernism*, 5.

Bibliography

Aarseth, Espen J. *Cybertext: Perspectives on Ergodic Literature*. Baltimore: The John Hopkins University Press, 1977.

Barba, Evan, and Ramon Zamora Marroquin. "A Primer on Spatial Scale and its Application to Mixed Reality." *2017 IEEE International Symposium on Mixed and Augmented Reality (ISMAR)*, 100–110.

Bell, John. *American Puppet Modernism: Essays on the Material World in Performance*. New York: Palgrave Macmillan, 2008.

———. "Playing with the Eternal Uncanny: The Persistent Life of Lifeless Objects." In *The Routledge Companion to Puppetry and Material Performance*, edited by Dassia N. Posner, Claudia Orenstein, and John Bell, 43–53. Florence, KY: Routledge, 2014.

Benford, Steve, and Gabriella Giannachi. *Performing Mixed Reality*. Cambridge, MA: The MIT Press, 2011.

Bennett, Jane. *Vibrant Matter: A Political Ecology of Things*. Durham: Duke University Press, 2010.

Dong, Weihua, Tianyu Yang, Hua Liao, and Liqiu Meng. "How Does Map Use Differ in Virtual Reality and Desktop-based Environments?" *International Journal of Digital Earth* 13, no. 12 (2020): 1484–1503.

Dubbelman, Teun. "Designing Stories: Practices of Narrative in 3D Computer Games." *Proceedings of the 2011 ACM SIGGRAPH Symposium on Video Games*, 2011, 37–41.

Fernández-Vara, Clara. "Play's the Thing: A Framework to Study Videogames as Performance." *Proceedings of the 2009 DiGRA International Conference: Breaking New Ground: Innovation in Games, Play, Practice and Theory*.

Fernández-Vara, Clara, José Pablo Zagal, and Michael Mateas. "Evolution of Spatial Configurations in Videogames." *DiGRA 2005 Conference: Changing Views—Worlds in Play*.

Freundschuh, Scott M., and Max J. Egenhofer. "Human Conceptions of Spaces: Implications for Geographic Information Systems." *Transactions in GIS* 1, no. 2 (1997): 361–375.

Galloway, Alexander. *Gaming: Essays on Algorithmic Culture*. Minneapolis: University of Minneapolis Press, 2006.

Heeter, Carrie. "Being There: The Subjective Experience of Presence." *Presence: Teleoperators and Virtual Environments* 1, no. 2 (1992): 262–271.

Heidegger, Martin. *Being and Time*, edited by J. Macquarrie and E. Robinson. London: SCM Press, 1962.

Jenkins, Henry, and Kurt Squire. "The Art of Contested Spaces." In *Game On: The History and Culture of Video Games*, edited by Lucien King, 64–75. New York: Universe, 2002.

Leino, Olli Tapio. "From Game Spaces to Playable Worlds." *Proceedings of the Philosophy of Computer Games Conference*, 2013.

Nitsche, Michael. *Video Game Spaces: Image, Play, and Structure in 3D Worlds*. Cambridge, MA: MIT Press, 2009.

Posner, Dassia N., Claudia Orenstein, and John Bell, eds. *Routledge Companion to Puppetry and Material Performance*. Florence, KY: Routledge, 2014.

Rouse, Rebecca. "Partners: Human and Nonhuman Performers and Interactive Narrative in Postdigital Theater." *Proceedings of ICIDS,* 2018, 369–382.

Schechner, Richard. *Performance Theory*. New York: Routledge, 2003.

———. *Performance Studies: An Introduction,* 4th edition. New York: Routledge, 2020.

Shneiderman, Ben. "Direct Manipulation for Comprehensible, Predictable and Controllable User Interfaces." *Proceedings of the 2nd International Conference on Intelligent User Interfaces*, 1997, 33–39.

Steck, Sibylle D., and Hanspeter A. Mallot. "The Role of Global and Local Landmarks in Virtual Environment Navigation." *Presence* 9, no. 1 (2000): 69–83.

Stoakley, Richard, Matthew J. Conway, and Randy Pausch. "Virtual Reality on a WIM: Interactive Worlds in Miniature." *Proceedings of the SIGCHI Conference on Human Factors in Computing Systems*, 1995, 265–272.

Takatalo, Jari, Jukka Häkkinen, Jeppe Komulainen, Heikki Särkelä, and Göte Nyman. "Involvement and Presence in Digital Gaming." *Proceedings of the 4th Nordic Conference on Human-computer Interaction: Changing Roles*, 2006, 393–396.

Walz, Steffen. *Toward a Ludic Architecture: The Space of Play and Games*. Pittsburgh, PA: ETC Press, 2010.

Wolf, Mark J. P. "Inventing Space: Toward a Taxonomy of On- and Off-Screen Space in Video Games." *Film Quarterly* 51, no. 1 (1997): 11–23. https://doi.org/10.2307/1213527.

Aerial Viscosity
The Architecture of Drone Photography

Jon Yoder

Aerial Overview

Eyes in the sky are practically everywhere. Indeed, drone imaging is starting to infiltrate all phases of architecture, from site reconnaissance to construction supervision.[1] Thesis students are speculating on the urban implications of delivery drone hives; architects like Jennifer Bonner are deploying drones for groundbreaking design projects; and architectural photographers such as Iwan Baan and Fernando Guerra are conducting pioneering experiments with unmanned flight systems.[2] Some of these new aerial images almost seem to realize the longstanding anti-gravitational teleology of Modernism with its floating eye-in-the-sky projections and omniscient (virtual) vantage points. Of course, less lofty imaging also abounds. Homemade quadcopter videos increasingly populate media platforms such as Facebook, Instagram, Vimeo, and YouTube. From amateur enthusiasts and wedding photographers to performance

1. I presented an early version of this chapter in the "After Analog: New Perspectives on Photography and Architecture" session chaired by Hugh Campbell and Mary N. Woods at the Society of Architectural Historians 68th Annual International Conference in Chicago, Illinois (April 15–19, 2015). I also organized the "Photo-Graphic Architecture" symposium at the Akron Art Museum and Kent State University College of Architecture and Environmental Design (April 14–15, 2022): https://www.photo-graphic-architecture.com.
2. Bonner used quadcopters to scan the brick elevations of Haus Lange and Haus Esters, two adjacent houses in Krefeld, Germany, designed by Ludwig Mies van der Rohe (1928–30). She installed this research as an exhibition titled "Haus Scallop, Haus Sawtooth" in Kent State University's Armstrong Gallery from November 18, 2019–January 15, 2020: https://jenniferbonner.com/05-Haus-Scallop-Haus-Sawtooth.

artists and social media influencers to development companies and real estate marketplaces, the future of commercial imaging seems to float. Drones are now poised to claim the low-altitude layer of a geocentric aerial imaging matrix whose outer spheres are patrolled by satellites and interplanetary rovers and telescopes.

Based on original research with images in the Julius Shulman Archive at the Getty Research Institute and the author's own aerial photography, this chapter contrasts Shulman's accomplished analog perspectives with parabolic aerial photos and videos produced with a GoPro digital camera mounted on DJI Phantom 2 and 4 quadcopter drones. Whereas the drone photography of architecture would construe drone imaging as a limpid lens through which to see buildings, the architecture of drone photography draws attention to the intricacies of the aerial apparatus itself. As Robin Evans always emphasized, no medium or representational system can be purely transparent. His conception of the viscosity or refraction of architectural projection is therefore instructive.[3] In Evans's terms, drone photography presents at least two distinctly viscous or refractive valances: 1) the hardware/software system of quadcopter camera and video editing platform; and 2) the literally viscous atmospheric environments of wind, sun, clouds, precipitation, GPS satellites, etc. Following a brief historical survey of aerial imaging, this chapter poses two main questions: how do variously viscous drone images help to reframe architectural environments and/or subjects that we think we already firmly understand? And what architectural logics does drone photography expose, or even produce, through its sometimes-surprising synchronous architectural operations?

Although the widespread use of unmanned flight systems is new, drone photography already has a long architectural history. One might frame it as part of a history of aerial vantage points dating from the Renaissance. Just as Roland Barthes suggested that the Eiffel Tower materialized the earlier aerial imagination of literature, the arrival of aerial photography

3. Robin Evans, "Architectural Projection," in *Architecture and Its Image: Four Centuries of Architectural Representation, Works from the Collection of the Canadian Centre for Architecture*, eds. Eve Blau and Edward Kaufman (Montreal: Canadian Centre for Architecture, 1989), 25.

seemed to realize Renaissance speculations on the shapes of cities from above, which often took the form of impressively detailed engravings of oblique aerial views. These speculative maps proliferated for hundreds of years before Gaspard-Féliz Tournachon, otherwise known as Nadar, made the first aerial photographs from a balloon in France in 1858. In 1906, George R. Lawrence famously documented the aftermath of the San Francisco earthquake in a 160-degree panorama (see image 7.1).

Image 7.1. Photo by George R. Lawrence, San Francisco in Ruins, 1906. Library of Congress.

For this photo, titled *San Francisco in Ruins*, Lawrence used a forty-nine-pound camera tethered to a series of kites 2,000 feet above San Francisco Bay. And in 1919, shortly after the end of World War I and the official formation of Britain's Royal Air Force, pilot and photographer Captain Gordon H.G. Holt celebrated low altitude, bird's-eye photography in an article for *The Architectural Review*. He wrote, "Characteristic details, anomalous or unusual effects, which with the spectator on the ground would perforce escape attention, reveal themselves instantly."[4] Holt's use of wartime technology for peacetime cultural pursuits was no anomaly. World War II aerial photography, for example, inspired naval officer Charlton Hinman's invention of a collator for literary manuscripts. And the Cold War space race famously enabled the crew of Apollo 17 to pho-

4. Gordon H.G. Holt, "Architecture and Aerial Photography," *The Architectural Review*, no. 45 (1919): 3–9.

tograph Earth as "The Blue Marble" in 1972. The popular appeal of these and other wartime creations tends to normalize the military-industrial complex, suggesting "that civilian applications are the benign destiny of military technologies."[5]

Images from above are rarely innocent, however. As Paul Virilio and Manuel DeLanda have demonstrated, the histories of aerial photography are intimately bound up with developments in military visualization.[6] From Lockheed's U-2 and SR-71 reconnaissance aircraft of the 1950s and 60s to the Stealth technologies of the Reagan era to the daily satellite updates of Russia's 2022 invasion of Ukraine, the military basis of aerial imaging is obvious. Witness the aptly named *Predator* and *Reaper* drones (MQ-1 and MQ-9) that notoriously emerged as part of the U.S. Air Force's controversial "Hunter-Killer" program. Activist critiques of remote warfare understandably tend to focus on issues of desensitization, the assumption that drone pilots—like video gamers—become detached from the horrific results of their destructive actions on the ground.[7] Drone flight is often more viscerally engaging than this model suggests, however. Even in civilian quadcopter navigation, the grainy images on controller or smartphone screens usually lack the resolution of final photos and videos. And a continual sightline toggling between the drone's position in the air and the camera angle on screen demands persistent mental immersion and physical exertion.[8] Military drone navigation also requires visceral involvement. Geographer Derek Gregory notes that drone pilots in distant locations are not as removed from the violent implications of their actions as the desensitization myths surrounding remote aerial warfare assume. Pilots are often in high-stress audio communication with

5. Paul K. Saint-Amour, "War, Optics, Fiction," *Novel: A Forum on Fiction* 43, no. 1 (Spring 2010): 93–94.
6. Paul Virilio, *The Aesthetics of Disappearance*, trans. Philip Beitchman (New York: Semiotext(e), 1991); Paul Virilio, *War and Cinema: The Logistics of Perception*, trans. Patrick Camiller (London & New York: Verso, 1989); and Manuel DeLanda, *War in the Age of Intelligent Machines* (New York: Zone Books, 1991).
7. See, for example, https://notabugsplat.com.
8. This is one reason Hollywood now usually divides drone shoot duties between two different operators: a pilot who flies the drone and a photographer who controls the camera.

troops in forward areas, which heightens urgency and produces what Gregory terms a "peculiarly new form of intimacy" that blurs the "techno-cultural distinction between 'their' space and 'our' space, between the eye and the target."[9]

This intensified intimacy, however, somehow coexists alongside drone pilots' notoriously dehumanizing identification of "bug splat" targets. During the twenty-year War in Afghanistan, anti-drone activists routinely staged "die-ins" to simulate the human devastation of the U.S. and British governments' drone programs. In 2013, a peace activist was arrested and sentenced to one year in prison for participating in a protest outside Hancock Field Air National Guard Base in Syracuse, New York. Mary Anne Grady Flores reportedly violated an order of protection by stepping into the driveway leading to the base to take photos with an iPhone. One of DeWitt Town Court Judge David Gideon's five principal arguments for Grady Flores's one-year sentence included a critique of her photographic approach. "To this court, if the defendant was there only to take pictures," Gideon wrote, "she could have adequately done so across the street using a zoom or otherwise. She obviously chose not to."[10] In other words, had Grady Flores employed remote surveillance techniques—possibly even her own drone photography—she would have been in compliance with the order of protection and might have avoided jail time. Of course, drone no-fly zones—including airspace surrounding military bases, stadiums, and government buildings—are also increasingly common. But aside from certain state registration rules and private property trespassing laws, the recreational use of drones remains largely unregulated below navigable airspace. The Federal Aviation Administration has been threatening to tighten regulations, however, so we might be coming to the end of the golden era of free-range drone photography.

9. Derek Gregory, "From a View to a Kill: Drones and Late Modern War," *Theory, Culture & Society* 28, no. 7–8 (December 2011): 206. I thank Hugh Campbell for this reference.

10. Jeff Stein, "Criminal or Martyr? Inside the Political Formation of Ithaca's Jailed Grandmother," *The Ithaca Voice*, July 15, 2014, http://ithacavoice.com/2014/07/criminal-martyr-inside-political-formation-ithacas-jailed-grandmother/.

From Object to Field

Architects famously love aerial vantage points. From ecstatic Futurist fantasies of flight to Le Corbusier's airplane revelry in *Towards a New Architecture* to Neil Denari's early training at Aerospatiale in Paris, many architects owe direct design debts to aerial apparatuses. We not only prize the synoptic quality of the bird's-eye view, we value the geo-spatial freedom, or what Marshall McLuhan called the "utmost discontinuity in spatial organization," provided by air travel.[11] In 1957, Roland Barthes' post-humanist "Jet-Man" seemed to have been inspired by Le Corbusier's "machine for living" Modernism. Barthes described a jet-pilot who is a member of a "new race in aviation, nearer to the robot than to the hero."[12] For the jet-man, the rumbling, motor-driven tactility of the rail-, sea- and road-bound vehicles of terrestrial humanism was replaced with the smooth, seemingly motionless condition of high-altitude observation. The parallax effect practically evaporates at the high altitudes and speeds of jet flight, suggesting that the earthbound effects we associate with bodily experience might be only one aspect of an expanding matrix of possible phenomena. In this respect, drone visualizations also seem sympathetic with the cinematic sensibilities of the *promenade architecturale*, and even the subversive potentials of Situationist *dérives* and parkour transgressions. The creative (mis)use of aerial imaging for illicit boundary crossing and guerilla occupation of public space and infrastructure seems practically inevitable.

Drone photography relocates our vantage point, de-emphasizing property lines while exposing surprising geo-physical patterns and continuities. But here, again, the synoptic view is nothing new. As Mitchell Schwarzer argues, "Aerial perception can make the routine seem unexpected, extraordinary." He suggests that the opening scene of *West Side Story* (1961), which was filmed from a helicopter, shifted the architectural

11. Marshall McLuhan, *Understanding Media: The Extensions of Man* (Cambridge, MA: The MIT Press, 2001 [1964]), 36.
12. Roland Barthes, "The Jet-Man," in *Mythologies*, trans. Annette Lavers (New York: Hill and Wang, 1972 [1957]), 71–73.

focus from elevation to plan.[13] Whereas this flight over New York City drew attention to extruded building plans, aerial perspectives can also de-emphasize the sanctity of building boundaries. This was Colin Rowe and Fred Koetter's focus in *Collage City*. As John Macarthur explains, "The Nolli plans and aerial photographs in *Collage City* have the appearance of late modernist painting, characterized by flatness, pattern and an 'all-over-ness,' that imply the painting is not a composition of elements, but an expanse which continues out of view or off the edge of the canvas."[14]

Other architects and scholars have also seen opportunities in this shift from terrestrial to aerial vision. As Stan Allen might point out, elevated vantage points can help shift our attention from object to field. Barthes famously argued that the Eiffel Tower's viewpoint "corresponds to a new sensibility of vision" that transforms the urban terrain of Paris into a "new nature" characterized by "concrete abstraction."[15] And according to Elisa Dainese, "the aerial view gives us back the dimension of landscape, filling the gap between nature's domestication and human destruction."[16] This is certainly the case with many aerial photographs that transgress terrestrial borders to expose the natural, industrial, or suburban sublime. Examples include William Garnett's aerial photos of Lakewood in Los Angeles and David Maisel's *Black Maps* series taken from airplanes and helicopters.[17] According to photographer Michael Light, the "politics of transgressing private property in a capitalist society" is an important

13. Mitchell Schwarzer, *Zoomscape: Architecture in Motion and Media* (New York: Princeton Architectural Press, 2004), 123.
14. John Macarthur, "The Figure from Above: On the Obliqueness of the Plan in Urbanism and Architecture," in *Seeing from Above: The Aerial View in Visual Culture*, eds. Mark Dorrian and Frédéric Pousin (London & New York: I.B. Tauris, 2013), 202–203.
15. Roland Barthes, *The Eiffel Tower and Other Mythologies*, trans. Richard Howard (New York: Hill and Wang, 1979), 9. I thank Mary N. Woods for this reference.
16. Elisa Dainese, "Le Corbusier, Marcel Griaule, and the Modern Movement: Exploring the Habitat from the Airplane," in *EAEA-11: Envisioning Architecture: Design, Evaluation, Communication*, eds. Eugenio Morello and Barbara E.A. Piga (Rome: Edizioni Nuova Cultura, 2013), 417.
17. William Garnett, *William Garnett, Aerial Photographs* (Berkeley: University of California Press, 1994); D.J. Waldie, "Beautiful and Terrible: Aeriality and the Image of Suburbia," *Places* (February 2013): https://placesjournal.org/article/beautiful-and-terrible-aeriality-and-the-image-of-suburbia/; and David Maisel, *Oblivion* (Portland, OR: Nazraeli Press, 2006).

aspect of his aerial photography. "That homeowners' association, or that world created by developers, wants total control over its narrative, and, in general, they have it," he insists. "They exclude anyone who wants to tell a different story."[18]

Highlighting this type of exclusion—or "expulsion," to use Saskia Sassen's term—is one of the most exciting transgressive potentials of aerial photography.[19] It promises to break territories out of what Sassen calls their "nation-state cages" through abstraction and critical distance.[20] So it is hardly surprising that landscapes are some of the most common environments for drone photography. The necessary distance from obstacles—trees, buildings, people, power lines—and the resulting openness seems to invite aerial images. Gliding views of glaciers and waterfalls; soaring shots of scenic gorges and mountain valleys; and aerial perspectives of archaeological ruins are a few common examples. Like the virtual cameras of digital flythroughs and first-person video games, these views usually adopt oblique angles in order to maximize dynamism within the frame. As Macarthur notes, "While the vertical view can provide a dimensionally accurate depiction of area, the oblique view adds an impression of depth, which, while it is unable to be dimensioned, is essential to the understanding of the architect and planner."[21] Light also emphasizes the vantage point provided by low altitude flight as an alternative to Google Earth's top-down images. He celebrates the ability of oblique photos to activate what he calls a "relational tableau."[22]

18. Michael Light, "Air America: The Dramatic Aerial Photography of Michael Light," interview by Geoff Manaugh and Nicola Twilley, *The Atlantic*, October 15, 2013, http://www.theatlantic.com/technology/archive/2013/10/air-america-the-dramatic-aerial-photography-of-michael-light/280345/.
19. Saskia Sassen, *Expulsions: Brutality and Complexity in the Global Economy* (Cambridge, MA: Belknap Press, 2014).
20. Sassen celebrates abstraction and critical distance in the black and white images of social documentary photographer Sebastião Salgado: "Color photography of actual settings," on the other hand, "overwhelms with its specificity and leaves little room for distance and thereby for theory." See Saskia Sassen, "Black and White Photography as Theorizing: Seeing What the Eye Cannot See," *Sociological Forum* 26, no. 2 (June 2011): 438.
21. Macarthur, "The Figure from Above," 190.
22. Michael Light, "Spatial Delirium: An Interview with Michael Light," interview by Geoff Manaugh *BLDG/BLOG*, October 7, 2013, http://bldgblog.blogspot.com/2013/10/spatial-delirium-interview-with-michael.html.

This non-dimensional yet relational perspective also approximates what Svetlana Alpers famously describes as the mapping impulse in seventeenth-century Dutch landscape painting.[23] Martin Jay insightfully identifies the faux floating views of these paintings as one alternative to the "scopic regime" of Cartesian perspectivalism.[24] The three-dimensional grid—with its attendant planimetric, sectional, elevational, and perspectival logics—does indeed tend to get lost from above. Still, wasn't the Cartesian grid the matrix within which many of the anti-gravitational ambitions of Modernism were explored, especially in Los Angeles? Just think of the steel and glass projects of John Entenza's Case Study House Program. Some of them almost seem to float because of the photographic perspective. Pierre Koenig and Richard Neutra's use of repeated linear structures and flat surfaces reinforced the rectilinear framing of black and white photos on the monochromatic pages of *Arts & Architecture* magazine (see image 7.2).

23. Svetlana Alpers, "The Mapping Impulse in Dutch Art," in *The Art of Describing: Dutch Art in the Seventeenth Century* (Chicago: University of Chicago Press, 1983), 119–168.
24. Martin Jay, "Scopic Regimes of Modernity," in *Vision and Visuality*, ed. Hal Foster (Seattle: Bay Press and Dia Art Foundation, 1988), 3–23.

Image 7.2. Photo by Julius Shulman (1960). Richard Neutra, Singleton House, Los Angeles, 1959. © J. Paul Getty Trust. Getty Research Institute, Los Angeles (2004.R.10).

In fact, the format of the magazine and the format of the Case Study Houses were utterly synchronized. The Case Study Houses—as the brainchildren of a publisher—were designed for publication.

Aerial Perspective

Julius Shulman's one-point perspective photos famously popularized Entenza's program. In many of Shulman's images, the Cartesian grid conspires with the logics of perspective to produce a floating, seemingly levitational position within the egalitarian ether of three-dimensional space. This mode of visualization has had a profound effect on architecture. As Schwarzer explains, "The experience of seeing the world reduced to the intensities of light and dark affected the perception—and the history—of architecture, encouraging the modernist aesthetic of expansive

glazing and flat white walls."[25] This viewpoint/vanishing point logic often requires a static snapshot frame. When one moves through and around the steel and glass spaces of the Case Study Houses, however, the perspectival illusion is destroyed. As Yve-Alain Bois argues, "if the spectator leaves the standpoint demanded by the perspective construction, the space of representation collapses like a house of cards."[26]

This is especially true for aerial photography. Upon leaving the frame of the house and taking to the air, the conceit of the Cartesian grid not only collapses, but seems to disappear altogether. The grid that seemed infinite from within the frame of perspective is exposed as a shrinking envelope of objecthood. For contemporary architectural photographers the challenge is reframed. If Shulman was concerned with furniture and camera placement within mid-century Modern spaces, Baan and Guerra shifted their attention to social and climatic phenomena. Technical problems are easily solved, and timing is everything. Guerra explains that his work is about "that perfect photo that cannot be repeated." It can be extremely difficult to capture ideal meteorological moments using drones with thirty-minute batteries. At the same time, he admits, the view from above is often "what moves the work from boring to interesting."[27] Of course, the architectural subject matter is also a major factor in the compositional equation. Landscape-scale complexes with sinuous forms, like Zaha Hadid's Galaxy Soho in Beijing and Alvaro Siza's Building on the Water in Jiangsu Province, seem to invite aerial imaging (see image 7.3).

25. Schwarzer, *Zoomscape*, 174.
26. Yve-Alain Bois, "Metamorphosis of Axonometry," *Daidalos* 1 (September 1981): 41–58.
27. Fernando Guerra, e-mail message to author, January 20, 2015.

Image 7.3. Photo by Fernando Guerra. Alvaro Siza, Building on the Water, Jiangsu, China, 2014. FG SG.

Case Study Houses like the Eames House (CSH #8) and Stahl House (CSH #22) present different challenges for drones. Given the utopian Jet Age rhetoric of mid-century Modernism, aerial imaging might seem like an ideal vantage point for photographing Modern houses.[28] Think of Ralph Rapson's iconic rendering of his unbuilt Greenbelt House (CSH #4) from 1945 (see image 7.4).

28. See, for example, Vanessa R. Schwartz, *Jet Age Aesthetic: The Glamour of Media in Motion* (New Haven & London: Yale University Press, 2020).

Image 7.4. Ralph Rapson, Case Study House #4, 1945 (unbuilt). Arts & Architecture, August 1945.

The project is sometimes discussed in terms of unbalanced gender roles that construed freedom for men and domestic servitude for women.[29] But it also presents a view of a personal flying machine from a personal flying machine. Rapson detailed the slender steel frame and butterfly roof to look light; the house almost appears to hover. At the same time, the house also seems curiously hermetic and introverted. It was designed for an urban lot, but Rapson conveniently omitted neighboring properties from the rendering. Is this because he knew neighbors might object to being surveilled from the air? This desire for privacy is one common rea-

29. See, for example, Dolores Hayden, "Model Houses for the Millions: Architects' Dreams, Builders' Boasts, Residents' Dilemmas," in *Blueprints for Modern Living: History and Legacy of the Case Study Houses*, ed. Elizabeth A.T. Smith (Los Angeles: The Museum of Contemporary Art; Cambridge, MA: The MIT Press, 1989), 197–211; and Lucinda Kaukas Havenhand, "Looking through the Lens of Gender: A Postmodern Critique of a Modern Housing Paradigm," *Journal of Interior Design* 28, no. 2 (2002): 1–14.

son for restricting drone photography at Case Study Houses.[30] Less obvious obstacles also abound. Orthogonal geometries can be ill-suited to the fluid flight paths of drones; glass walls are easier to see through than to fly through; and small interiors provide inadequate space for aerial maneuvers. Traditional architectural photography often relies on the camera to overcome these spatial limitations, imbuing lines and surfaces with the impression of infinite extension through careful cropping.

From Walkthrough to Flythrough

The houses designed by Los Angeles architect John Lautner tell a different story. Their spacious interiors and broad fenestration provide plenty of room for flying and viewing, and their curvaceous geometries sometimes seem more synchronized with the smooth flight of quadcopters and the parabolic lenses of GoPro cameras than with the parallactic POV pathways of first-person video games. Some of Lautner's houses even display vehicular—or "dromoscopic"—logics themselves.[31] His Sheats/Goldstein and Reiner "Silvertop" Houses from 1963 have both been repeatedly described as ships that seem to float. This is no accident. In his own travel photography, Lautner often adopted aerial and nautical points of view from planes, ships, and helicopters. His free-flowing interior spaces therefore seem better suited for flythroughs than walkthroughs. They sometimes even create their own atmospheric perspectives. Alan Hess accurately describes the "high, featureless interior surface" of the shallow arched concrete shell at Silvertop, observing that it "gives the ceiling little more presence than a cloud cover."[32] In one particularly effective photograph, Shulman used floodlights to visually mottle the smooth concrete ceiling and mimic the dramatic tonal shifts of sky (see image 7.5).[33]

30. The owners of the Eames House and Stahl House have both denied my requests to conduct drone photography on multiple occasions. The Eames House staff explained that roof repairs were under way, so aerial photos were not allowed. Both owners expressed concern about the privacy of their neighbors. When drones are involved, NIMBY (not in my backyard) becomes NIMBA (not in my back airspace).
31. Paul Virilio, "Dromoscopy, or The Ecstasy of Enormities," trans. Edward R. O'Neill, *Wide Angle* 20, no. 3 (July 1998): 11–22.
32. Alan Hess, "The Redoubtable Mr. Lautner," *L.A. Style* (October 1986): 83.
33. Julius Shulman, *Image 5802-12,* Julius Shulman Archive, Getty Research Institute (GRI) Special Collections.

Image 7.5. Photo by Julius Shulman (1980). John Lautner, Reiner House "Silvertop," Los Angeles, 1963. © J. Paul Getty Trust. Getty Research Institute, Los Angeles (2004.R.10).

Lautner's buildings have also been frequently compared to caves. The glare produced by the radically different lighting levels of his shadowy interiors and bright exteriors poses serious problems for photographers. In Shulman's photograph of the Sheats House, the interior disappears into what seems like a cavernous interior of shadow.[34] This is the case even though viewers can see all the way through the main living space to the hillside behind the house. In an exterior photo of Silvertop, Shulman cleverly solved this problem—but also denied the viewer's ability to explore the dark interior of the enclosed space—by screening it with the faceted floor-to-ceiling glass of the main living area (see image 7.6).

34. Julius Shulman, *Image 3494-02,* Julius Shulman Archive, GRI Special Collections.

Image 7.6. Photo by Julius Shulman. John Lautner, Reiner House "Silvertop," Los Angeles, 1963. © J. Paul Getty Trust. Getty Research Institute, Los Angeles (2004.R.10).

This created a mirrored effect that vertically bifurcates an otherwise horizontal composition. The house's interior is effectively absent. Instead of penetrating the glass wall, the viewer's eye receives the reflected vista of Silver Lake in the opposite direction, an effect that instantiates the distant landscape as a surrogate for the house's interior.[35]

One might assume that the vectoral video advantage of drones—the ability to float freely from dark to light and vice versa—might eliminate the problem of glare. But even the expansive interiors of Silvertop and the Sheats/Goldstein House can be difficult to navigate with drones. Quadcopter chassis threaten to mar wall surfaces and damage artwork, and propeller gusts threaten to scatter papers and spill drinks. These interiors, it seems, provide better parkour for human eyes than for quadcopter

35. Julius Shulman, *Image 3583-1-3,* Julius Shulman Archive, GRI Special Collections.

cameras. Of course, the problem disappears for virtual cameras and exterior shots.[36] In photos made from the hillsides below Lautner's houses, Shulman produced an intriguing series of portraits that depict the buildings as creatures about to take flight (see image 7.7).

Image 7.7. Photo by Julius Shulman (1975). John Lautner, Garcia "Rainbow" House, Los Angeles, 1962. © J. Paul Getty Trust. Getty Research Institute, Los Angeles (2004.R.10).

They seem like subjects, even from below. This is one of the surprising roles buildings sometimes play in the construction of aerial images: they can be cast in intersubjective relationships with drones. As performative building skins, biomorphic blobs, and the lively organisms of object-oriented ontology seem to suggest, buildings are no longer merely seen as inanimate reifications of ideological regimes. Like drones, they are beginning to be seen as intentional beings.

36. Lautner's Malin House "Chemosphere" (1960) in Los Angeles has famously appeared in many types of media, including the video game *Grand Theft Auto: San Andreas* (Rockstar Games, 2004).

Kino-Eye in the Sky

This new subjecthood surpasses the post-humanist decentering potentials of cinema. Architects have long focused on kino-eye's supposed ability to displace the humanist subject through montage, parallax, and other machine effects. When turning our attention to media and representation, we tend to say and write things such as "the camera pans," "the camera zooms," and "the camera glides," seemingly forgetting that expert cinematographers initiate and control dolly shots, long shots, close-ups, slow-motion, panning, time-lapse, and many other types of moving images. Film phenomenologist Vivian Sobchack argues, however, that cinematic experiences are inherently intersubjective—that moviegoers engage with onscreen images as though they are active agents.[37] These cinematic relationships closely resemble those construed by drone photography. Whether wide-angle or conventional frame, the impressive smoothness of GoPro video can approximate aerial Steadicam shots. The sensitive gimbal mount of a GPS-stabilized drone can produce oddly—even eerily—smooth axial movements in depth. It is as though the "motionless crisis of bodily consciousness," which Barthes described as a unique aspect of high-altitude flight, has descended into the thickened ether of terrestrial vision.[38]

These viscous drone movements are both impossibly smooth and often non-orthogonal; their organic pathways of fluid flight replace the straight lines of the Cartesian grid.[39] Silvertop, for example, with its curving panoramic forms, photographs beautifully from above (see image 7.8).

37. Vivian Sobchack, *Address of the Eye: A Phenomenology of Film Experience* (Princeton, NJ: Princeton University Press, 1992).
38. Barthes, "The Jet-man," 71.
39. See Gilles Deleuze and Félix Guattari's famous distinction between subversive smooth space and hegemonic striated space in Deleuze and Guattari, *A Thousand Plateaus: Capitalism and Schizophrenia*, trans. Brian Massumi (Minneapolis: University of Minnesota Press, 1987).

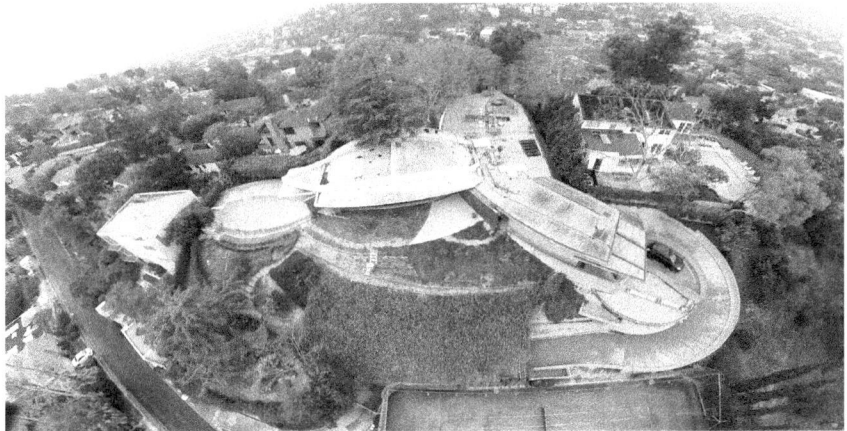

Image 7.8. Photo by Jon Yoder (2015). John Lautner, Reiner House "Silvertop," Los Angeles, 1963.

The house almost seems to grow as the camera glides. The curving distortions produced by the camera's parabolic lens mesh with Lautner's own curvilinear deformations to make Silvertop seem indigenous and the surrounding conventional houses look like boxy intruders.[40] Still, if drone imaging sometimes construes intersubjective relationships between earthbound and aerial subjects, not all curves are created photographically equal. Lautner's Harpel House #2 (1966) in Anchorage, Alaska,—whose main living space employs a precisely circular plan—also looks like an alien from the air.[41] But its Platonic geometry is too perfect for the rotational and circumambulatory movements of quadcopter cameras. Ironically, geometrical purity on the ground and excessive speed in the air—two of architects favorite things—sometimes present problems for drone imaging. Quadcopters can rotate so fast that panning shots induce vertigo. Indeed, objects sometimes appear and disappear so quickly within the frame that the notorious parallactic overload of digital flythroughs seems to emerge in physical space. Unlike the gradual movements of conventional Steadicams, whose size and weight limit rotational velocity, the high-speed aerial rotation of drones resembles the frenzied

40. Here I thank architect Barbara Bestor and her associate Stacey Thomas for facilitating my drone photography of Lautner's Reiner House "Silvertop" in Los Angeles on February 7, 2015.
41. Here I thank homeowners Kathryn and David Cuddy for facilitating my drone photography of Lautner's Harpel House #2 in Anchorage on August 6, 2018.

animations of POV walkthroughs and first-person video games. Lautner's angular Sheats/Goldstein House, on the other hand, introduces differently viscous conditions. The GoPro camera's parabolic lens visibly warps the house's straight lines (see image 7.9).

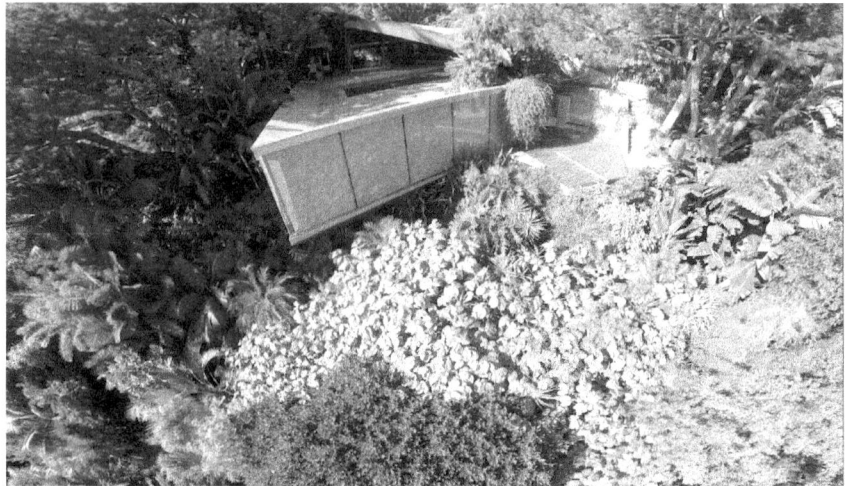

Image 7.9. Photo by Jon Yoder (2014). John Lautner, Sheats/Goldstein House, Beverly Hills, 1963/89.

But orthogonal fidelity is not an issue. Lautner did not design this peculiar project according to the logics of Cartesian perspective. In a sense, its acute and oblique geometries had already been distorted from the rectilinear norm before quadcopter cameras exposed the visual viscosity of this massive concrete house from the air.[42]

Escape Velocity

Michael Light describes hiring a helicopter for aerial photography as a dangerously precipitous proposition: "Drive to Van Nuys, get into this tiny little dragonfly of a machine, a flying motorcycle with a seat belt, doors come off . . ."[43] It is a visceral and viscous experience that lacks the presumed safety and comfort ostensibly provided by both virtual cam-

42. Here I thank homeowner James Goldstein and his assistant Roberta Leighton for facilitating my drone photography of Lautner's Sheats/Goldstein House in Beverly Hills on October 19, 2014.
43. Michael Light, "Michael Light in Conversation with Lawrence Weschler," interview by Lawrence Weschler, *The Believer*, November/December 2010, https://believermag.com/a-conversation-with-micahel-light/.

eras and drones. "I think it's through my own selfishness that I would not want to send a drone up to transgress over a site when I could do it, instead," Light explains. "I could just sit at my computer screen and kick back in my chair—but we spend enough time in chairs as it is. It's more that I am putting my butt on the line; I'm breaking no laws, but there is the experience of physical exploration that I would be denied by using drones."[44] While he observantly notes the weight and turbulence involved with conventional flying machines and insightfully predicts the imminent proliferation of personal drones, will our eyes actually "be able to go anywhere and everywhere without our bodies," as he claims?[45] Assumptions of gravity-free visual omniscience like these recycle the naive teleological assumptions of Modernism. After all, the drones-eye view is not simply a three-dimensional displacement of a z-axis vantage point; it conditions and constructs vision in different ways than Modernist myths often assume.

This has long been true for the aerial view. Vittoria Di Palma explains that pioneers of ballooning stressed the visual expansion of ascension. "Many stressed that an airborne perspective enabled them to see more," she explains. "But it is not so much a question of seeing more, as of seeing differently."[46] Indeed, differences expose the impossibility of making essentializing claims about the drone's-eye view. Scholars continue to emphasize the insidious implications of eye-in-the-sky technologies while artists like Addie Wagenknecht make action paintings using quadcopters.[47] According to drone artists Yael Messer and Gilad Reich, "You can see the view from above, which is traditionally a view of power, of state power, of corporate power, a view we were educated to think of as a perspective of control, of obedience, is now suddenly being reappropri-

44. Light, "Spatial Delirium."
45. Light, "Air America."
46. Vittoria Di Palma, "Zoom: Google Earth and Global Intimacy," in *Intimate Metropolis: Urban Subjects in the Modern City*, eds. Vittoria Di Palma, Diana Periton, and Marina Lathouri (New York: Routledge, 2009), 243.
47. Wagenknecht creates "Black Hawk" action paintings using Parrot drones and smaller hobby store quadcopters. See Addie Wagenknecht's website: https://www.placesiveneverbeen.com/works/black-hawk-paint.

ated by activists for different reasons."[48] In 1994, Diller + Scofidio created *Overexposed*, a 28-minute video performance that slowly pans horizontally and vertically across the curtain wall of Gordon Bunshaft's Pepsi-Cola Corporation World Headquarters, constructing a deadpan narrative of everyday office occupation. According to Diller + Scofidio, "The transparency of the curtain wall, along with other, more insidious forms of surveillance, may have created an overexposed world, leaving few shadow zones of privacy."[49] Had they used drone photography, it might have shifted the focus of the project from the planar Cartesian surface to different (transformative) pathways of flight.

Just as it is neither entirely innocent nor entirely sinister, drone photography relates differently to different environments. It often seems synchronized with large-scale landscapes, and its different lenses respond differently to different geometries. With Walter Benjamin, we might still celebrate the camera's ability to penetrate deeply into the "web of reality."[50] With drone photography, however, the malleability of an outdated concept like "reality" is exposed. As drone imaging transfers the digital flythroughs of virtual cameras to the arena of physical space, the ostensibly liberating drone apparatus reveals a surprisingly viscous aerial architecture. Instead of bypassing geo-climatic considerations, drone systems bring the paradoxical weight of aerial maneuvers to the fore.[51] Old dyads such as real/virtual, static/dynamic, and optical/tactile lose significance once lightness is revealed to have heft and virtual refraction is seen as a viable starting point for cultural production. The gravity of both physics and politics within specific environments becomes palpable. And, impor-

48. Gilad Reich, "A Conversation with High & Low Bureau," interview by Arthur Holland Michel, The Center for the Study of the Drone at Bard College, October 6, 2014, http://dronecenter.bard.edu/high-low-bureau/.
49. Diller Scofidio + Renfro, *Overexposed*, 1994, https://dsrny.com/project/overexposed.
50. Walter Benjamin, "The Work of Art in the Age of Mechanical Reproduction," in *Illuminations*, ed. Hannah Arendt, trans. Harry Zohn (New York: Schocken Books, 1968), 217–251.
51. All media have weight. For my discussion of the gravity of comics, see Jon Yoder (The Inventor), "Atlas of Graphic Novel Tectonics," *Flat Out* 2 (Spring 2017): 2, 13–15.

tantly, longstanding myths about the nature of architectural vision cease to serve as adequate frameworks for understanding the smooth, curvaceous, and levitational potentials of this rapidly proliferating aerial architecture.

Bibliography

Alpers, Svetlana. "The Mapping Impulse in Dutch Art." In *The Art of Describing: Dutch Art in the Seventeenth Century*, 119–168. Chicago: University of Chicago Press, 1983.

Barthes, Roland. *The Eiffel Tower and Other Mythologies*. Translated by Richard Howard. New York: Hill and Wang, 1979.

———. "The Jet-Man." In *Mythologies*. Translated by Annette Lavers, 71–73. New York: Hill and Wang, 1972 (1957).

Benjamin, Walter. "The Work of Art in the Age of Mechanical Reproduction." In *Illuminations*, edited by Hannah Arendt. Translated by Harry Zohn, 217–251. New York: Schocken Books, 1968.

Bois, Yve-Alain. "Metamorphosis of Axonometry." *Daidalos* 1 (September 1981): 41–58.

Bois, Yve-Alain, Michel Feher, Hal Foster, and Eyal Weizman. "On Forensic Architecture: A Conversation with Eyal Weizman." *October* 156 (Spring 2016): 116–140.

Dainese, Elisa. "Le Corbusier, Marcel Griaule, and the Modern Movement: Exploring the Habitat from the Airplane." In *EAEA-11: Envisioning Architecture: Design, Evaluation, Communication*, edited by Eugenio Morello and Barbara E.A. Piga, 411–418. Rome: Edizioni Nuova Cultura, 2013.

DeLanda, Manuel. *War in the Age of Intelligent Machines*. New York: Zone Books, 1991.

Deleuze, Gilles, and Félix Guattari. *A Thousand Plateaus: Capitalism and Schizophrenia*. Translated by Brian Massumi. Minneapolis: University of Minnesota Press, 1987.

Diller Scofidio + Renfro. *Overexposed*. 1994. https://dsrny.com/project/overexposed.

Di Palma, Vittoria. "Zoom: Google Earth and Global Intimacy." In *Intimate Metropolis: Urban Subjects in the Modern City*, edited by Vittoria Di Palma, Diana Periton, and Marina Lathouri, 239–270. New York: Routledge, 2009.

Evans, Robin. "Architectural Projection." In *Architecture and Its Image: Four Centuries of Architectural Representation, Works from the Collection of the Canadian Centre for Architecture*, edited by Eve Blau and Edward Kaufman, 18–35. Montreal: Canadian Centre for Architecture, 1989.

Garnett, William. *William Garnett, Aerial Photographs*. Berkeley: University of California

Press, 1994.

Gregory, Derek. "From a View to a Kill: Drones and Late Modern War." *Theory, Culture & Society* 28, no. 7–8 (December 2011): 206.

Havenhand, Lucinda Kaukas. "Looking Through the Lens of Gender: A Postmodern Critique of a Modern Housing Paradigm." *Journal of Interior Design* 28, no. 2 (2002): 1–14.

Hayden, Dolores. "Model Houses for the Millions: Architects' Dreams, Builders' Boasts, Residents' Dilemmas." In *Blueprints for Modern Living: History and Legacy of the Case Study Houses*, edited by Elizabeth A.T. Smith, 197-211. Los Angeles: The Museum of Contemporary Art; Cambridge, MA: The MIT Press, 1989.

Hess, Alan. "The Redoubtable Mr. Lautner." *L.A. Style* (October 1986): 78–84.

Holt, Gordon H.G. "Architecture and Aerial Photography." *The Architectural Review*, no. 45 (1919): 3–9.

Jay, Martin. "Scopic Regimes of Modernity." In *Vision and Visuality*, edited by Hal Foster, 3–23. Seattle: Bay Press and Dia Art Foundation, 1988.

Light, Michael. "Air America: The Dramatic Aerial Photography of Michael Light." Interview by Geoff Manaugh and Nicola Twilley, *The Atlantic*, October 15, 2013. http://www.theatlantic.com/technology/archive/2013/10/air-america-the-dramatic-aerial-photography-of-michael-light/280345/.

———. "Michael Light in Conversation with Lawrence Weschler." Interview by Lawrence Weschler. *The Believer*, November/December 2010. https://believermag.com/a-conversation-with-micahel-light/.

———. "Spatial Delirium: An Interview with Michael Light." Interview by Geoff Manaugh. *BLDG/BLOG*, October 7, 2013. http://bldgblog.blogspot.com/2013/10/spatial-delirium-interview-with-michael.html.

Macarthur, John. "The Figure from Above: On the Obliqueness of the Plan in Urbanism and Architecture." In *Seeing from Above: The Aerial View in Visual Culture*, edited by Mark Dorrian and Frédéric Pousin, 202–203. London & New York: I.B. Tauris, 2013.

Maisel, David. *Oblivion*. Portland, OR: Nazraeli Press, 2006.

McLuhan, Marshall. *Understanding Media: The Extensions of Man*. Cambridge, MA: The MIT Press, 2001 (1964).

Reich, Gilad. "A Conversation with High & Low Bureau." Interview by Arthur Holland Michel. The Center for the Study of the Drone at Bard College, October 6, 2014. http://dronecenter.bard.edu/high-low-bureau/.

Saint-Amour, Paul K. "War, Optics, Fiction." *Novel: A Forum on Fiction* 43, no. 1 (Spring 2010): 93–99.

Sassen, Saskia. "Black and White Photography as Theorizing: Seeing What the Eye Cannot See." *Sociological Forum* 26, no. 2 (June 2011): 438–443.

———. *Expulsions: Brutality and Complexity in the Global Economy*. Cambridge, MA: Belknap Press, 2014.

Schwartz, Vanessa R. *Jet Age Aesthetic: The Glamour of Media in Motion*. New Haven & London: Yale University Press, 2020.

Schwarzer, Mitchell. *Zoomscape: Architecture in Motion and Media*. New York: Princeton Architectural Press, 2004.

Sobchack, Vivian. *Address of the Eye: A Phenomenology of Film Experience*. Princeton, NJ: Princeton University Press, 1992.

Stein, Jeff. "Criminal or Martyr? Inside the Political Formation of Ithaca's Jailed Grandmother." *The Ithaca Voice*, July 15, 2014. http://ithacavoice.com/2014/07/criminal-martyr-inside-political-formation-ithacas-jailed-grandmother/.

Virilio, Paul. *The Aesthetics of Disappearance*. Translated by Philip Beitchman. New York: Semiotext(e), 1991.

———. "Dromoscopy, or The Ecstasy of Enormities." Translated by Edward R. O'Neill. *Wide Angle* 20, no. 3 (July 1998): 11–22.

———. *War and Cinema: The Logistics of Perception*. Translated by Patrick Camiller. London & New York: Verso, 1989.

Wagenknecht, Addie. *Black Hawk Paint*. 2007-ongoing. https://www.placesiveneverbeen.com/works/black-hawk-paint.

Waldie, D.J. "Beautiful and Terrible: Aeriality and the Image of Suburbia." *Places* (February 2013): https://placesjournal.org/article/beautiful-and-terrible-aeriality-and-the-image-of-suburbia/.

Yoder, Jon (The Inventor). "Atlas of Graphic Novel Tectonics." *Flat Out* 2 (Spring 2017): 2, 13–15.

about the editors

Dave Gottwald is a designer and design historian. His research explores the theming of consumer spaces and interplay between the built and the virtual. Along with Gregory Turner-Rahman, he was recipient of the 2019 Design Incubation Writing Fellowship for their current collaboration, *Theme Parks, Video Games, and Evolving Notions of Space: The End of Architecture* (forthcoming, Intellect Books). He is also co-author of *Disney and the Theming of the Contemporary Zoo: Kingdoms of Artifice* (forthcoming, Lexington Books). He is currently an Assistant Professor at the University of Idaho in the College of Art & Architecture where he teaches interaction design, experiential design for the built environment, and exhibit design.

Gregory Turner-Rahman is a designer and writer-illustrator. His current research and creative activity explores both the intersections of physical and virtual spaces and visual and experiential storytelling. In 2019, he and Dave Gottwald were recipients of the Design Incubation Writing Fellowship for their collaboration, *Theme Parks, Video Games, and Evolving Notions of Space: The End of Architecture* (forthcoming, Intellect Books). He has also contributed to *The Journal of Design History, Post-Identity, Fibreculture and Media Authorship*, an edited American Film Institute Reader published by Routledge. As a member of a creative team, he garnered Apex and Clarion awards for writing and design work. He is currently an Associate Professor at the University of Idaho in the College of Art & Architecture where he teaches motion graphics and design history.

Vahid Vahdat is an architect, interior designer, and historian of architecture and urban form. His primary field of research is the global circulation of modern architecture, with an emphasis on medial agency. He is the author of *Occidentalist Perceptions of European Architecture in Nineteenth Century Persian Travel Diaries—Travels in Farangi Space*. Dr. Vahdat has held academic positions in the US and abroad, including at the University of Houston and Texas A&M University. He is currently an Assistant Professor at the School of Design and Construction at Washington State University. His teaching primarily involves explorations in architectural media, including virtual interiorities and filmic expressions of space.

about the contributors

Stefano Gualeni is a philosopher who designs digital games and a game designer who is passionate about philosophy. He is an Associate Professor at the Institute of Digital Games (University of Malta), and a Visiting Professor at the Laguna College of Art and Design (LCAD) in Laguna Beach, California. Stefano is the writer and designer of the point-and-click video game adventure series *Tony Tough* (2001–2007) as well as many other titles both commercial and experimental. He is the author of four monographic books: *Virtual Worlds as Philosophical Tools* (Palgrave, 2015), *Virtual Existentialism: Meaning and Subjectivity in Virtual Worlds* (Palgrave Pivot, 2020—with Daniel Vella), *Fictional Games: A Philosophy of Worldbuilding and Imaginary Play* (Bloomsbury, 2023—with Riccardo Fassone), and *The Clouds: An Experiment in Theory-Fiction* (forthcoming, Routledge).

Graham Harman is Distinguished Professor of Philosophy at the Southern California Institute of Architecture (SCI-Arc) in Los Angeles. Previously he was Distinguished University Professor at the American University in Cairo, where he spent sixteen years on the faculty. He is a founding member of the Speculative Realism and Object-Oriented Ontology movements, Editor-in-Chief of the journal Open Philosophy, Series Editor of the Speculative Realism series at Edinburgh University Press, and Series Co-Editor (with Bruno Latour) of the New Metaphysics Series at Open Humanities Press.

Johan Höglund is professor of English at Linnaeus University and member of the Linnaeus University Centre for Concurrences in Colonial and Postcolonial Studies, at Linnaeus University, Sweden. He has published extensively on the relationship between imperialism and popular culture in a number of different contexts and media. He is the author of *The American Imperial Gothic: Popular Culture, Empire, Violence* (2014), and the co-editor of several scholarly collections and special issues, including "Nordic Colonialisms" for *Scandinavian Studies* (2019), "Revisiting Adventure" for *Journal of Popular Culture* (2018), *Gothic in the Anthropocene* (2021), *Nordic Gothic* (2020), *B-Movie Gothic: International Perspectives* (2018), and *Animal Horror Cinema: Genre, History and Criticism* (2015).

Cornelius Holtorf is Professor of Archaeology and holds a UNESCO Chair on Heritage Futures at Linnaeus University in Kalmar, Sweden. He is also directing the Graduate School in Contract Archaeology (GRASCA) at his university. In his research, he is currently particularly interested in contemporary archaeology, heritage theory, and heritage futures, with numerous international publications in these areas. He is the author of *From Stonehenge to Las Vegas* (2005), *Archaeology is a Brand!* (2007) and has co-edited collections of papers on

The Archaeology of Time Travel (with B. Petersson, 2017), *Authenticity and Reconstruction* (for International Journal of Cultural Property, 2020), and *Cultural Heritage and the Future* (with A. Högberg, 2021).

Scott A. Lukas is Faculty Chair of Teaching and Learning at Lake Tahoe Community College, where he has taught Anthropology and Sociology. He was Visiting Professor of American Studies at the Johannes Gutenberg University Mainz and taught Anthropology and Sociology at Valparaiso University. He was the recipient of the national AAA/McGraw-Hill Award for Excellence in Undergraduate Teaching of Anthropology by the American Anthropological Association in 2005 and the California statewide Hayward Award for Excellence in Education by the California Community Colleges in 2003. He is the author/editor of seven books, including *The Immersive Worlds Handbook*, and has consulted for the themed entertainment industry. Scott has provided interviews for *The Wondery*, *To the Best of Our Knowledge*, the Canadian Broadcasting Company, *The Independent*, *The New York Times*, *The Washington Post*, *Slate*, *The Chicago Tribune*, *The Financial Times* (of London), *The Daily Beast*, *Huffington Post UK*, *Atlas Obscura*, *Skift*, *Caravan*, the *Angie Coiro Show*, and was part of the documentary film and video series, *The Nature of Existence*.

Michael Nitsche works as Associate Professor in Digital Media at the Georgia Institute of Technology where he teaches mainly on issues of hybrid spaces and performance as interaction. He is fascinated by the intersection of the digital with the physical domain and explores this borderline in video games and VR as well as craft and performances. He directs the Digital World and Image Group and is involved with various interdisciplinary research centers. Nitsche has contributed to numerous journals and conferences, his books *Vital Media* (2022), *Video Game Spaces* (2009) and *The Machinima Reader* (2011) (co-edited with Henry Lowood) were published at MIT. Since 2015, he is co-editor of the Taylor&Francis journal *Digital Creativity*.

Nele Van de Mosselaer is a postdoctoral researcher (Research Foundation Flanders – FWO) at the University of Antwerp, Belgium. Her fields of interest are the philosophy of fiction, game studies, and narratology. In her research, she explores the relation between imagination, emotions, actions, and desires in the context of fiction experiences. She is especially interested in how the boundaries between reality and fiction can be blurred within virtual environments.

Daniel Vella is a senior lecturer at the Institute of Digital Games at the University of Malta, where he teaches classes in digital game studies, player experience and narrative in games. His research interests including the phenomenology of player experience, aesthetic theory and digital games, subjectivity and identity in virtual worlds, and narrativity and fictionality in games. His work has been published in a number of international journals, including *Game Studies*, *Countertext* and the *Journal of Virtual Worlds Research*. He is the co-author of *Virtual Existentialism* (Palgrave Macmillan, 2020), and is also a narrative designer for board games.

Jon Yoder is a designer and scholar of modern architecture and visual media who received his Ph.D. in Architecture from UCLA. He teaches design and theory at Kent State University

and taught previously at Syracuse University and SCI-Arc. His designs with Pei Cobb Freed, ZGF Architects and SPF:architects have been published widely, and his research and teaching have been supported by numerous grants and awards. These include an ARCHITECT Studio Prize for his design studio, "Graphic Novels / Novel Architecture," and a Graham Foundation grant for his forthcoming Getty Research Institute Publications book, *Widescreen Architecture: Immersive Media and John Lautner*.

about the etc press

The ETC Press was founded in 2005 under the direction of Dr. Drew Davidson, the Director of Carnegie Mellon University's Entertainment Technology Center (ETC), as an open access, digital-first publishing house.

What does all that mean?

The ETC Press publishes three types of work: peer-reviewed work (research-based books, textbooks, academic journals, conference proceedings), general audience work (trade non-fiction, singles, Well Played singles), and research and white papers

The common tie for all of these is a focus on issues related to entertainment technologies as they are applied across a variety of fields. Our authors come from a range of backgrounds. Some are traditional academics. Some are practitioners. And some work in between. What ties them all together is their ability to write about the impact of emerging technologies and its significance in society.

To distinguish our books, the ETC Press has five imprints:

- **ETC Press:** our traditional academic and peer-reviewed publications;
- **ETC Press: Single:** our short "why it matters" books that are roughly 8,000-25,000 words;
- **ETC Press: Signature:** our special projects, trade books, and other curated works that exemplify the best work being done;
- **ETC Press: Report:** our white papers and reports produced by practitioners or academic researchers working in conjunction with partners; and
- **ETC Press: Student:** our work with undergraduate and graduate students

In keeping with that mission, the ETC Press uses emerging technologies to design all of our books and Lulu, an on-demand publisher, to distribute our e-books and print books through all the major retail chains, such as Amazon, Barnes & Noble, Kobo, and Apple, and we work with The Game Crafter to produce tabletop games.

Since the ETC Press is an open-access publisher, every book, journal, and proceeding is

available as a free download. We're most interested in the sharing and spreading of ideas. We also have an agreement with the Association for Computing Machinery (ACM) to list ETC Press publications in the ACM Digital Library.

We don't carry an inventory ourselves. Instead, each print book is created when somebody buys a copy.

Authors retain ownership of their intellectual property. We release all of our books, journals, and proceedings under one of two Creative Commons licenses:

- **Attribution-NoDerivativeWorks-NonCommercial:** This license allows for published works to remain intact, but versions can be created; or
- **Attribution-NonCommercial-ShareAlike:** This license allows for authors to retain editorial control of their creations while also encouraging readers to collaboratively rewrite content.

This is definitely an experiment in the notion of publishing, and we invite people to participate. We are exploring what it means to "publish" across multiple media and multiple versions. We believe this is the future of publication, bridging virtual and physical media with fluid versions of publications as well as enabling the creative blurring of what constitutes reading and writing.